ART AND POLITICS NOW

Anthony Downey

ART AND POLITICS NOW

Thames & Hudson

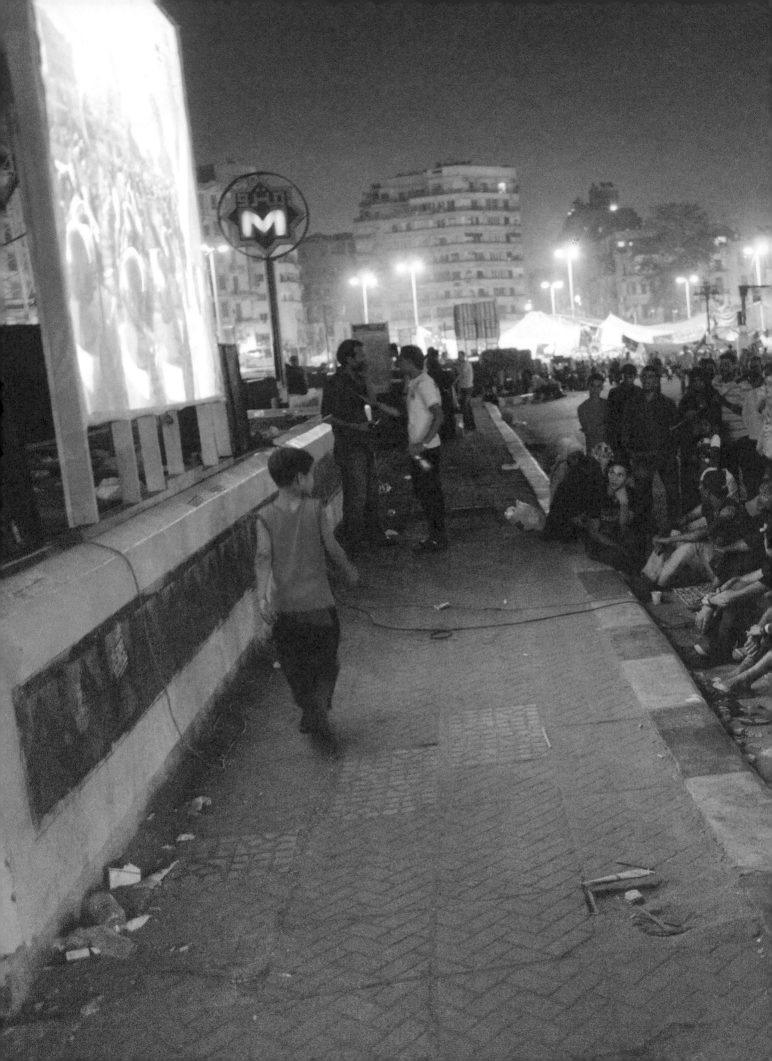

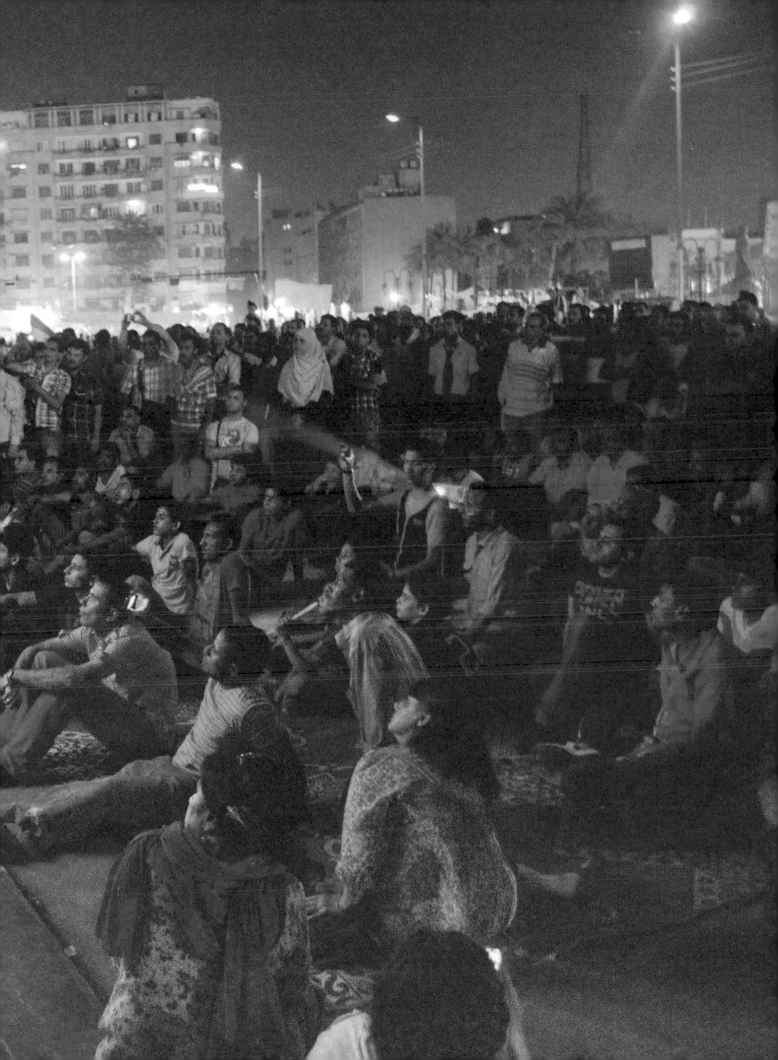

The headings and captions in this book are set in ZXX, a
typeface developed by the South Korean graphic designer
SANG MUN. Described by SANG as a 'disruptive typeface', it is
designed to be unreadable by optical character recognition
(OCR) software, as used by the intelligence services. Its name
is taken from the three-letter codes used by the Library of
Congress to denote the language in which a book is written;
'ZXX' stands for 'no linguistic content/not applicable'. For
further information, see www.z-x-x.org.

Art and Politics Now
© 2014 Thames & Hudson Ltd, London
Text © 2014 ANTHONY DOWNEY
Designed *by* JONATHAN ABBOTT *at* Barnbrook

First published *in* 2014 *in* paperback *in*
the United States of America *by*
Thames & Hudson Inc., 500 Fifth Avenue,
New York, New York 10110

thamesandhudsonusa.com

Library of Congress Catalog Card Number 2014900121

ISBN 978-0-500-29147-4

Printed *and* bound *in* Hong Kong *by* Paramount

CONTENTS

INTRODUCTION

Global Culture and Political Engagement

DOING ART MEANS
DISPLACING ART'S
BORDERS, JUST AS
DOING POLITICS
MEANS DISPLZCIMG
THE BORDERS OF WHAT
IS ACKNOWLEDGED AS
THE POLITICAL.
-
JACQUES RANCIÈRE

THE INCREASINGLY POLITICAL DIMENSION OF CONTEMPORARY ART HAS GIVEN RISE TO A NUMBER OF IMPORTANT QUESTIONS ABOUT THE ROLE IT PLAYS IN SOCIETY TODAY.

Since the turn of the new millennium, we have seen artists progressively engage with the politics of globalization, migration, labour, citizenship, activism, income inequality, injustice, conflict, terrorism, biopolitics, free trade, financial crisis, environmentalism and information technology. *Art and Politics Now* sets out to explore the implications of this development – for art and politics alike – and the ways in which artists both address specific political issues and tactically engage with, negotiate and examine the nature of politics. Contemporary art, this book will propose, imagines that which remains politically unimaginable. In this context, contemporary art practices not only offer ways of thinking about some of society's most pressing concerns, but also can rethink what we understand by the term 'politics'.

In focusing on the politics of, for example, terrorism or migration, artists have opened up new areas of consideration and reflection for audiences. Moreover, the formal methods and techniques employed by contemporary artists have become more diverse. These include lecture-performances, the use of documentary and archive material, artist-led workshops, social activism, collaborations, community-based projects, research-led seminars, artist-initiated

political movements, artist-funded organizations and, in particular, a growing tendency to co-opt individuals and communities into the processes involved in creating a work of art.

To these developments it is necessary to add the changes in the way we have come to understand the role of the artist in contemporary society. Artists are increasingly seen as occupying a number of different roles, from curators, writers and researchers to educators, documentarists and ethnographers. Most significantly, perhaps, they have also come to be regarded as social antagonists and political activists, working from within given social and political orders, rather than existing in distinction to them.

Taken as a whole, these changes to both subject matter and forms of engagement give rise to two important questions: why have contemporary artists turned towards the realm of the political in search of subject matter, and why are the formal elements of contemporary art – be they community-based practices or artist-led workshops – increasingly considered suitable platforms for discussing social and political engagement?

It is arguable, in the first instance, that the turn towards the political in contemporary art is a result of certain historical events. We could observe here a number of such events that would support this assertion, including the terrorist attacks of 11 September 2001; the ensuing war in Afghanistan; the invasion of Iraq in 2003 and its legacy of violence; the worldwide politicization of 'terror'; the opportunistic and ongoing suspension of legal rights and *habeas corpus*; the financial crash of 2007; the radicalization of civil protest and its incremental criminalization; the perceived ineffectiveness

[1] ALLAN SEKULA – <u>Waiting for Tear Gas</u>, 1999–2000. Diaporama, 81 diapositives, 16 min.

of politics in the face of global capital; recent conflicts across North Africa, the Middle East and elsewhere; and the ubiquitous forms of interconnectivity and advanced surveillance systems that determine models of social interaction. All have proved significant in the politicization of not only artists but also, crucially, their audiences.

This is not to suggest that artistic practices in the past were somehow apolitical; on the contrary, art, being a social practice largely carried out in the public sphere, is inseparable from the broader political realm. Nevertheless, recent artistic engagements with politics need to be considered in the context of globalization and how that process is radically reconfiguring social, political, economic and cultural relationships worldwide. In the context of globalization, art as a practice has developed in terms of both content and form so as to address precisely the complexity of these reconfigurations. In the works under consideration in the early chapters of this book, there is a singular question being asked: what is it to live under the conditions of globalization? Or, more specifically, what is it to experience globalization as an uneven economic, social, historical and political fact of life, rather than an abstract ideal or theoretical framework?

Globalization, as we shall see, not only has a dramatic effect on political, economic and cultural relations, but also generates worldwide conflict and upheaval. It is with this in mind that *Art and Politics Now* will consider how contemporary art both reflects on these and other such issues and – through its varied forms and processes – actively operates within them. In later chapters, we shall see how artists strategically engage with, for example, the precarious status of the refugee, the politicization of terror and geopolitical conflict, the (mis) representation of history, the uses and abuses of information technology, the social impact of global recession, and the denigration of environments worldwide.

Also critical to any examination of the relationship between art practices in the twenty-first century and globalization is an evaluation of neo-liberalism as a dominant, global political ideology. The impact of neo-liberalism can be clearly seen if we consider, for example, the trend towards casual, migratory forms of labour and international policies on deregulating barriers to free trade, both of which are key elements of the discussion in the second chapter of the book, 'Labour'. The influence of neo-liberalism can be likewise found in the relationship between free markets and private interests, and the assumption that these factors will result in prosperity for all. For free markets to operate successfully, and for the apparent good of all, they must have minimal controls placed on them; indeed, this is the central tenet of neo-liberal, free-market capitalism. The counterargument to this position is that the deregulation of markets in favour of private initiatives results in the exploitation of the many for the benefit of the few. For some, as we shall see in the third chapter, 'Citizens', neo-liberalism is effectively a means of accumulating capital through various forms of dispossession, be it of rights, citizenship or access to the global economy.[1]

In choosing to address the social and political realms, the works discussed in *Art and Politics Now* not only engage a broader audience with the politics of globalization and neo-liberalism, but also

enquire into what form social and political interaction with these issues might take. This book is therefore particularly concerned with the way in which formal experimentation, as much as the ideas behind a work, furthers our engagement with and understanding of the political. Allan Sekula's *Waiting for Tear Gas* (1999–2000) [1] is a sequence of photographs taken during the demonstrations against the World Trade Organization (WTO) in Seattle, Washington, in 1999. In his approach to these demonstrations, which saw an estimated 40,000 people protest against the economic policies of the WTO and the International Monetary Fund, both seen by many as agents of globalization and neo-liberalism, Sekula presented his work as a form of 'anti-journalism' – no auto-focus, no flash, no zoom lens – thus avoiding the spectacle and media-friendly images often associated with civil protest and activism.[2]

By refusing to sensationalize his subject, Sekula manages to adopt a position within the political debates surrounding globalization and yet, in his discerning use of his chosen media, maintain a critical distance from them. No longer understood as separate to or indeed antagonistic towards the political realm, such artists as Sekula offer complex responses to the geopolitics of power and social change in the early part of the twenty-first century and, crucially, provide alternative models of engagement with these and other issues.

A desire to interact and engage with politics in a manner that re-imagines possible forms of social engagement (while not necessarily expressing an overt political opinion) is common to many of the artists included in this book. This is particularly important to understanding the main thrust of the discussion in the fourth chapter, 'Activism': that it is necessary to maintain a distinction between artist-based and political activism if the former is not to be subsumed into the latter. For art to maintain its critical powers in relation to politics, it must, somewhat paradoxically, adopt a radical position within society and yet refrain from using the often reductive terms of political rhetoric. In Jeremy Deller's *It Is What It Is* (2009) [2], the artist acquired a car that had been destroyed in a Baghdad marketplace on 5 March 2007 and exhibited it across the United States, taking in cities from New York to Los Angeles. Accompanying the car was Jonathan Harvey, a reservist in the US military who had recently served in Iraq, and Esam Pasha, an Iraqi artist who had sought asylum in the United States in 2005. As part of the tour, members of the public were encouraged to ask questions of both Harvey and Pasha and enter into a dialogue about Iraq. Although pointedly apolitical, inasmuch as no stance was being adopted in relation to the war in Iraq, Deller's work has an inevitable political undertone that implicates it in debates about the war and its legacy. It creates an event, moreover, in which the viewer becomes an active interlocutor with, rather than a mere spectator of, a work of art.

This process of inserting artistic practices into sociopolitical debates – and, by implication, the spectator/viewer – is central to the work of Spanish artist Santiago Sierra. The politics of employment, for immigrant workers in particular, provided the inspiration for Sierra's *Workers who cannot be paid, remunerated to remain inside cardboard boxes* (2000) [3]. Based on earlier pieces

exhibited in Guatemala and New York, this work involved placing refugees from Chechnya inside large cardboard boxes, where they remained for four hours a day for the six-week duration of the exhibition. At the time of the show, staged at Kunst-Werke Institute for Contemporary Art in Berlin, German legislation was such that refugees were entitled to a small monthly allowance on the condition that they did not work; any person found to be breaking this rule would be returned to their home country. As a result, the details of this piece could not be made public until after the exhibition, and its participants were forced to collect their salaries in secret.

In common with much of the work featured in this book, Sierra's *Workers ...* does not necessarily offer a definitive comment on the issues under consideration; rather, it suggests an active engagement with and nuanced negotiation of those issues. As a form of social practice, contemporary art needs to be understood not so much in terms of 'political art' (agitprop or propaganda, for example), but in relation to how it has become part of the social and political imagination through various forms of representation and engagement. These processes, in addition, can be open-ended and defy traditional ideas of closure.

Although artists often utilize the principles of activism, a clear distinction between art and activism nevertheless remains, inasmuch as the former is not always accompanied by any clear intent or indeed ambition to bring about change.[3] There is a distinction to be had between art practices that engage with politics, and the overall aims of political activism: art as a practice does not necessarily have any clear-cut goals, nor are its end results quantifiable in terms of desirable or fixed outcomes. The focus of this book is therefore not so much on artists as outright activists, a role that can be readily co-opted into the often divisive, issue-led world of political activism, as it is on how artistic practice is able to expand the very notion of activism, protest and political participation.

Michael Rakowitz's *Enemy Kitchen* (2006–) [5] is a collaboration between Rakowitz and his Iraqi-Jewish mother, with whom he compiles recipes from traditional Baghdadi cuisine. With these recipes, Rakowitz leads a series of cooking classes with different groups of people, ranging from middle- and high-school students to the chefs in school cafeterias, some of whom have relatives in the US Army stationed in Iraq. While cooking and eating Iraqi delicacies, conversations between students about the war in Iraq arise, revealing the opinions, myths and facts that can circulate in a country, in this case the United States, during a period of conflict. As a consequence, each iteration of *Enemy Kitchen* is shaped according to the willingness of its participants to speak about the politics of war through the activity of cooking.[4] Although this work could be seen in terms of activism, inasmuch as it opens up a space for potential discussion about a controversial subject, *Enemy Kitchen* does not express a political standpoint or point of view; rather, it is the expression of social practices and political values, and therefore already political in its intentions.

This sense of art decoding political values and engaging communities in a common experience chimes with an individual and community-based understanding of how the political realm can

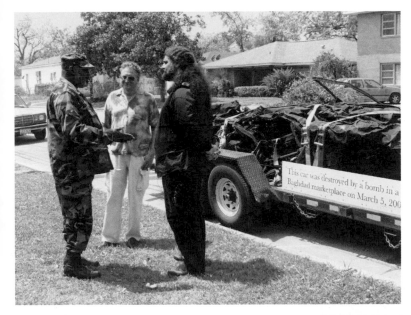

[2] JEREMY DELLER – It Is What It Is, 2009.
Photographs taken during the It Is What
It Is: Conversations About Iraq tour,
by Jeremy Deller. Installation view,
New Museum, New York

For It Is What It Is, the artist obtained
a car that had been bombed in a Baghdad
marketplace in 2007 and took it on a tour
across the United States. The car was
accompanied by an Iraqi artist and a US
military reservist, to whom viewers were
encouraged to pose questions about the
Iraq war and its impact and legacy.

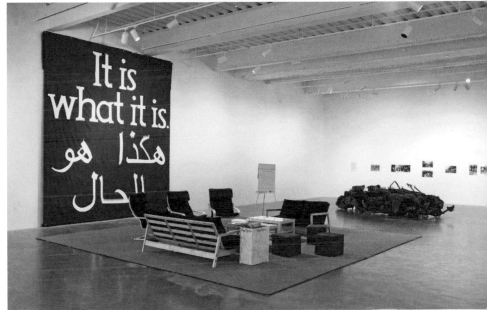

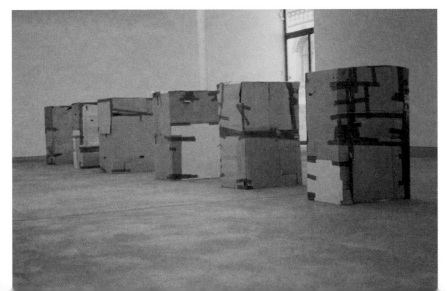

[3] SANTIAGO SIERRA – Workers who
cannot be paid, remunerated to remain
inside cardboard boxes, 2000.
Performance

In this performance in a Berlin
gallery, the artist paid Chechen
political refugees to 'live' in boxes
for four hours a day for six weeks.
Accused by many of being exploitative,
the performance nevertheless drew
attention to the fact that the
participants were unable to work
legally in Germany.

[4] AI WEIWEI – <u>Remembering</u>, 2009.
8,738 backpacks on metal structure,
9.2 x 106 m (30¼ x 347⅞ ft)

<u>Remembering</u> pays tribute to the thousands of young
students from Sichuan province in China who lost
their lives when an earthquake struck in May 2008.
When visiting the site of the disaster, Ai Weiwei was
struck by the number of colourful rucksacks lying
around, many of them representing lives lost.

be expanded and its values rethought. In the wake of the major earthquake in the province of Sichuan in China in 2008, the Chinese artist Ai Weiwei decided to visit the country to see the devastation for himself. Following repeated attempts to obtain an official list of casualties, however, he was beaten with a truncheon and taken to hospital, where he received emergency surgery to relieve a cerebral haemorrhage. This did not prevent the artist from publishing on his website a year after the earthquake the names of 5,385 people who had died in the disaster. Nor did it stop him, in *Remembering* (2009) [4], from using 8,738 children's backpacks to spell out, in Chinese characters, the sentence 'She lived happily for seven years in this world', a quote from the mother of one of the earthquake's victims.[5] Here, again, art as a practice opens up a space in which to imagine and give form to that which politics deems unimaginable or beyond the bounds of public discussion and debate.

In the majority of the works examined in *Art and Politics Now*, the artist's chosen media and formal method of production are rarely presented as either definitive or closed to scrutiny. Instead, form and media are often positioned as propositional and contingent. For *Episode I* (2000–3) [6], Dutch artist Renzo Martens travelled to the city of Grozny to film the aftermath of the Second Chechen War (1999–2000), a bloody conflict that had left thousands dead and many more displaced and traumatized. In the film, Martens complicates any notion of objectively reporting or documenting what he sees in Grozny by placing himself at the forefront of the investigation, often drawing direct attention to the fact of his presence and pointedly asking people what they think of him being there amid such devastation. Martens's film, in its quasi-journalistic technique and conscious foregrounding of the artist throughout, makes two important points about conflict and its representation: that there is no such thing as a decontextualized or depoliticized viewing experience, and that artists, institutions and the viewer are inevitably involved in the production of meaning, political or otherwise. It is in the moment of exposing this fact that Martens, together with other artists featured in this book, tactically engage audiences in the politics of cultural production. These issues are explored in more detail from the fifth chapter, 'Conflict', onwards.

To the extent that the subject of Martens's work was a regional conflict, the Cuban-American artist Coco Fusco has chosen to confront the legislation and interrogation procedures being deployed in the worldwide 'war on terror', a subject that is addressed in the sixth chapter of the book, 'Terror'. For *Operation Atropos* (2006) [7], a 59-minute video, Fusco and six other women enrolled in an interrogation-training workshop run by Team Delta, a cohort of retired US military interrogators. We watch as Fusco and her companions are ambushed and bound, have their heads covered, and are thereafter subjected to ex-military personnel performing, with brutal verisimilitude, the role of guards and interrogators in a makeshift camp. Dressed in an orange jumpsuit, a reference to the clothing worn by inmates of Guantánamo Bay, Fusco forces the viewer to confront the hidden realities of the war on terror, and, in so doing, holds up a mirror to an era that has become largely defined by global forms

[5] MICHAEL RAKOWITZ – Enemy Kitchen, 2006–. Performance. Installation view at Smart Museum of Art, University of Chicago

Collaborating with his Iraqi-Jewish mother, and drawing on the cultural memories associated with certain foods from Iraq, Michael Rakowitz uses the act of cooking to explore the complexity of responses to the Iraq war and its legacy. The work often involves schoolchildren, who are encouraged to share their thoughts and opinions on the war.

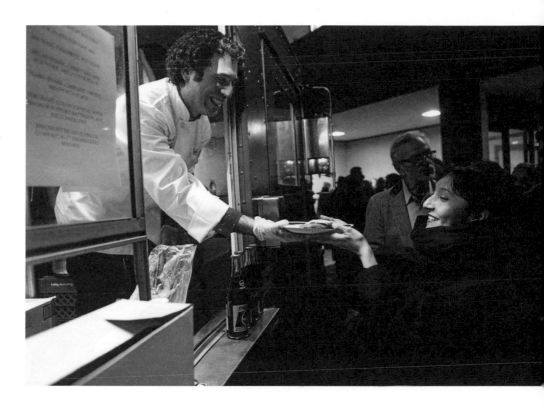

[6] RENZO MARTENS – Episode I, 2000–3. Video, colour, sound, 45 min.

[7] COCO FUSCO – Operation Atropos, 2006. Video, colour, sound, 59 min.

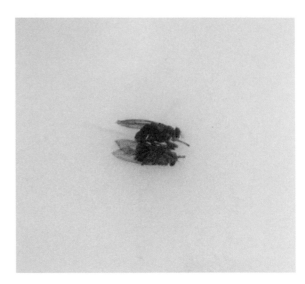

[8] PRATCHAYA PHINTHONG – Sleeping Sickness, 2012. Installation, tsetse flies presented on a marble block under glass, on a plinth, 170 x 50 x 50 cm (67 x 19¾ x 19¾ in.)

[9] RABIH MROUÉ – The Fall of a Hair, Part 1: The Pixelated Revolution, 2012. Video projection with countdown screen, colour, sound, 21 min. 58 sec.

of clandestine warfare and 'enhanced interrogation techniques' – or, to put it bluntly, torture.

One of the key proposals explored in 'Terror', and elsewhere in the book, is the suggestion that the apparent threat of terrorism has come to define contemporary politics and law-making. In recent years we have seen the emergence of a lexicon that includes such terms as 'bioterrorism', 'racial profiling' and 'biopolitical surveillance'. This has been accompanied by, among other things, the legitimization of torture, the criminalization of organized protest and, significantly, artistic practices that engage with these issues. In 2004 one of the members of Critical Art Ensemble (CAE), a group of five practitioners who specialize in film/video, photography, text art, book art, web design and performance, was arrested on suspicion of bioterrorism. On the morning of 11 May 2004, Steve Kurtz woke to find that his wife, Hope, had died in her sleep. Following a call to the police, Kurtz was subjected to questioning by the Federal Bureau of Investigation (FBI) over a biology lab the police had found in his house. Detained for 24 hours, and then freed, Kurtz was nonetheless ordered to appear before a grand jury to answer 'bioterrorism' charges. Despite the fact that he was cleared of all suspicion in July 2004, the FBI continued to press charges against him until 2008. Art, as we shall see, can sometimes come into vertiginous proximity with anti-terrorism legislation.

Central to the heightened awareness of global turmoil has been the rise of information technology and social media, as well as the increased demands of international news corporations – all of which, as we shall see in the seventh chapter, 'History', has come to define how we understand and perceive historical events. Art has always been at the forefront of interpreting, if not defining, how history is represented, and this fact remains critical to any consideration of art's contemporary relationship to the politics of history and conflict. In Rabih Mroué's *The Fall of a Hair, Part 1: The Pixelated Revolution* (2012) [9], the artist conducts a forensic examination of the way in which information has been presented during the ongoing civil war in Syria. For Mroué, who focuses on images that have been recorded by Syrian protesters and uploaded to the Internet, the mediation of information is of immediate interest, alongside the question of how images are produced by a global media for general consumption. Speaking about the project, Mroué has observed that *The Pixelated Revolution* is not an act of activism on his behalf; rather, it is 'about how images are being produced and used in the Syrian revolution'.[6] Mroué's reluctance to see his work in terms of political activism mirrors the misgivings of many of the artists featured in this book, who see the label as yet another way of limiting the potential of their practice to offer different ways of engaging with and re-imagining the boundaries of the political sphere.

At the beginning of 2014, the United Nations High Commissioner for Refugees estimated that the civil war in Syria had so far led to 2.4 million people seeking respite in the various refugee camps that have been set up in Turkey, Iraq, Iraqi Kurdistan, Lebanon and Jordan (the last of these being home to the Zaatari refugee camp, the largest in the Middle East). For some commentators, globalization, regional conflicts

and mass migration have effectively dictated the redistribution of populations on both a micro- and a macro-level. This has resulted in the camp – usually seen as a borderline, peripheral, if not historical phenomenon – being regarded as a typical space of modern geopolitics, rather than an exception.[7] Indeed, the artist and film-maker Ursula Biemann has referred to the refugee camp as a 'capsule' and an embodiment of the intricate political demands of the present.[8]

The ubiquity of the camp in the context of global politics is explored in the eighth chapter of the book, 'Camps', together with the many different ways in which artists have chosen to examine the emergence of the camp as an unavoidable feature of globalization and modernity. Although 'Camps' focuses primarily on refugee camps, it is worth noting how often other types of camp emerge in the work of the artists featured in the book, including detention camps (Coco Fusco, Ashley Hunt, Christoph Büchel and Gianni Motti); concentration camps (Harun Farocki, Artur Zmijewski, Omer Fast and Santiago Sierra); internment camps (Reza Aramesh, Nada Prlja, Ayreen Anastas and Rene Gabri); labour camps (Steve McQueen); protest camps (Mark Wallinger); and transit camps (Ursula Biemann and Yto Barrada). To this already extensive list we could add another form of camp, one that has appeared over the modern political horizon only recently: the climate refugee camp.

In the moment in which artists offer practical, or indeed impractical, solutions to climate change or environmental issues, we witness a deliberate blurring of any distinction between eco-activism and art practice.

Stemming from extensive research carried out in Ethiopia, Tanzania and Zambia, Pratchaya Phinthong's *Sleeping Sickness* (2012) [8], first shown as part of Documenta 13 in Kassel, Germany, is deceptively slight, consisting as it does of two tsetse flies inside a large vitrine. The flies were a fertile female and a sterile male. The sterilization of male tsetse flies is a common approach to controlling the spread of 'sleeping sickness', a tropical disease that kills thousands of people across Africa every year. Phinthong's research, which was conducted with the help of local communities, culminated in the promotion of an ecological flytrap. Developed by a company in Thailand, the flytrap was used by local people to combat sleeping sickness and thus pre-empt the use of harmful chemicals to sterilize male tsetse flies in the region. While Phinthong's practice offers a practical solution to an immediate environmental issue, other artists explored in the ninth chapter of the book, 'Environments', provide less convincing remedies. They do, however, use their art to raise awareness of environmental issues and the politics of climate change.

As we shall see in 'Economies', the tenth chapter, the work of those artists who have chosen to address the current economic climate and the impact of an enduring financial crisis is often concerned with finding narratives that capture the frequently confusing realities of economic systems. Hito Steyerl's *In Free Fall* (2010) [10] consists of three short films – *Before the Crash*, *After the Crash* and *Crash* – inspired by a photograph of an aeroplane 'graveyard' in the Californian desert. During periods of recession, there is an increase in the number of aeroplanes that are grounded

and subsequently fall into disrepair. Steyerl confirms this phenomenon with the owner of the graveyard in California, but also imaginatively traces the story of a Boeing 707 from commercial and military service to scrapheap, where it is finally blown up for the 1994 action movie *Speed* and thereafter recycled as a component of the pirated DVDs on to which the film is copied. One economy of value is here subverted by another: the so-called black market, a system of economic exchange that exists outside the official system, as defined by law and copyright regulations.

The subject of knowledge, be it financial or otherwise, has become central to contemporary art's interest in communications systems and the production of images and information, as we shall see in the final chapter of the book, 'Knowledge'. As the starting point for his installation *May 1st, 2011* (2011) [11], Alfredo Jaar selected an iconic image from our recent past: an official photograph of President Barack Obama and his advisers sitting in the White House as they watch – on a screen that is out of our view – the Navy Seal attack that resulted in the death of Osama bin Laden. To the left of this photograph is a blank screen, which acts as a substitute for the one being watched by the president and his advisers. The original photograph had been retouched to avoid exposing sensitive information, and images of the death of Bin Laden were not released. Thus, at the heart of one of the most significant events of recent years, there remains an informational lacuna. In Jaar's work this gap is represented by the blank screen, a stand-in for an act of violence that we are told has happened but of which we have no proof, other than a fundamentally

politicized photograph. Knowledge, in its formal production and global dissemination, has become not only politicized but also subject to a network of political decisions that prescribe what we can and, crucially, cannot see.

In an age of neo-liberal-inspired forms of free trade and outsourcing, the accumulation of capital within the art world itself has also come under increasing scrutiny – a point to which we shall return throughout the book. We could observe here, in passing, not only how artists represent one of the vanguards of globalization – their fluid, nomadic international travel being indicative of the apparently smooth flow of capital within the art world – but also how they embody and negotiate global working practices. In addition, it is necessary to observe that neo-liberal economies are well practised in absorbing criticism into the fabric of their operations: artworks that criticize the market, for example, are frequently co-opted by the market. However, this should not be seen as a barrier to engagement: the existence of artists within economic systems means they can often be more effective in drawing attention to the broader demands involved in producing art in a globalized cultural and economic environment.

Although this book has been organized into discrete chapters, there are inevitable crossovers between the subjects outlined above; similarly, a number of the featured artists are discussed in more than one chapter. There are also a number of key terms – 'migration', 'surveillance' and 'biopolitics', for example – that could have formed chapters in their own right, but which frequently recur across the entire book in different contexts. This overlap gives

a further sense of the breadth and focus of contemporary art practices. Of the works examined, the majority have been produced since 2000, and represent an international take on contemporary art. The ambition here is to provide an overview of the changing relationship between art and politics, and, in so doing, clarify what is at stake in the debates discussed. It is also to provide the reader with an accessible frame of reference for both understanding and exploring these issues further.

Rather than examining politics as a government-led system of administration, or as a series of policies that advocate specific views on certain issues, this book looks towards an expanded notion of the political. Politics is understood, in this context, as the construction of a shared realm of experience and perception that includes the majority but excludes others. Furthermore, in viewing politics as a distribution of certain roles to members of a community, including the power to determine what voices can be heard within that community, we can develop an understanding of art as a social practice that challenges and negotiates the allocation and distribution of those roles, as well as the rationale behind the exclusion of individuals and communities across the globe.[9] If politics is about determining who has the right to speak, be heard or be seen, then contemporary art of a political nature needs to be understood in the context of how, through various tactics and strategies, it disturbs, disrupts, re-imagines and expands engagement with the political.[10] This book, finally, is about the critical activities of culture and its institutions in the early part of the twenty-first century, and, in particular, the ongoing role of creative practices in producing potential forms of engagement with the social and political realms. It is when these realms are challenged, when an agreed sphere of shared experience and understanding comes under scrutiny, that politics proper begins.

This plane took part in the famous rescue operation
at Entebbe airport in 1976.

[10] HITO STEYERL – In Free Fall (Before the Crash,
After the Crash, Crash), 2010. Single-screen video
projection, colour, sound, 33 min. 42 sec.

[11] ALFREDO JAAR – May 1st, 2011, 2011. 2 LCD monitors and 2 C-prints,
74.2 x 497.8 cm (29¼ x 196 in.)

GLOBALIZATION

Worldwide Trade and Uneven Development

THE ~~TRANSFORMATION~~ OF THE MODERN ~~IMPERIALIST~~ ~~GEOGRAPHY~~ OF THE GLOBE AND THE REALIZATION OF THE ~~WORLD~~ MARKET SIGNAL A PASSAGE WITHIN THE <u>CAPITALIST</u> MODE OF ~~PRODUCTION~~. MOST SIGNIFICANT, THE ~~SPATIAL~~ <u>DIVISIONS</u> OF THE THREE WORLDS (FIRST, SECOND, AND THIRD) HAVE BEEN ~~SCRAMBLED~~ SO WE CONTINUALLY FIND THE FIRST WORLD IN THE THIRD, THE THIRD IN THE FIRST, AND THE SECOND ALMOST ~~NOWHERE~~ AT ALL.

—

MICHAEL HARDT AND ANTONIO NEGRI

THE IMPACT OF GLOBALIZATION ON COMMUNITIES AND INDIVIDUALS CONTINUES TO BE ONE OF THE MOST SIGNIFICANT FACTORS IN THE RESTRUCTURING OF SOCIAL AND POLITICAL RELATIONS WORLDWIDE.

The tensions produced by globalization are manifold and resist cursory analysis, but they can be readily identified in the unequal distribution of wealth and risk; the deregulation of labour laws intended to protect workers; the impact of so-called free-market ideology on local communities; the presence of a globalized underclass of migrant labourers; and the increasingly visible fact of economic and political refugees. The causes of such tensions are of course varied, but the fact remains: globalization has produced political unrest and social upheaval, if not outright conflict, across the globe.[1] And key to this is the role of trade and its dramatic effect on working conditions.

The sinuous channels of globalization form the basis of *The Forgotten Space* (2010) [12], a film by Allan Sekula and Noël Burch that explores maritime trade and the physical space of the oceans and seas that support it. An open and yet highly regulated space, the sea is referred to by the film's directors as the 'forgotten space' of modernity, and in the film we witness its apparently indeterminate but nonetheless crucial role in the processes of globalization. Employing a range of narrative devices, including voiceovers, interviews, archive stills and documentary footage, as well as excerpts from classic films, *The Forgotten Space* exposes the harsh conditions endured by workers, the inhuman scale of sea trade and the day-to-day reality of life in a port city.

In tracing the journey of container cargo aboard ships, barges, trains and lorries, *The Forgotten Space* sheds light on the global maritime economy on which so many of us depend and the politics of global trade. We hear the stories of displaced farmers and villagers in the Netherlands and Belgium, listen to underpaid truck drivers in Los Angeles, observe seafarers aboard mega-ships shuttling between Asia and Europe, and watch as factory employees in China go about their work. This is the experience of globalization for many across the world: displacement, migration, alienation, casual labour, impoverishment, exploitation and uneven forms of socioeconomic development. This unevenness of development is, perhaps inevitably, an integral feature of globalization, so much so that it is largely seen not as 'a single process, but a set of processes that operate simultaneously and unevenly on several levels and in various dimensions'.[2]

The Forgotten Space had a precursor in an earlier work by Sekula, *Fish Story* (1995) [14], in which we see footage of, among other things, the prow of a ship heading into what appear to be uncharted waters. In both works, the container ship takes on an allegorical quality and becomes symbolic of how capital entrenches itself within the political networks of global trade. The fact that these two works were created in roughly the same period of recent history gives an indication of how

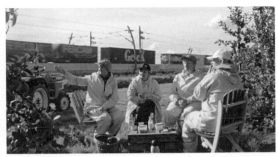

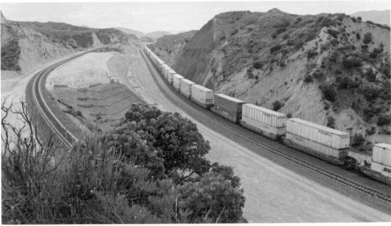

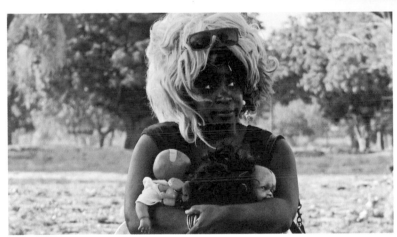

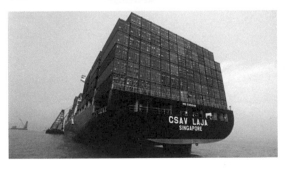

[12] ALLAN SEKULA AND NOËL BURCH – The Forgotten Space, 2010.
Film essay/feature documentary, DCP, DigiBeta, DV CAM,
colour/black and white, sound, 112 min.

The Forgotten Space is concerned with the role of the sea in
globalization and the latter's uneven spread. In tracing the
journey of container cargo aboard ships, barges, trains and
lorries, the work sheds light on the global maritime economy
on which so many of us depend.

globalization – which, as a political force, has arguably been around since the late nineteenth century – has speeded up in the last few decades as a result of significant advances in technology.

The politics of production, distribution and consumption, of both goods and services, are central to understanding globalization. In Adrian Paci's *The Column* (2013) [13], we see another container ship traversing the oceans of the world, this time between China and France. We begin in the brilliant white of a quarry in China, where a block of pristine marble is hewn from the ground. Its journey continues as we see it loaded on to an empty container ship. There – waiting in the hull, and in lieu of actual containers – Chinese stonecutters begin to fashion the marble into a classical column topped by a Corinthian capital. The mechanisms by which labour produces value, within the context of maritime trade, are condensed here into a parable of production and delivery, which, in a globalized world, needs to be as refined and as closely monitored as the carving of a classical column. Rather than merely observe this process, Paci has inserted his own practice into the channels of global labour, resulting in a work that is both a comment on and part of a broader political economy of trade and exchange.

Somewhat paradoxically, the standardizing aspect of globalization has the effect of redistributing spaces, places and people in different ways, at different times and to different degrees. In one instance of this process, stevedores, longshoremen and dockers worldwide found themselves surplus to the needs of international trade with the advent of the container. At the same time, labour laws were deregulated to ensure a more flexible and 'cost efficient' labour force. In Chen Chieh-jen's *The Route* (2006) [15], the politics of global labour conditions, specifically the casualization of jobs as a result of the use of containers, are explored through an archive film of a dockworker's strike in Liverpool in the 1990s, and more recent footage of a picket line staged by dockworkers in the Port of Kaohsiung, the largest harbour in Taiwan. The events in Liverpool in 1995 saw the summary sacking of 500 dockworkers, all of whom were dismissed because they refused to cross a picket line. The dockers were protesting at the conditions of employment being introduced by the Mersey Docks and Harbour Company, which was seeking to impose a casual form of labour. Under these deregulated, less secure conditions, dockworkers were expected to become more and more responsive to the needs of their employers, regardless of their own requirements as workers attempting to make a living wage. The security of profit, in short, is based on the insecurity of others.

An apparent disregard for the well-being of those who participate in global trade, but who ultimately have little worth in it, is a consistent feature of globalization. In *Solid Sea 01: The Ghost Ship* (2002) [16], a multimedia project by the collective Multiplicity, the details of a maritime tragedy are examined. On 26 December 1996 a fishing boat sailing under a Maltese flag was rammed by its Lebanese mother ship during trans-shipping in the Mediterranean Sea. This resulted in the death of all but a handful of the 300 Sinhalese, Pakistani and Indian refugees who were on board at the time. The details surrounding this

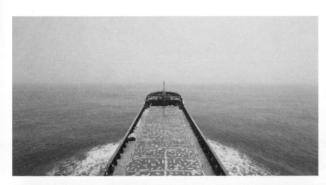

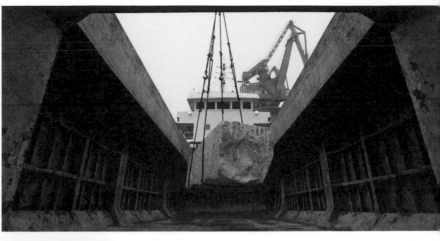

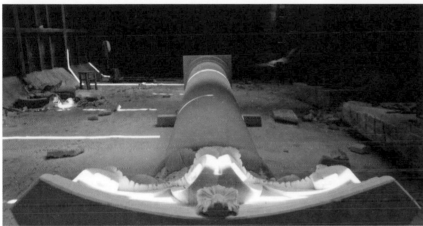

[13] ADRIAN PACI – The Column, 2013.
HD video projection (Blu-ray), colour,
sound, 25 min. 40 sec. Edition of 6 (+ 3 AP)

In Adrian Paci's film, labour, exchange,
economics and production – all enacted
under the rubric of globalization –
coalesce into a parable of modern-day
trade and the often arduous demands
placed on workers in a global economy.

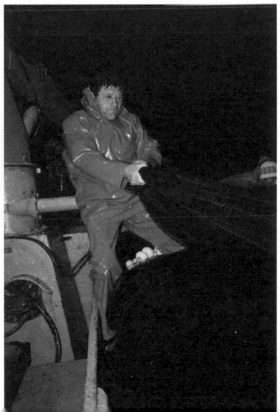

[14] ALLAN SEKULA – Fish Story, 1995.
Above: Testing robot-truck designed to move
containers within automated ECT/Sea-Land cargo
terminal. Maasvlakte, Port of Rotterdam, The
Netherlands. September 1992. Right: Unsuccessful
fishing for sardines off the Portuguese coast

[15] CHEN CHIEH-JEN – <u>The Route</u>, 2006.
35mm film transferred to DVD,
colour/black and white, silent,
single channel, 16 min. 45 sec.,
continuous loop

Incorporating footage of a staged
picket line, this short film explores
the politics of labour conditions and
a dockworker's strike in Liverpool.
It also presents more recent footage
of dockworkers in Kaohsiung port,
the largest harbour in Taiwan.

[16] MULTIPLICITY – <u>Solid Sea 01: The
Ghost Ship</u>, 2002. Images produced by
<u>La Repubblica</u> for its report 'Naufragio
nave fantasma 1996', 2001, edited by
Giovanni Maria Bellu

One of four case studies that together
constitute a larger, multidisciplinary
research project, <u>Solid Sea 01: The
Ghost Ship</u> explores migratory patterns
in the Mediterranean and the largely
ignored deaths of 283 Sinhalese,
Pakistani and Indian refugees in 1996.

tragedy have been consistently obfuscated and challenged by the local authorities, and, to date, no one has been held to account over the loss of life.

In Yto Barrada's *Container 1. Plafond rouillé d'un container de marchandises, Tanger* (Container 1. Rust holes in the top of a shipping container, Tangier) (2003) [18], we are faced with a more allusive reference to death in the Mediterranean Sea. Drawing on her experiences in the port city of Tangier, Barrada's photograph – part of a wider series titled *The Strait Project: A Life Full of Holes* (1998–2004) – concerns the plight of the so-called burnt ones: migrants who burn their passports before embarking on a perilous journey across the Strait of Gibraltar in search of work in Spain and Europe. Before 1991, any Moroccan wishing to travel to Europe could do so with a valid passport; however, since the full implementation of the European Union's Schengen Agreement, such travel has been subject to severe restrictions. At first glance this photograph appears to be an image of an archipelago or a map of some sort, but it soon resolves itself into the rusted interior of a container, an extremely risky form of transport for those migrants trying to make it from Africa to the southern ports of Spain and France – including the thousands who drown each year in the process.[3]

Although globalization advocates a borderless world for the ease of capital transactions and transnational communications, it can be selective, and is often determined by technological know-how and access to such technology. These issues are at the heart of Ursula Biemann's *Sahara Chronicle* (2006–9) [17], a collection of short videos that look at sub-Saharan migration to North Africa and the determination of migrants to reach Europe. Tracing the displacement and movement of peoples across an entire region, Biemann's videos engage the viewer in a series of investigations into the geopolitics of conflict and modern migration, the human costs of globalization, and the often deadly legacy of arbitrary colonial boundaries. The videos include a number of interviews with Tuareg border guides in the Libyan desert and, in a clear reference to the repercussions awaiting those who attempt these often fraught journeys, a close-up of the deportation prison in Laayoune, Western Sahara. Closely related to this theme of capture are the symbols of surveillance technology that Biemann uses to punctuate her images, which, in turn, depict a multifaceted network of migration that stretches across Morocco, Niger, Mauritania and sub-Saharan Africa. Surveillance, a key element in population control, is here presented as an unavoidable part of the lives of migrants and their stories of flight and incarceration.

The relationship between trade and conflict can be seen in CAMP's *Wharfage and Radio Meena (Sharjah Biennial 2009)* (2009) [20]. Produced in the ports of Sharjah in the United Arab Emirates, this documentary-based work details how the old routes of pre-modernity and the newer, more globalized ones often come into direct contact. CAMP's records of trade in the ports of Sharjah note that a large number of dhows leave for Somalia, which – as a collection of semi-state entities (or, indeed, an example of a de facto 'failed' state) – is an interesting example of a free trade zone, where tariffs do not apply and the rule of law is

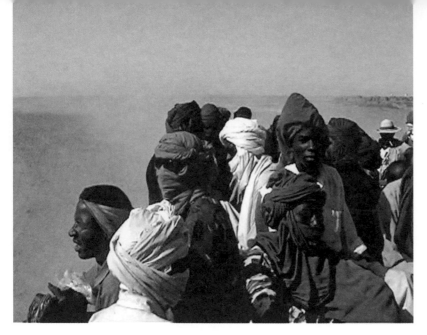

[17] URSULA BIEMANN – Sahara Chronicle, 2006–9.
12 videos, colour, sound, 78 min. in total

This exploration of the social practices involved in migration from sub-Saharan Africa to Europe features excerpts from surveillance footage. Although the overall project covers a vast geopolitical area, each of the twelve videos in this work specifically reflects on the migratory networks of Morocco, Niger and Mauritania.

[18] YTO BARRADA – Container 1. Plafond rouillé d'un container de marchandises, Tanger (Container 1. Rust holes in the top of a shipping container, Tangier), 2003. C-print, 60 x 60 cm (23½ x 23½ in.)

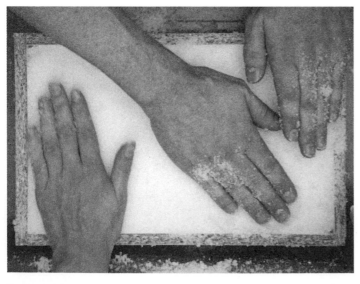

[19] LONNIE VAN BRUMMELEN AND SIEBREN DE HAAN – Monument of Sugar: How to Use Artistic Means to Elude Trade Barriers, 2007. 16mm film, colour, silent, 67 min.

[20] CAMP – Wharfage and Radio Meena (Sharjah Biennial 2009), 2009.
Book publication and FM broadcast

Conceived for the 9th Sharjah Biennial, Wharfage and Radio Meena
(Sharjah Biennial 2009) was a two-year, multifaceted project that
mapped the contemporary landscape of the old trade routes between
Somalia and the ports of Sharjah in the United Arab Emirates.

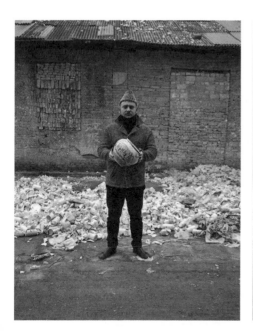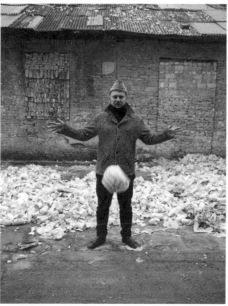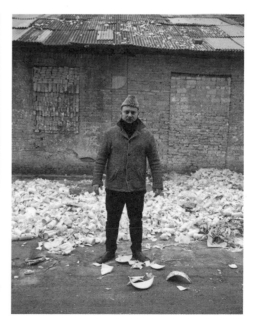

[21] RAED YASSIN – Dropping a Yassin Dynasty Vase (after Ai Weiwei), 2012.
Triptych, archival inkjet prints, each 120 × 90 cm (47¼ x 35½ in.)

effectively suspended. Referring to the ports of Sharjah, CAMP explore how the 'arrow of trade ... is not an escape from but an entry into the space of conflict'.[4] Again, the forces of globalization seem content to produce deregulated zones of conflict while simultaneously capitalizing on them.

In *Monument of Sugar: How to Use Artistic Means to Elude Trade Barriers* (2007) [19], Lonnie van Brummelen and Siebren de Haan produced a silent film and a sculpture made of sugar, the latter being the 'monument' of the title. In the course of their research into trade barriers and the global movement of goods, they discovered that a significant amount of European sugar is exported. Deciding to follow the subsidized sugar trade, the artists found themselves travelling from the Netherlands to Poland and on to Nigeria, where they bought cheap sugar in Lagos and exported it back to Europe. In an effort to avoid trade tariffs, they exported it as a 'monument', rather than a commodity. As a portrait of global trade, *Monument of Sugar* utilizes the processes of globalization while actively subverting them.

The circulation of people in the context of globalization can often reduce individuals to mere commodities or, indeed, collateral. In Ni Haifeng's photographic series *Self-Portrait as Part of the Porcelain Export History* (1999–2001) [22], we see images of the artist as product, his body covered with decorative patterns from seventeenth- and eighteenth-century Dutch-Chinese porcelain, as well as extracts from scientific studies and examples of labels used to identify Chinese objects sold at auction or held in European collections. In their examination of the politics of

globalization and cultural exchange, Ni's images explore not only the fact that international trade and global commerce are nothing new (Chinese porcelain has had markets throughout Europe since at least the seventeenth century), but also the fact that artworks have always had an international commodity value within this system.

In its forms of trade and capital accumulation, the art world itself both benefits from globalization and is an integral part of its processes. In Raed Yassin's *Dropping a Yassin Dynasty Vase (after Ai Weiwei)* (2012) [21], a homage to Ai Weiwei's controversial work *Dropping a Han Dynasty Urn* (1995), in which the artist destroyed an ancient ceramic vase, we see how appropriation and circulation – two features of globalization – can also be employed by artists. In 2011 Yassin travelled to Jingdezhen, one of the porcelain capitals of China, to fabricate seven porcelain vases depicting key battles of the Lebanese Civil War (1975–90). The work, which seeks to combine the ancient Chinese tradition of narrating epic battles and mythologies with the oral and written histories of the war in Lebanon, also demonstrates how the 'global' artwork utilizes and, indeed, exploits the channels of globalized trade.[5]

The politics of trade and the tenacious links between foreign-aid policies and free trade agreements are explored in Anawana Haloba's *The Greater G8 Advertising Market Stand* (2010–11) [23]. Haloba's installation, resembling a street kiosk and featuring goods from what the United Nations refers to as 'least developed countries' (LDCs), including Iraq, Sudan, Colombia, Bolivia, Malawi and Somalia, appears to be offering for sale such directly

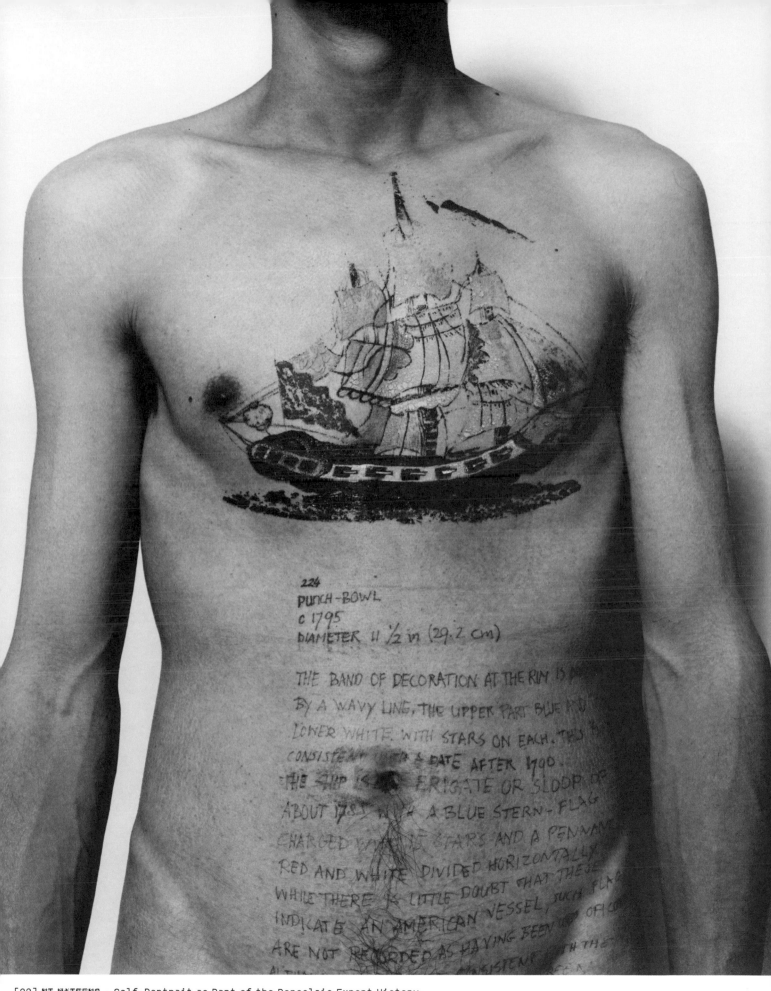

[22] NI HAIFENG – Self-Portrait as Part of the Porcelain Export History,
1999–2001. C-print, 165 x 127 cm (65 x 50 in.)

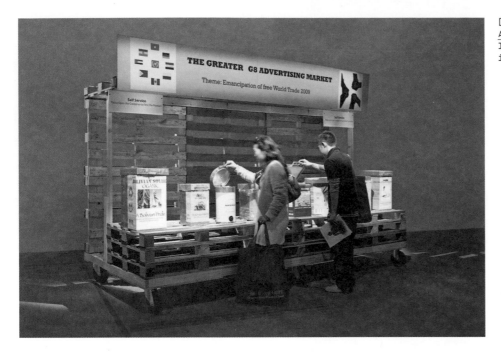

[23] ANAWANA HALOBA – The Greater G8 Advertising Market Stand, 2010-11. Interactive sculptural and sound installation

[24] ANNA BOGHIGUIAN – Untitled, 2010-11. From the installation The Simple Affair that Moved the World, 2010-11. Gouache and pencil on paper, 30 x 40 cm (11¾ x 15¾ in.)

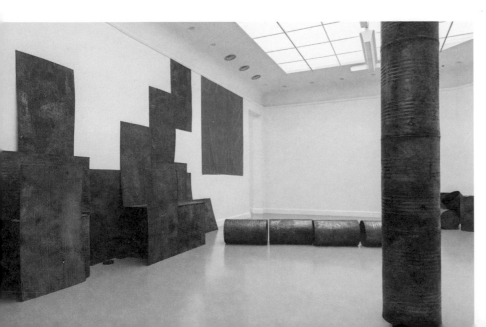

[25] SHEELA GOWDA – Kagebangara, 2008. Flattened tar-drum sheets, tar drums, mica tar sheet, mica, tarpaulin, dimensions variable

GLOBALIZATION

sourced and eco-friendly products as 'Bolivian Organic Soybeans' and 'Vigobe Corn Flakes: A Malawian Product Not Genetically Modified'. Foreign-aid policies are often a means of imposing on certain countries a form of 'free trade' that ensures that they buy expensive produce from the West while exporting inexpensive produce back to it. Such policies are at best an inequitable form of exchange that reflects colonial patterns of trade. In an attempt to highlight the viewer's complicity in this system and its one-sidedness, Haloba encourages us to take some of the products from the kiosk. However, on closer inspection we realize that these products are commercially produced goods from the West, thereby undermining any claim to the ideals of so-called free trade espoused by both the International Monetary Fund (IMF) and the World Bank.[6]

In Anna Boghiguian's project *The Simple Affair that Moved the World* (2010–11) [24], the international links between Egypt, the United Arab Emirates, India and the United States are explored through the artist's apparently random and naive-looking renditions of geopolitical relations. Boghiguian's dense, haphazard drawings connect the elements that these places share – economically, politically and intellectually – as a result of trade, imperialism and globalization. These connections are also to be found in the appalling conditions endured by labourers, who, subjected to forms of displacement based on either economic need or political conflict, are the all-too-visible reminders of the inequities and hardships wrought on communities by globalization.

Beyond the borders of the city, be they real or imagined, the movement of

capital and the casualization of labour to suit the demands of the global market have produced entire communities populated by an underclass of the dispossessed. In a series of photographs taken between 1997 and 2000, Ravi Agarwal explored the plight of landless workers in South Gujarat in India. The region, which has seen the highest rates of population growth in the country since independence in 1947, has been under the supervision of the IMF and the World Bank for more than a decade. Agarwal's photographs, published together as *Down and Out: Labouring under Global Capitalism* (2000) [26], show the often abject conditions in which landless labourers live and how globalization segregates communities under the dogma of apparent development. Known locally as *kalu be*, the money used by these landless workers has no legal standing outside the communities in which it is used – a fitting metaphor, if one was needed, for the vicious circle of poverty that attends the day-to-day lives of those denied access to the goods and wealth generated by globalization.

In Sheela Gowda's installation *Kagebangara* (2008) [25], the constituent elements of the work are strategically positioned so as to refer to the use of certain materials across the Indian subcontinent. By featuring empty oil drums, which were once used for transporting and heating tar (a material central to both construction work and the development of transport links), *Kagebangara* not only suggests minimalist and post-minimalist art forms, but also refers to the modes of production and distribution that are imposed on India under the rubric of globalization. The language of abstraction is here used to

explore the socio- and geopolitical status of modern-day India, where millions toil to service both a building boom for the middle classes and the immense debt owed to such institutions as the IMF and the World Bank.

The ideals of globalization – specifically, that the integration of markets and telecommunications systems will bring about not only prosperity but also a reduction in intra- and inter-state violence – are often thwarted. In that moment of apparent integration, the neo-liberal mantra of free trade causes ethnic violence and instability.[7] When we look more closely at globalization and the political assumptions behind policies on free trade and labour, one thing in particular stands out: how patterns of outsourcing, of both production and people, can often reflect former colonial relations and the legacy of many decades of conflict and exploitation.[8] From the *maquiladoras* of northern Mexico (see page 49) to the sweatshops of Bangladesh, the diamond mines across Africa and the so-called free trade zones in Morocco, the process of globalization, a key feature of both modernity and late-modernity, is seen by many as merely reinforcing in a neocolonial setting the inequities and iniquities of colonization.[9]

In his short film *Gravesend* (2007) [27], Steve McQueen reveals how globalization produces misery for the many while yielding considerable profits for the few. Against the stark backdrop of colonization in the Democratic Republic of the Congo (DRC) and lax international treaties that allow for foreign support for civil war in the country, McQueen focuses on the mining of coltan (short for columbite-tantalite), a metallic mineral used by the world's largest computer and telecommunications corporations in the production of computers and mobile telephones. The mining of coltan has been subject to much criticism and enquiry, with its extraction and long-term legacy – in terms of conflict and environmental damage – being compared to the effects of unregulated hydraulic mining and the circulation of so-called blood diamonds.

In choosing to look at the mining of coltan, an activity in which men scuttle across the face of an open mine and literally scratch out a living, *Gravesend* is also concerned with its end uses. By means of a dual screen, we see the brutal, impoverished and anonymous conditions involved in the mineral's extraction juxtaposed with images of futuristic processing plants in England. It is in such plants that coltan is refined before its utilization in systems of global communication – the very same systems that are often denied to the people who produce the raw materials necessary for them to operate in the first place. In this context, where the resources of the DRC are extracted to effect the enrichment of others, it is all the more deplorable to note that the country, despite its immense natural wealth, shares the world's lowest Human Development Index (a composite quality-of-life statistic published by the United Nations) with Niger, another country whose resources are daily exploited for global benefit.

Throughout McQueen's film, issues of visibility and invisibility – of what we can and cannot see, literally and metaphorically – play a key role in the representation of individuals caught up in the pernicious web of globalization. In *Western Deep*, which was shown with *Caribs' Leap* (both 2002) [28], we

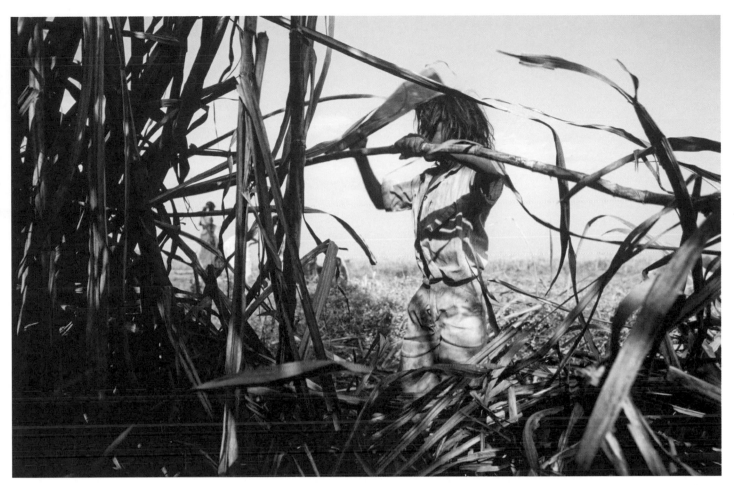

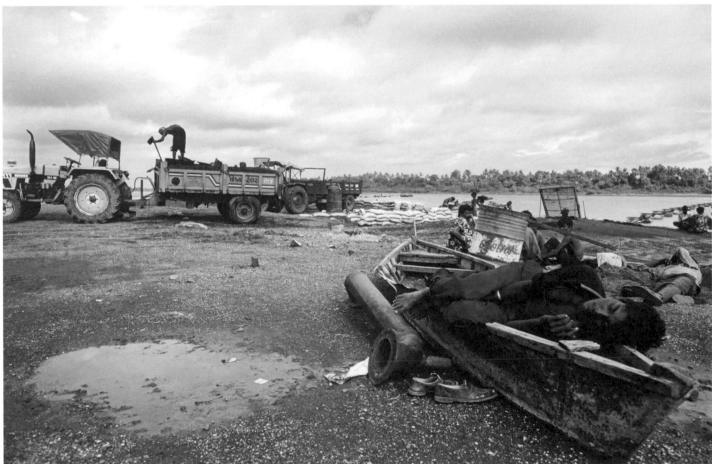

[28] RAVI AGARWAL – <u>Down and Out: Labouring under Global Capitalism</u>, 1997–2000.
Digital archival prints from transparencies, 50.8 x 76.2 cm (20 x 30 in.)

are given a taste of the tenebrous and abysmal world of the TauTona Mine in Johannesburg. The camera, and hence the viewer, follows the miners as they begin their descent into the darkness of the mine shaft, the only light being that of a miner's torch. This apparently fathomless journey ends when we find ourselves deep in the belly of the mine, where the miners must go about the formidable and squalid task of extricating gold from the mine's seams. Here, questions of visibility and ownership are given physical form by the miners, faceless workers who, a full 3 kilometres (2 miles) beneath the earth's surface, generate wealth not for themselves but for the shareholders of AngloGold Ltd (since renamed AngloGold Ashanti Ltd). What we see in McQueen's film is the legacy of colonization as it returns not only in forms of neocolonial exploitation but also in the name of globalization and 'progress' – a progress achieved through dehumanizing communities the world over and the degradation of the environments in which they live.

In 2009 Santiago Sierra initiated *NO, Global Tour* (2009–12) [29], an ambitious undertaking involving a monumental sculpture in the form of the word 'no'. Chosen for its ability to be universally understood, this denouncing of globalization started its journey on 18 July 2009 at the Napoleonic stables in Lucca, Italy. From there it travelled to Milan, Bernburg and numerous industrial areas before pausing at Art Forum Berlin, the now-defunct annual art fair; it then journeyed to Toronto, Detroit, Cleveland, Pittsburgh, Rotterdam, Maastricht, Brussels, London, New York and Miami. *NO, Global Tour* has since been turned into a film, providing a visual account

of what was essentially an epic road trip and an engagement with the politics of globalization and its adverse effects on communities and individuals.

In its rationalization and standardization, global trade has had a detrimental impact not only on the way in which millions of people work, but also on patterns of migration. Moreover, as we shall see in the next chapter, it has led to processes of outsourcing, downsizing and rationalization that both reinforce historical patterns of inequality and contribute to newer, more ascendant forms of impoverishment and what some refer to as the 'precarization' of labour.

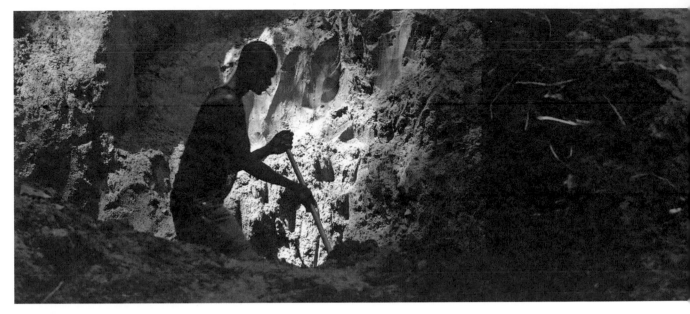

[27] STEVE MCQUEEN – Gravesend, 2007. 35mm colour film, transferred to HD digital format, sound, 17 min. 58 sec.

[28] STEVE MCQUEEN – Caribs' Leap/Western Deep, 2002. Video, three projections, colour, sound, 28 min. 53 sec., 24 min. 12 sec., 12 min. 6 sec.

[29] SANTIAGO SIERRA – NO, Global Tour, 2009-12. Still from film of tour

LABOUR

Human Capital and the Work of Art

WHILE TOO MUCH CAN BE
MADE OF THE ˙RACE TO
THE BOTTOM˙ TO FIND
THE ~~CHEAPEST~~ AND MOST
DOCILE LABOUR SUPPLIES,
THE GEOGRAPHICAL
MOBILITY OF ~~CAPITAL~~
PERMITS IT TO DOMINATE
A GLOBAL ~~LABOUR~~ FORCE
WHOSE OWN GEOGRAPHICAL
MOBILITY IS
CONSTRAINED. CAPTIVE
~~LABOUR~~ FORCES ABOUND
BECAUSE ~~IMMIGRATION~~
IS RESTRICTED.
-
DAVID HARVEY

IN 2007 THE COLOMBIAN ARTIST DORIS SALCEDO INTRODUCED A JAGGED CRACK INTO THE FLOOR OF TATE MODERN IN LONDON.

The crack ran the entire length of the gallery's Turbine Hall and effectively 'split' the foundations of the building. In *Shibboleth* [30], the title being an archaic term for a border, Salcedo addressed the politics of belonging, the legacy of colonization and the conditions of migrant labour under the impervious pressures of globalization. Referring to the work, the artist observed that it represented the negative space that illegal immigrants occupy in this new world order, a precarious space marked by dispossession and alienation.[1] Salcedo's intervention raises questions about immigration and the perilousness of lives lived on the edge of social, political and economic representation. However, a broader and perhaps more profound issue is how a transient underclass of migrant workers, exposed to lax labour laws, are not so much an unfortunate side-effect of globalization as a precondition of its existence. For global wealth and capital accumulation to continue unabated, there must exist a flexible, non-unionized and ultimately unassertive underclass to both maintain such accumulation and contribute to, but not necessarily benefit from, the increasingly concentrated nature of global wealth.

It is within the context of this apparent contradiction – that the continued production of global wealth is both structurally and endemically reliant on perpetuating impoverishment for many – that this chapter will examine how contemporary art engages not only with the politics of modern-day labour practices but also, crucially, with labour relations and the structures of global employment.

In 2001 Santiago Sierra paid twenty workers, mostly of Maghrebi and sub-Saharan origin, $20 each to sit for three hours in the hold of a cargo boat moored in Barcelona docks. Alluding to the usual method of arrival for displaced persons and immigrant workers, *20 Workers in a Ship's Hold* (2001) [31] was produced in collaboration with the local government and an immigrant aid association. This did not make the work any less controversial, however, and Sierra's actions attracted a significant amount of criticism from the local media. Although the work was eventually abandoned, for various reasons, its timely focus on the plight of a particular social order – specifically, transient immigrant workers in Barcelona – cast a none-too-flattering light on the conditions of labour for many migrants working in Spain and Europe.

The inequities of labour and capital distribution can affect whole communities and are a key factor in the geopolitics of migration. In Chantal Akerman's film *From the Other Side* (2002) [32], we witness the tensions that exist along the highly patrolled border that runs between Mexico and the United States. For this film, Akerman conducted lengthy interviews with the families of Mexicans who had risked their lives crossing the desert looking for work in the southern states of America. Juxtaposed with these tales are interviews with a number of Americans, who were asked to comment on the

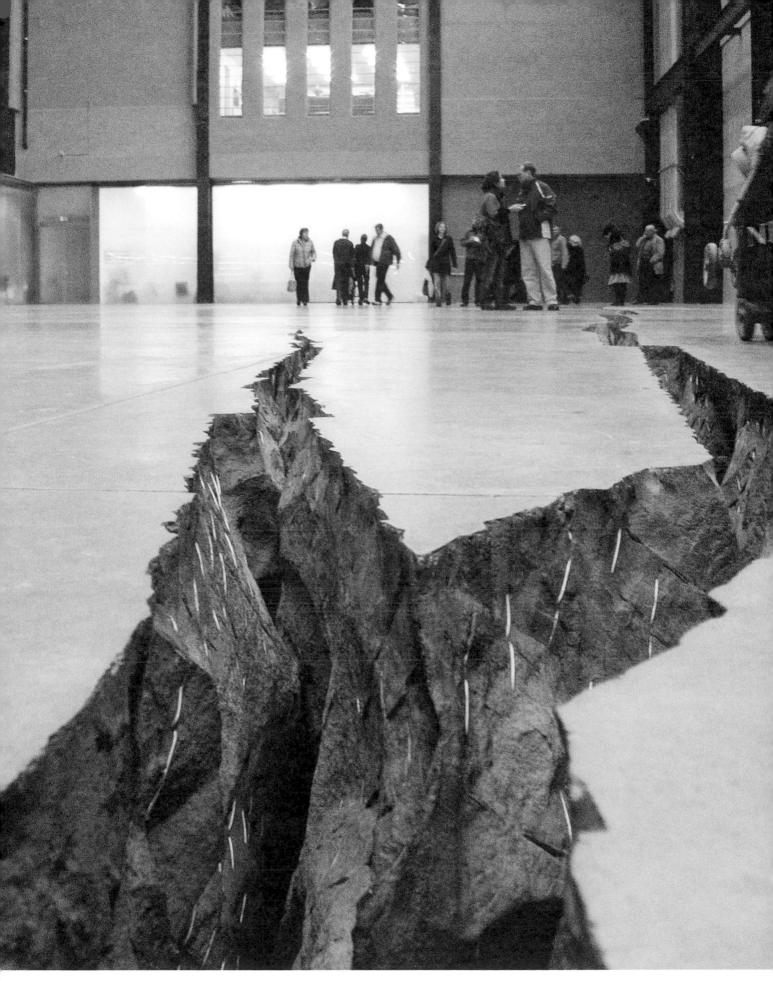

[30] DORIS SALCEDO — Shibboleth, 2007. Concrete, metal,
length 167 m (548 ft). Turbine Hall, Tate Modern, London,
9 October 2007 – 6 April 2008

[31] **SANTIAGO SIERRA** – <u>20 Workers in a Ship's Hold</u>, 2001. Performance

Realised in the port of Barcelona in July 2001, Sierra's project involved paying twenty immigrants to remain hidden for three hours a day in the hold of a 20-metre (65¾-ft) cargo boat. For one week, the boat would pick up twenty people (chosen by an immigrant aid association), head to another part of the port and then return to where it had started its journey – all of which would take three hours.

[32] **CHANTAL AKERMAN** – <u>From the Other Side</u>, 2002. Video installation, colour, sound, 102 min.

[33] **TERESA MARGOLLES** – <u>Lote Bravo, Lomas de Poleo, Anapra y Cerro del Cristo Negro</u>, 2005. Single-channel projection, video transferred to DVD, colour, silent, 42 min. 57 sec. Including 2 sound works, <u>Lote Bravo, Lomas de Poleo, Cerro de Cristo Negro</u>, 13 min., <u>Anapra</u>, 14 min. Edition of 4 (+ 1 AP + EP)

Margolles's work represents an investigation into the politics surrounding the large-scale factories along the US–Mexican border where many Mexicans find low-paid work. In particular, it traces the insidious connections between sub-standard conditions of labour and the deregulatory aspirations that underwrite free-trade capitalism.

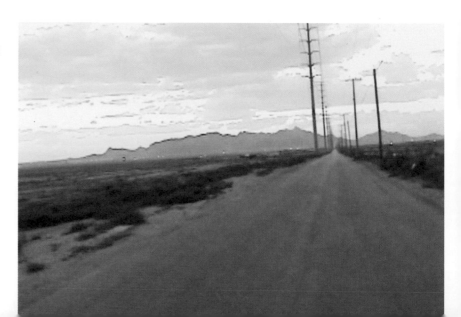

representation of these migrant workers. At certain points in the film, the camera lingers on its subject, as if to integrate itself into the daily round of thwarted expectations and the boredom of waiting. In so doing, it further implicates the viewer in the processes and politics of representing immigrants and the so-called marginalized.

For those reluctant to risk the journey across the Mexican border, there are always the free trade zones (FTZs) that dot the northern region of the country. The use of FTZs has given rise to more than 3,000 *maquiladoras*, sprawling manufacturing plants – the majority of which are run by US companies – where labour is cheap and regulation lenient so as to attract and retain overseas investment. It is estimated that Mexican workers in a *maquiladora*, in what are effectively the same jobs, work for on average one-sixth of what their counterparts work for in North America. The conditions of employment in these factories are often substandard, with little in the way of job security.

Described by one Mexican newspaper as the most violent place on earth outside declared war zones, Ciudad Juárez – a city with a concentration of more than 300 *maquiladoras* – has attained the dubious title of one of the world's most dangerous cities. In addition to being infamous for its rampant corruption and drug wars, the city is synonymous with the deaths of some 4,000 women between 1993 and 2003, many of whom were raped, tortured and brutally murdered before being discarded in ditches or fields. These deaths have never been fully explained, and may well never be. Nevertheless, for some commentators, they are directly related to the 'export-processing zone' that is Ciudad Juárez.[2]

In Teresa Margolles's *Lote Bravo, Lomas de Poleo, Anapra y Cerro del Cristo Negro* (2005) [33], the deaths of these women are commemorated in a video and a series of brick-like objects made from dirt collected at the sites where the victims' bodies were found. Margolles's work is a detailed exploration of the politics surrounding the *maquiladoras*, where a significant number of the murdered women had found much-needed employment, most of them migrating from other parts of Mexico to look for work. Apart from their youth and vulnerability, the women were linked by a common denominator that seems to have been decisive in their deaths: they were poor and, in the ruthless logic of economic viability, ultimately dispensable.[3] Under the conditions of globalization and neo-liberalization, as David Harvey has observed, 'the figure of the "disposable worker" emerges as prototypical on the world stage'.[4]

The practice of outsourcing work to FTZs in order to minimize costs, increase the competitiveness of goods and maximize the profits of multinational corporations finds an inverted counterpart in the migrant workers who are 'exported' to other countries to make a living. In *Rendezvous* (2009) [34], Nikolaj Bendix Skyum Larsen juxtaposes footage of migrant Indian workers in Dubai with film of the families they have left behind in their homeland of Kerala. Such expatriate labourers are generally excluded from the image of a prosperous society that is projected across the United Arab Emirates, but Larsen positions them in the foreground of his work, giving them not only a face but also a further context

that exposes both the conditions that brought them to Dubai in the first place and the system that often keeps them there indefinitely.

In May 2009 Human Rights Watch published a damning report on labour conditions in Abu Dhabi. The report contained evidence of the widespread abuse of migrant labourers, including forced labour, the confiscation of passports, the withholding of wages and working conditions deemed unfit, if not fatal. Shortly afterwards, in 2011, a coalition of international artists working under the name Gulf Labor was set up to ensure that the rights of migrant workers are protected during the construction and maintenance of museums in Abu Dhabi.[5] In March 2012, despite noting improvements since the beginning of their involvement, Gulf Labor observed continued failings across a number of areas in relation to the building of Saadiyat Island, the location of what will eventually be the world's biggest cultural district, featuring the largest Guggenheim museum to date, an outpost of the Louvre, a Zaha Hadid-designed arts centre and concert hall, and a New York University campus.

It would seem that while global labour relations are an important subject for contemporary artists, the art world as a business is happy to continue to exploit deregulated conditions of employment. The precarious nature of global labour is not only a situation to be investigated by artists but also, it appears, a structural necessity for the art world's ongoing development and expansion. These issues give rise to questions around the operation of the art world, specifically its reliance on short-term contracts, unpaid internships, flexible working

conditions and the insecurity of workers involved in the production of artworks and their circulation as objects of value. Contemporary art, as a system of value, has its own attendant institutions – from commercial galleries to museums and art fairs – that are closely linked to, if not supported by, neoliberal systems of capital accumulation.

Larsen's workers, like the countless millions living similar lives the world over, are the price of prosperity in a globalized world. They are, to use Guy Standing's term, indicative of the 'precariat', an emerging subclass whose members, through chronic and pervasive economic insecurity, are increasingly denied the sense of community and collective memory that would provide them with individual safety, long-term security and peace of mind.[6] The precariat are as likely to be found in the cities of developed countries – with their increased reliance on casual labour and so-called zero-hour contracts – as they are in under- or, indeed, non-developed countries. For every job that is outsourced from a developed country to a developing one, the effect on the local population is not only notable but also radical in its realignment of social and political relations.

In the summer of 2009, during a particularly fraught strike at the New Fabris factory in Châtellerault in the Poitou-Charentes region of France, Bruno Serralongue produced *New Fabris, Châtellerault* (2009) [36], a series of nine photographs depicting the more mundane aspects of what were serious clashes between management and the workers at the factory. These clashes drew a great deal of media attention, and even resulted in an alarming threat by the workers to blow up the factory if

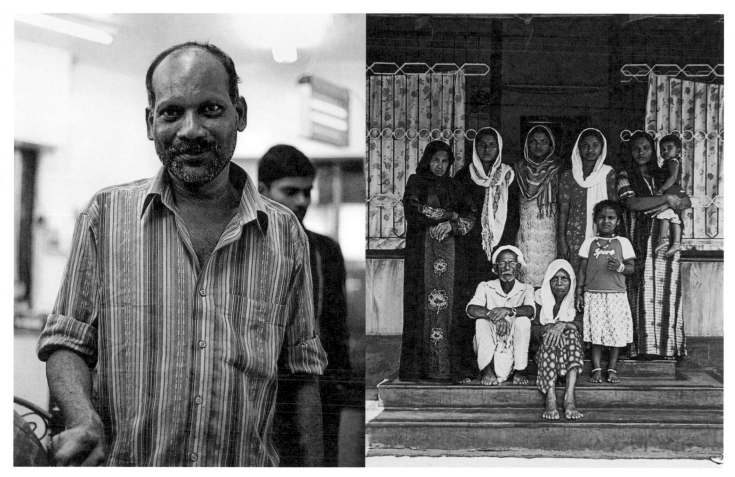

[34] NIKOLAJ BENDIX SKYUM LARSEN – Rendezvous, 2009.
HD video, 2-screen projection, colour, 4-channel soundtrack, 24 min.

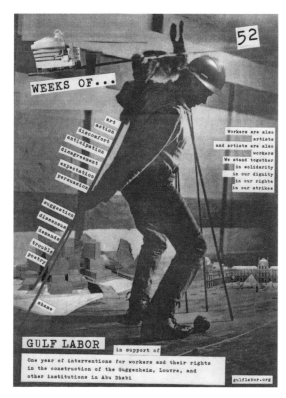

[35] GULF LABOR PROJECT – 52 Weeks, 2013.
Campaign

[36] BRUNO SERRALONGUE – Assemblée générale
des salariés en grève, New Fabris,
Châtellerault, jeudi 23 juillet 2009, 2009.
From the series New Fabris, Châtellerault.
Ilfochrome print, 125 × 156 cm
(49¾ × 61½ in.)

[37] DULCE PINZÓN – BERNABE MENDEZ from the State of Guerrero works
as a professional window cleaner in New York. He sends 500 dollars
a month, 2004-5. From the series The Real Story of the Superheroes.
C-print, 50.8 × 61 cm (20 × 24 in.)

[38] CAO FEI – Whose Utopia?,
2006. Video, colour, sound,
22 min.

[Page 55] [39] AI WEIWEI –
Sunflower Seeds, 2010.
100 million sunflower seeds,
porcelain, paint

their demands were not met. The context of this confrontation was not a local issue but the widespread strikes and factory sit-ins being staged across France in direct response to its decision to out-source production to countries offering cheaper labour. Serralongue's photographs were shot on the penultimate day of the strike, but instead of focusing on dramatic exchanges or stereotypical scenes of conflict, he chose to present images that are often excluded from the mainstream media. As we saw in Allan Sekula's *Waiting for Tear Gas* (page 11), Serralongue's refusal to sensationalize the situation allowed him not only to maintain a critical distance but also to challenge the viewer's understanding of the notion of conflict.

In a political environment defined by neo-liberal policies on deregulation, the reconfiguration of socioeconomic groups in accordance with the demands of glo-balization and the rise of a post-Fordist model of production (which advocates the specialization of labour and a focus on consumers), the question of what labour means to the workers them-selves has become increasingly perti-nent within developed countries. Dulce Pinzón's *The Real Story of the Superheroes* (2004–5) [37] is a collection of twenty colour photographs featuring Mexican immigrants who work in New York and send part of their earnings back to their families or communities in Mexico. Each photograph depicts a worker engaged in their professional activity – cleaning windows, baby-sitting, driving a taxi – while wearing the costume of a popular American or Mexican superhero, as chosen by the worker to reflect their personality. A short text accompanies each portrait and includes the worker's

name, their home town in Mexico, the number of years they have been working in New York and the amount of money they send to Mexico each week. In drawing attention to the politics of labour and migration, Pinzón pays homage to the men and women who, in most cases, withstand extreme working conditions with no acknowledgement of their contribution to both the US and the Mexican economies.

In Cao Fei's *Whose Utopia?* (2006) [38], there is a similar intention to per-sonalize the lives of individuals who have become not only statistics in a burgeon-ing national and global economy, but also alienated from their own daily lives and dreams. Filming workers at the Osram Lighting Factory in China's Pearl River Delta, Cao documents the manufacture of light bulbs and the day-to-day realities of those employed by the factory. The final section of the film reveals their inner lives and hopes for the future as they act out their individual, suppressed fantasies within the confines of a highly impersonal factory environment. A traditional peacock dancer appears, as does a flamenco dancer. A ballerina flits incongruously across the factory floor dressed as an angel. A breakdancer goes through a routine while someone plays a guitar. As in the case of Pinzón's 'super-heroes', a sense of individualism emerges amid the daily drudgery of working under the conditions of a globalized and largely indifferent system of production and consumption.

The relationship between labour and the individual was at the heart of Ai Weiwei's installation *Sunflower Seeds* (2010) [39]. This monumental work was composed of 100 million handcrafted porcelain sunflower seeds, which

were poured into the east end of Tate Modern's Turbine Hall. Covering approximately 1,000 square metres (10,764 square feet) to a depth of 10 centimetres (4 inches), the installation was a massive undertaking, employing roughly 1,600 artisans in small-scale workshops and taking almost two and a half years to complete. While it was labour-intensive by nature, *Sunflower Seeds* nevertheless pointed to a personalization of working practices, inasmuch as each seed was intricately handcrafted in porcelain by artisans based in Jingdezhen, the former centre for state-owned porcelain firms in China, as well as, as we saw in the previous chapter, the city in which Raed Yassin produced his vases (page 36).

The phenomenon of artists engaging directly with the structures of employment – something we saw earlier in Santiago Sierra's *Workers ...* (page 15) and *20 Workers in a Ship's Hold* (page 48) – is central to Nada Prlja's *Aliens Inc.* and *Workers' Production Line* (both 2008) [40], an installation and performance that took place as part of the artist's solo exhibition at the Museum of Contemporary Art in Skopje. Inspired by a song by the English punk-rock band The Clash, the exhibition's title, *Should I Stay or Should I Go*, is a blunt illustration of the political and economic disarray in Macedonia following the dissolution of Yugoslavia in the early 1990s. The performance involved a group of workers sitting in rows and producing T-shirts using industrial sewing machines. The artist, posing as one of the workers, began writing slogans on the T-shirts, such as 'Give 'em Hell', 'Alien Mother' and 'Legal Alien', all of which she had taken from anti-immigration protests. Prlja's performance thus drew

attention not only to working conditions in Macedonia but also to the malice directed at migrant workers.

In Prlja's work we see an example of artists placing themselves at the heart of labour relations. This is a significant act, in so far as it demonstrates the way in which contemporary art can be both a comment *on* and a system *within* such relations. As we shall see in the remainder of this chapter and elsewhere in the book, art as a form of social practice produces a unique space within which to engage the politics of labour – migratory or otherwise – and, in turn, reimagine models of political engagement with labour's processes. This is often focused, as we have noted, on the co-option of certain constituencies into the production of the work itself.

For *Soul Manufacturing Corporation* (2012) [42], Theaster Gates created a temporary factory within a gallery space. Composed of four pavilions, the factory housed a range of 'skilled makers', including three master potters; also involved were a yoga instructor, a DJ and a reader. The last of these was partly inspired by the figure of the lector, or reader, who, in the early industrial era, was employed by factory owners to read the news and literature to illiterate workers. Over the course of the exhibition, the pots produced by the master potters were incorporated into free-standing, cupboard-like structures. One of the key elements in Gates's work, which we shall return to later, is the engagement with constituencies beyond the gallery space and, in his urban regeneration projects, an emphasis on an expanded artistic practice that 'includes space development, object-making, performance, and critical engagement with many publics'.[7]

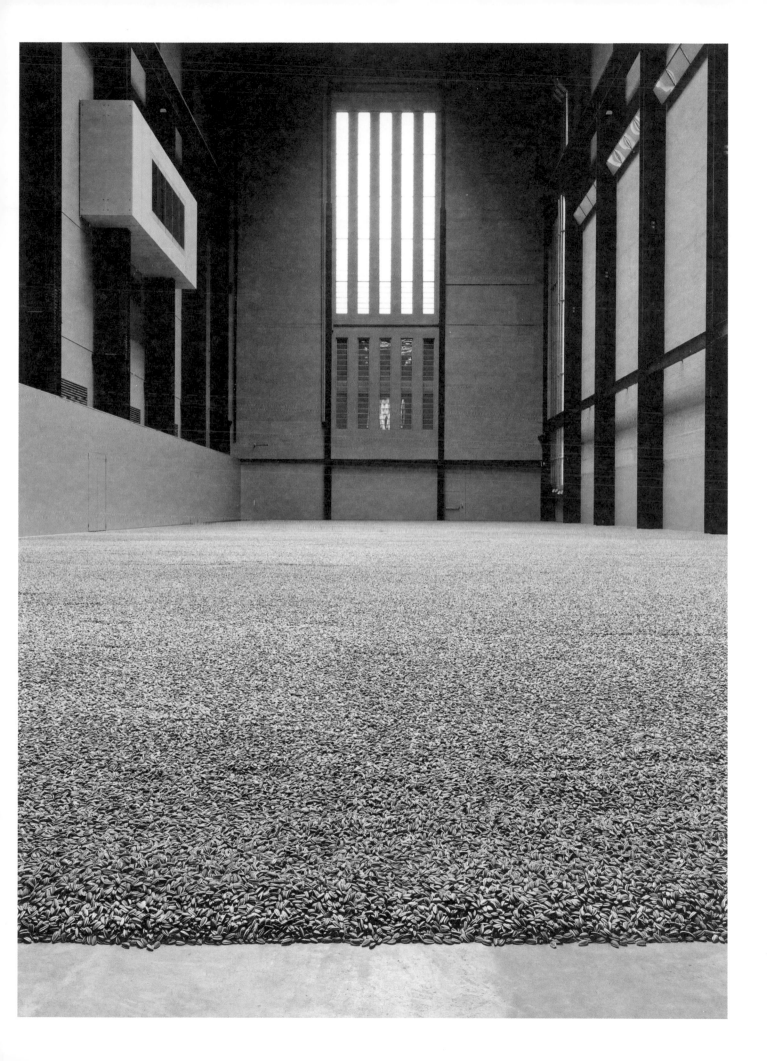

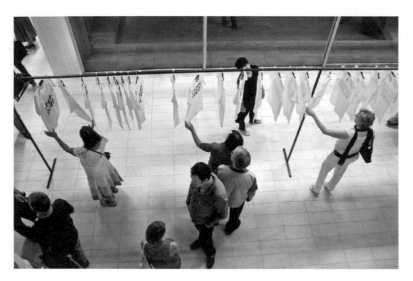

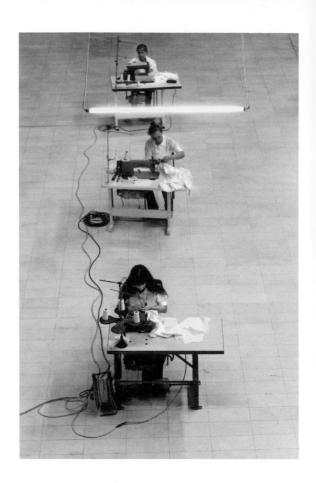

[40] NADA PRLJA – Above: <u>Aliens Inc.</u>, 2008. Installation, industrial shirt railing, 100 hand-painted T-shirts, 100 hangers. Right: <u>Workers Production Line</u>, 2008. Live art event: 8 factory workers, the artist, 6 industrial sewing machines, T-shirt fabric, one-day production

[41] LEE MINGWEI – <u>The Mending Project</u>, 2009. Interactive installation: 1 wooden table, 2 wooden chairs, 400 cones of thread, dimensions variable. Installation view at Lombard-Freid Projects, New York

During the course of Lee Mingwei's installation, the artist repaired garments brought to him by members of the public. As the garments began to accumulate, they became symbolic of the conversations, stories, memories and thoughts exchanged between artist and visitor.

[42] THEASTER GATES – Soul Manufacturing
Corporation, Locust Projects, Miami,
10 November – 21 December 2012.
Multidisciplinary project

Soul Manufacturing Corporation is an
enterprise dedicated to the development
of skills and new forms of creative
production. Focusing mostly on design,
the project partners artists with
designers and small businesses.

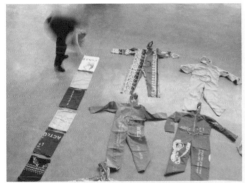

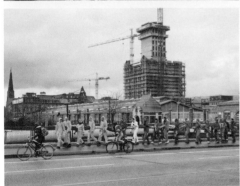

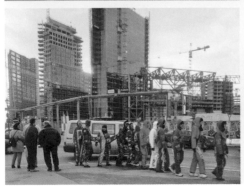
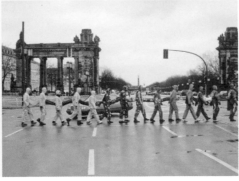

[43] LUCY + JORGE ORTA – Nexus
Intervention with architecture
students from the Technische
Universität Berlin, 1998. Original
Lambda colour photographs laminated
on Dibond, 200 × 170 cm (78¾ ×
67 in.). 6 modules (edition of 7)

Lee Mingwei's *The Mending Project* (2009) [41] explored the politics of labour through the figure of the artist at work and his relationship to the wider world. An interactive installation, *The Mending Project* invited members of the public to bring along items of clothing that needed repair. The installation consisted of one long table, two chairs and a wall displaying the colourful cone-shaped spools of thread with which the artist mended each garment. Using rainbow-like embroidery, the project was not so much a restorative gesture – intended to sew up a rip, for example – as a celebration of the tear itself, investing significant personal and artistic value in each item as it was repaired. Taken as a whole, the mended garments symbolized the conversations, stories, memories and thoughts exchanged between the artist and his visitors over the course of the installation. As such, *The Mending Project* acted as a vehicle for examining ideas of trust and intimacy between strangers in an often alienating world of globalized labour and forced migration.

Nexus Architecture (1993–) [43] consists of a series of performances developed by Lucy + Jorge Orta in collaboration with groups of marginalized individuals, including inmates from the prison in Metz in north-east France, children from a foster home and unemployed female migrant labourers in Johannesburg. A central strand of the project involved teaching skilled and unskilled women to cut, sew and assemble 'nexus' suits to be worn and performed in by their makers at the 2nd Johannesburg Biennale in 1997. Made with fabrics sporting colourful batik designs, their jumpsuit-like creations were linked by detachable appendages.

After ten days of paid participation, thirteen women marched through the art fair in a single human chain, evoking the ideas and ideals of solidarity on which *Nexus Architecture* is based.

In *Surplus Value* (2009) [46], Mona Vatamanu and Florin Tudor restaged an assignment that was often given to Romanian students before the fall of Communism: the whittling down of a piece of metal until it is not there, or at least barely visible. The assignment was just one of several manual-labour exercises undertaken by students over the course of an academic year, and each student was ultimately expected to buy back the objects they manufactured, the price rising in proportion to the complexity of the craftsmanship. Shot in Super 8, *Surplus Value* is infused with a sense of nostalgia. The repeated gestures, metallic hues and raw quality of the film enhance the absurdity of the exercise, and neatly symbolize the struggle that defines the relationship between labour, surplus value, profit and materiality.

The exchange of labour for goods and services is central to e-flux's project *Time/Bank* (2009–) [44]. In 2008 e-flux co-founders Anton Vidokle and Julieta Aranda established an online platform where members of the cultural community could exchange time and skills, rather than purchase goods and services using money. Offering an alternative economic model, time banking – a practice dating from the nineteenth century – is a form of reciprocal service exchange that uses units of time as currency. Based on concepts of alternative currencies and the Marxist theory of labour value, where the surplus value of labour costs becomes profit, *time/bank* creates a system of worth that is not dependent on the

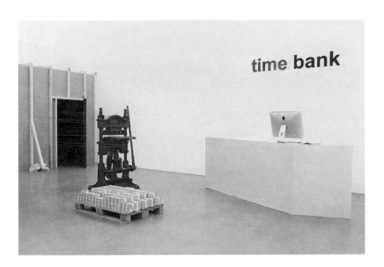

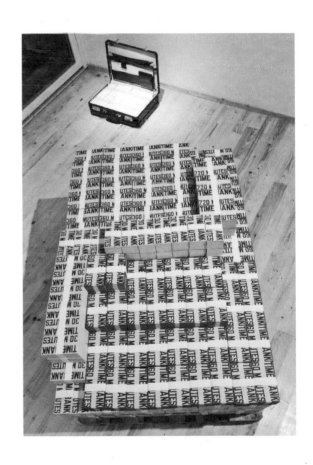

[44] E-FLUX – Time/Bank, 2009–. Clockwise from top left: Portikus, Frankfurt am Main, 2011; Installation at the 9th Gwangju Biennale, 2012; Currency, Documenta 13; Alternative currencies, Documenta 13; Portikus, Frankfurt am Main, 2011

Based on concepts of alternative currencies and the Marxian theory of labour value, Time/Bank creates a system of exchange for those who possess skills but do not necessarily produce physical commodities.

[45] CHRISTOPH BRECH — Sea Force One, 2009.
Video on DVD, colour, sound, 5 min. 9 sec.

[46] MONA VATAMANU AND FLORIN TUDOR —
Surplus Value, 2009. Super 8 film, colour,
silent, 4 min. 30 sec.

Prior to the revolution of 1989, Romania
was a socialist republic with a state-run
economy. In filming the type of manual
labour that underwrote such a system and its
forms of material value, Vatamanu and Tudor
engage with the often absurd demands that
were placed on workers and students alike.

production and sale of physical commodities. With upwards of 4,000 members in such cities as Berlin, Frankfurt, Moscow, New York and Sydney, *time/bank* both questions and exploits the processes of globalization and global patterns of labour distribution.

Sustaining the culture of the art world is itself a business based on often inequitable forms of employment.[8] Christoph Brech's video *Sea Force One* (2009) [45] takes its title from a yacht that was moored in front of the Punta della Dogana, a centre for contemporary art in Venice founded by François Pinault. The making of *Sea Force One* coincided with the opening of both the Punta della Dogana and the 53rd Venice Biennale. A considerable amount of wealth was on ostentatious display at the time, but instead of focusing on the finer aspects of the luxury vessel, Brech confines his audience to a view of the yacht's hull in the process of being cleaned by two anonymous seamen. With J. S. Bach's Prelude in D minor playing in the background, the soapy textures against the black surface of the yacht leave the distinct impression of an abstract and painterly work of art. However, this work is as much about the labour needed to sustain the art world, which, through various biennials and worldwide events, is itself a force of globalization.

There are further issues to be considered here, but that would require a lengthier reading of the paradigm shift that has seen an incremental move away from forms of industrial production towards information-led production, or 'immaterial labour'. For such commentators as Maurizio Lazzarato, immaterial labour is that which produces the 'informational and cultural content of the commodity', rather than the commodity itself.[9] In later chapters, this will re-emerge as a key element in considerations of the politics of the art world and the knowledge economy it produces alongside actual objects.[10]

CITIZENS

Global Refugees and the Logic of Exclusion

THE CALAMITY OF THE
RIGHTLESS IS NOT THAT
THEY ARE DEPRIVED OF
LIFE, LIBERTY, AND THE
PURSUIT OF HAPPINESS,
OR OF EQUALITY BEFORE
THE LAW AND FREEDOM
OF OPINION – FORMULAS
WHICH WERE DESIGNED TO
SOLVE PROBLEMS <u>WITHIN</u>
GIVEN COMMUNITIES –
BUT THAT THEY NO
LONGER BELONG TO ANY
COMMUNITY WHATSOEVER.
–

HANNAH ARENDT

WHAT IS A CITIZEN?

This question is a consistent source of difficulty for legal, philosophical, governmental and social definitions of modern-day citizenship, just as much as its opposite – the non-citizen, the refugee, the dispossessed, the disappeared, the itinerant, the migrant – continues to haunt the political imagination of the modern nation state. In its most basic sense, the term 'citizen' is applied to an individual legally protected by the state by virtue of either birth or naturalization. In return for such protection, the citizen pledges loyalty to the state. The question of what weight is given to each of these ideals, to loyalty to the state and to the protection granted by it, is subject to much debate, if not increased politicization. What remains clear is that the citizen is legally protected, whereas the non-citizen remains grievously unprotected and susceptible to harm, injustice and deprivation.

Somewhat paradoxically, the non-citizen is both included in the apparatus of state power – in so far as they help to define citizenship by acting as a 'limit case' – and excluded from it.[1] Throughout this chapter we will look at how contemporary art engages with the ambiguities surrounding citizenship and its limit cases, and at how these issues inform debates concerning patterns of migration, so-called economic and political refugees, human rights, democracy and surveillance. While nominally titled 'Citizens', this chapter is therefore focused on its apparent opposite, the non-citizen, or that which gives the ideal of citizenship its legal and political purchase in the first place.

Launched in 2010 in the borough of Queens in New York City, Tania Bruguera's community-based project *Immigrant Movement International* [47] brings the question of citizenship and political representation to the fore, not as a marginal issue but as a central, key element *within* the state. Queens is a borough that attracts a large immigrant population, with approximately 140 languages spoken and more than 45 per cent of the population being foreign-born. Bruguera's practice, the formal remit of which encompasses legal services, activism, social and self-help organizations, and volunteer-led activities, is effectively a form of social practice concerned with reforming the legal framework of immigration as it applies to citizenship and with utilizing the political capital to be had in highlighting these questions. The project, to paraphrase Bruguera, seeks to challenge the way in which migration is understood and to question the social stigma attached to it. More specifically, the issue of migration is examined through political and artistic actions – including organized protests, community-based workshops and social interventions – that seek to empower migrants and their communities.

The politicizing of a community in Bruguera's project, or the ambition to do so, has the long-term goal of politically empowering migrant communities. For Bruguera, however, the question is more complex, involving an enquiry into how art can be applied to everyday political issues and debates, and how practice can implicate the viewer in an act of 'citizenry' that effects change. To this end, the debate around citizenship, for Bruguera, begins with the fact of the non-citizen and the immigrant.

The ideal of the citizen and its counterpart, the non-citizen or refugee, is the focus of Omer Fast's *Nostalgia* (2009) [49]. In a reversal of the tendency to view Europeans as citizens – a key trope in colonial discourse – and Africans, or the so-called other, as non-citizens or immigrants, Fast's complex film imagines a future in which Europe has been destroyed and its people have become refugees seeking asylum in Africa by means of clandestine underground tunnels.[2] The refugee in this dystopian world is an Englishman, rather than a fleeing African, and the film opens with his interrogation by an African woman sitting behind a desk. While not unsympathetic, the woman questions the veracity of the tale being presented to her.

Fast's film destabilizes any easy forms of association or affiliation. As viewers, our position is complicated by the unmooring of traditional modes of representing the refugee and the non-citizen. We must question the reversal of roles here, as well as enquire into the legitimacy of the story being told. There are no witnesses to this asylum seeker's tale of escape, and we must make judgements on the basis of the film alone. We are asked to assume not only the role of the refugee or asylum seeker, but also the role of the interrogator.

How this question of veracity is resolved can often mean the difference between life (being granted citizenship in another country) and death (being returned to a conflict zone or a country where torture and summary execution are routine). This same question is often reducible to forms of bio-political analysis, whereby populations are regulated through the application of political power to all aspects of life, including our innermost thoughts and even the timbre of our voices.

In Lawrence Abu Hamdan's multilayered work *Aural Contract: The Freedom of Speech Itself* (2012) [50], the voice, rather than the story, is explored as the signifier of truth in the refugee's appeal for asylum. In the main part of the work, an audio documentary, Abu Hamdan investigates the United Kingdom's controversial use of voice analysis – or 'language analysis for the determination of origin' (LADO) – in its assessment of asylum seekers. Accent, which has always been a key aspect of identity, has now become a means of proscribing and outlawing individuals when determining their claims to asylum and eventual citizenship. Drawing on testimony from lawyers, phonetic experts, asylum seekers and Home Office officials, the work reveals the geopolitics of accents and how, when it comes to the human rights afforded to refugees, such voice-analysis techniques create new forms of limbo-like exclusion.[3]

The sense of being in a suspended or limbo-like state is a common enough experience for refugees and non-citizens. In *Seaview* (2008) [48], a documentary directed by Nicky Gogan and Paul Rowley, we observe a holiday camp in Ireland that has been turned into a refugee centre for asylum seekers. One of the workers at the centre notes that it has become a 'waiting room' for most – a place of refuge for sure, but also one of uncertainty where many exist in a state of limbo.[4] In the context of such uncertainty, an obvious connection could be made between this refugee centre and other, less hospitable internment camps, a point to which we will return in the chapter on camps.

[47] TANIA BRUGUERA – Immigrant Movement International, 2010–. Artist-initiated sociopolitical movement

Immigrant Movement International is a long-term project that appropriates political strategies to examine the status of migrants and their representation. In what appears to be a considerable departure from art displayed in a gallery or a museum, Bruguera encourages the viewer to re-imagine the role of art in society today.

[48] NICKY GOGAN AND PAUL ROWLEY – Seaview, 2008. 35mm film, colour, sound, 82 min.

[49] OMER FAST – Nostalgia, 2009.
Video installation in three parts.
Stills from Nostalgia III, Super 16
film transferred to HD video, colour,
sound, 31 min. 48 sec.

Shown in three separate but
interrelated parts, Nostalgia
explores the ambiguities and dangers
of migration through the theme of
animal trapping. Featuring different
characters in different contexts,
the work addresses a future in which
migration from Africa to Europe has
been reversed.

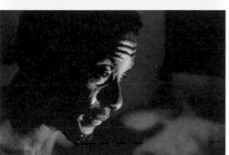

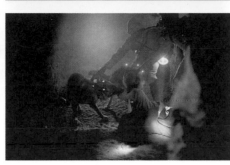

[Page 69] [51] MIKE PARR –
Aussie Aussie Aussie Oi Oi Oi
(Democratic Torture), 2003.
30-hour performance, 2–3 May
2003, Artspace, Woolloomooloo,
NSW, Australia

[50] LAWRENCE ABU HAMDAN – Aural
Contract: The Freedom of Speech Itself,
2012. Multidisciplinary project and
audio documentary

Aural Contract began life as an
investigation into communal knowledge
and evolved, in a self-reflexive
manner, into an examination of the
legality and politics of voice analysis
and the role of the voice in law.
The project consists of a number of
elements, including a voice-activated
sound installation (right) and foam
contour maps based on voiceprints of
two different people saying the word
`you` (right, bottom).

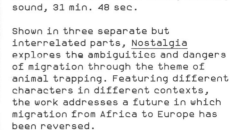

In *Aussie Aussie Aussie Oi Oi Oi (Democratic Torture)* (2003) [52], Mike Parr staged a 30-hour performance in which he had his face cut and stitched by an attending doctor. The performance, which took place at Artspace in Sydney, was intended to draw attention to Australia's strict immigration laws (which have become all the more prohibitive in the decade since the performance was staged). Parr's act of self-mutilation was a direct reference to the harm that immigrants have inflicted on themselves in Australia's detention centres in protest against their apparently indefinite incarceration. Taking place over hours and days, Parr's performances are often impossible to watch in their entirety, owing not only to their length but also to the graphic nature of their content. Nevertheless, they succeed in highlighting the plight of those denied citizenship in a globalized, neo-liberal world, as well as the absence of any concerted protest on their behalf.

A state of limbo-like existence, in which the non-citizen perceives life in terms of an indefinite period of waiting, also figures in *The Impostor in the Waiting Room* (2004) [54] by the Raqs Media Collective (Jeebesh Bagchi, Monica Narula and Shuddhabrata Sengupta). The collective's work consists of three video projections, notice boards, light boxes, an architectural drawing, a soundscape and a framed letter. In the central projection, a male figure, possibly the eponymous 'impostor', shape-shifts from one character to another. In one scene he is dressed in a South Indian ceremonial costume; in the next, he is in a business suit. The space in which this unfolds, the 'waiting room', is described as one of the many 'enclaves that subsist in the shadow of the edifices of legality'.[5]

The complexities of citizenship and non-citizenship, and the relationship between the two, were the focus of *Citizens and Subjects*, Aernout Mik's contribution to the 52nd Venice Biennale in 2007. A multichannel video installation, *Citizens and Subjects* featured three works – *Mock Up* [52], *Training Ground* [53] and *Convergencies* – presented within a mock-up of a detention-centre holding cell. For *Training Ground*, Mik staged and filmed a 'training' session, in which participants adopted the role of refugee, asylum seeker or policeman. Interspersed with these images is footage of a police exercise in which violence is used against asylum seekers. At first viewing, *Training Ground* appears to be *cinéma-vérité*, that is, actual documentary footage of a training session set up to demonstrate ways of apprehending, controlling and processing immigrants. The role-play element, however, in all of its stiltedness, soon reveals the fact that we are watching a re-enactment. The spectator is invited not only to rethink their views or dwell critically on the criminalization of immigration, but also to consider the very role of the spectator in the unfolding events.[6]

There is a flexibility in the definitions of citizen and non-citizen that is often politicized. The definition of the non-citizen can be expanded, under expedient legal and political processes, to include criminals, drug addicts, foreign-language speakers, so-called ghost prisoners and unlawful combatants, and even those who do not possess a bank account. A key factor in the fluidity of these representations is that they can often be employed within a rhetoric and politics of fear that opportunistically targets groups within the nation state.

[52] AERNOUT MIK – Mock Up, 2007.
From Citizens and Subjects. 4-channel video installation

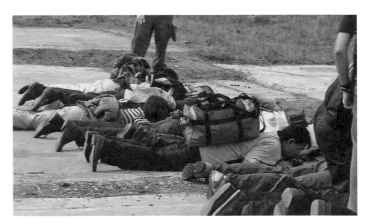

[53] AERNOUT MIK – Training Ground, 2007.
From Citizens andSubjects. 2-channel video installation

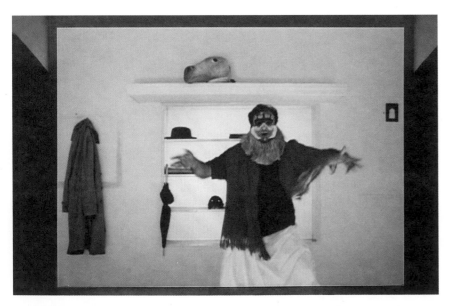

[54] RAQS MEDIA COLLECTIVE – The Impostor in the Waiting Room, 2004.
Installation with video, photography, performance, text, sound and print

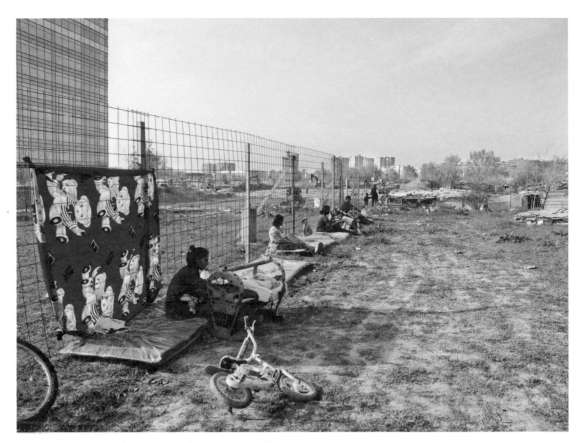

[55] VLADAN JEREMIĆ AND RENA RÄDLE – Belleville, 2009.
PAL video, colour, sound, text and subtitles. Serbian,
Romani, German and English with English text and subtitles

[56] MOHAMED BOUROUISSA – Untitled, 2008. From
the series Temps mort. Silver print on Diasec,
mounted on aluminium, 109 × 135 cm (43 × 53 in.)

[57] MOHAMED BOUROUISSA – La rencontre, 2005. From the
series Périphérique. C-print, 90 × 120 cm (35¼ × 47¼ in.)

[58] REGINA JOSÉ GALINDO – America's Family Prison, 2008. Performance/installation

[59] WOCHENKLAUSUR – A Cinema for Immigrants, 2008. A 4-week free cinema programme, Limerick, Ireland

[60] ATELIER VAN LIESHOUT – AVL-Ville, 2001. Collaborative project

This politics of fear can be seen in the way in which Europe has treated, and indeed continues to treat, its minorities. In the documentary film *Belleville* (2009) [55], produced by Vladan Jeremić and Rena Rädle, we witness an incident that occurred near a residential complex in New Belgrade, the eponymous Belleville, which was built to host athletes participating in the 2009 Summer Universiade. On 3 April that year, and with no warning, mechanical diggers were used to demolish forty nearby houses belonging to Serbia's Roma community, displacing forty-five families in the process. In a harsh irony, 2009 was also the year in which Serbia presided over the 'Decade of Roma Inclusion', a Europe-wide initiative intended to enhance the lives of the Roma. Living close by at the time, Jeremić and Rädle filmed their neighbours' efforts to obtain justice. Shot on a handheld camera, the work foregrounds a Roma community – made up of individuals who inhabit the political and legal margins of citizenship – that is often overlooked by the mainstream media.

The collective WochenKlausur, formed in 1993, also uses its work to engage directly with issues of immigration and exclusion. In *A Cinema for Immigrants* [59], realized in 2006 in Limerick in Ireland, the group produced 'Belltable Open', a free cinema programme featuring films chosen by and targeted at ethnic minorities living in the city. Noting that, since 1996, Ireland's net migration rates had gone from negative to positive (meaning more people were entering the country than leaving it), WochenKlausur invited immigrants from Romania, the Democratic Republic of the Congo, China, Hungary, Lithuania, Russia and South Africa, as well as members of the Irish travelling community, to schedule films for the project.

The notion of 'second-class' citizens is a feature of Mohamed Bourouissa's series *Périphérique* (2005) [57], which explores the lives of those living in the *banlieues*, or suburbs, of Paris. Shot in the months following the riots there in 2005, Bourouissa's staged images record a day-to-day existence marked by unemployment, social alienation and economic disenfranchisement. One of the artist's friends who had helped with the staging of *Périphérique* was later sent to prison, but the two men stayed in touch. After receiving a photograph from his incarcerated friend, Bourouissa developed *Temps mort* (2008) [56], a work consisting of an 18-minute video and a series of photographs of the low-resolution images sent to Bourouissa from inside the prison. Citizenship, incarceration and the politics of visibility coalesce here into an indictment of a nation's treatment of its youth.

The politics of locking up those designated 'alien' or a threat to national security underscore Regina José Galindo's *America's Family Prison* (2008) [58], a performance in which the artist incarcerated herself and her family in a prison cell for 24 hours in a gallery in San Antonio, Texas. For the purposes of the work, Galindo rented a 'demonstration' cell that had been exhibited at trade fairs; at the end of her performance, the cell was left open for visitors to enter and explore. The starting point for this work was the T. Don Hutto Residential Center in Taylor, Texas, a holding centre for illegal immigrants awaiting deportation. Until 2009 the facility was used to house children and whole families, a fact much criticized by human rights groups.

In addition to investigating what constitutes the citizen in political terms, this chapter is concerned with the question of what other forms of political community and citizenship can emerge from artistic practices. In the 1990s the multidisciplinary company Atelier Van Lieshout developed a series of community-based projects that culminated in the establishment of a 'free state' in the port of Rotterdam in 2001. This free state, called AVL-Ville [60], had its own constitution, currency and flag, and was designed to be self-sufficient. Water-purification and energy plants were put in place, as were the means to produce food and alcohol. Before declaring a free state, however, the core members of AVL-Ville wanted to be able to protect themselves, so in 1998 the 'Workshop for Weapons and Bombs' was set up to produce such items as a pistol, a car mounted with a 57mm cannon and an 'AVL M80 Mortar' – all of which, in the wake of the assassination of Dutch far-right politician Pim Fortuyn in 2002, were confiscated by the Dutch police.[7] A year after opening, a process later described by the participants as 'tumultuous', AVL-Ville was closed because of fears over apparent lawlessness.

The liminality of the non-citizen, their estrangement from the civic sphere and yet their centrality to the politics of fear, is addressed in Adrian Paci's *Centro di Permanenza temporanea* (2007) [61], a short video in which a group of people – who could be immigrants, refugees or labourers waiting for work – trudge towards the steps of a waiting aircraft. The camera lingers on individual faces, and follows the group up the steps as they wait patiently to be admitted. As the camera pulls away, however, we become aware that there is neither a plane to be boarded nor a journey to be undertaken. Rather, there are only the aircraft steps on which the group is perched. These unfortunate individuals are stranded in a politicized form of purgatory, a limbo-land of neglect in which they are ferried from place to place without ever really moving.

The artist and film-maker Christoph Schlingensief had already gone one step further than Paci with *Please Love Austria* (2000) [62], his own version of an immigrant removal centre. The film of this work, directed by Paul Poet, shows twelve individuals, introduced by Schlingensief as asylum seekers, spending one week in a shipping-container complex sited next to the Vienna opera house. The complex was placed under strict CCTV surveillance, while a sign on one of the containers read 'Ausländer raus' (Foreigners out). For the duration of the work, members of the public could vote out a number of asylum seekers every day. At the end, reportedly, the remaining asylum seeker would be given a cash prize and the possibility of citizenship via marriage. Writing in the German newspaper *Die Ziet*, one commentator noted that 'There can hardly be a clearer illustration of the inextricable links between the stage-managed cynicism of TV and the objective cynicism of a society that judges asylum policy on the basis of its majority mandate while ignoring moral values.'[8]

Schlingensief's work was eventually brought to an end by demonstrators protesting at the treatment of those held in the makeshift removal centre. Nevertheless, its presence offered a searing commentary on the collusion of the media and political interests in the

[61] ADRIAN PACI – *Centro di Permanenza temporanea*, 2007. Video projection, colour, sound, 5 min. 30 sec. Edition of 6 (+ 2 AP)

 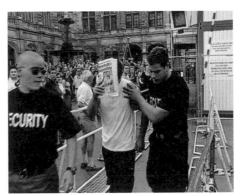

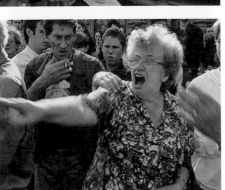 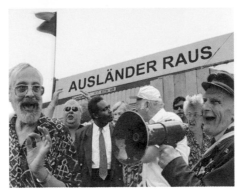

[62] CHRISTOPH SCHLINGENSIEF – *Please Love Austria*, 2000. Stills from film of the event, *Ausländer Raus!*, by Paul Poet, 2001, 90 min.

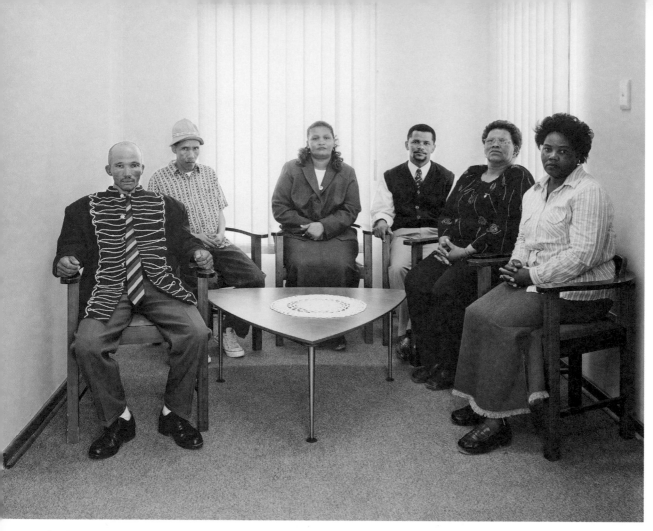

[63] DAVID GOLDBLATT – <u>Council of the Khai-Ma Local Municipality in the municipal</u>
<u>offices at Pofadder, Northern Cape.</u> Left to right: Johannes Swartbooi, Lakus van Rooi,
Alexandra Beukes [Mayor], Marcellinus Gall, Hedwiga Jaar, Rosina Secondt. 24/6/2004,
2004. Archival pigment ink on cotton rag paper, 38 × 48 cm (15 × 19 in.). Edition of 15

An assiduous chronicler of South Africa since 1948, David Goldblatt has traced the
country's development from an apartheid-based regime to a post-apartheid democracy.
However, despite the emergence of a new citizenry in recent years, his work often notes
the disadvantages and impoverishment that continue to be experienced by many.

[64] PHIL COLLINS – <u>how to make a refugee</u>, 1999.
Single-channel video, colour, sound, 12 min.

castigation of immigrants. To note as much is to propose that the creation of the refugee or non-citizen is also a matter of representation and non-representation, by artists and non-artists alike.

Phil Collins's video *how to make a refugee* (1999) [64] details the workings of such representation with brutal efficiency. In the video, we are introduced to Besher, a fifteen-year-old boy who was wounded in the Kosovo War (1998–9).[9] On the accompanying soundtrack, we hear conversations between a photographer, a journalist and a translator, who are seeking to construct an ideal representation of a refugee. As the photographer asks Besher to remove his shirt to reveal a bullet wound, the camera shifts uncomfortably, echoing our own discomfort as viewers. The intentions of these people are conveyed through the use of their own camera, and Collins records the callous nature of the whole process from almost, but not quite, the same vantage point. As such, the title of this work, when read literally, is misleading, as it gives little insight into the events that led to this boy being shot and his family becoming refugees. Rather, *how to make a refugee* investigates how the image of the refugee is produced by the media for mass consumption.

Throughout this chapter we have explored how citizens and non-citizens interact in various social and political arenas, and how art as a social practice engages with and negotiates these spheres. In the work of David Goldblatt, who has been photographing the historical realities of South Africa for more than fifty years, the effects of apartheid and post-apartheid politics on its citizens remain central. Although Goldblatt's images date back to 1948, the year in which the National Party came to power and declared an apartheid state, more recent images, such as *Council of the Khai-Ma Local Municipality ... (2004)* [63], have documented the emergence of a black municipal class. In conversation, Goldblatt has noted the difficulties of being white in South Africa at a time when racial prejudice was being systematized. The question that remains for Goldblatt concerns how best to engage with such a process without resorting to either subversive political action or sensationalism: 'Once I became seriously engaged in it, photography became my way of being politically active. It was a political act ... [However,] I would not allow my photographs to be used for political purposes.'[10] Goldblatt's words remind us that art as a practice can reveal certain political values and ideas without necessarily endorsing them. Moreover, Goldblatt's body of work also recalls the degree to which art as a practice must, somewhat paradoxically, maintain a position *within* social orders but *beyond* political ones if it is to maintain critical purchase on the issues at hand.

The question, finally, of how we determine the extent to which art as a practice is able to effect change is a moot point. However, it does not preclude, as we shall subsequently observe, an investigation into the political and social effects of art as a community-based practice and form of social activism.

ACTIVISM

The Politics of Non-engagement

WHAT ~~ARTISTIC~~
~~ACTIVIST~~ AIMS
HAVE IN COMMON
IS A FAITH THAT
<u>AWARENESS</u> CAN
~~CHANGE~~ THE
WORLD WITHOUT
ANY ~~SPECIFIC~~
FOLLOW-THROUGH.
-

STEPHEN DUNCOMBE
AND STEVE LAMBERT

THE FORMS ASSUMED
BY CIVIL PROTEST
AND POLITICAL
ACTIVISM TODAY,
FROM THE WORLD
TRADE ORGANIZATION
DEMONSTRATIONS IN
SEATTLE, WASHINGTON
AND GENOA TO THE
SOCIAL MOBILIZATION
OF THE OCCUPY
MOVEMENT AND THE
PROTESTS AGAINST THE
TREATMENT OF THOSE
DEEMED NON-CITIZENS,
REPRESENT A COMPLEX
SHIFT IN HOW PROTEST
AND ACTIVISM ARE
CURRENTLY DEPLOYED
AND UNDERSTOOD
WITHIN CULTURAL AND
POLITICAL DEBATES.

These forms of protest and agitation reveal other types of political activism, including community- and collective-based activities, individual voluntarism, direct action, non-violent protests, 'hacktivism', lobbying and boycotting, propaganda, civil disobedience, and networks of non-engagement or passive non-participation. Individuals and communities are taking to the streets in unprecedented numbers, and activism, however we define its remit, is a significant feature of the contemporary political landscape. The question we need to ask here is: how does art as a practice engage with this landscape and to what ends?

As we have seen, art practices are becoming increasingly involved in a variety of socially engaged, activist and community-based projects. However, the ideal of activism, broadly speaking, suggests a proactive approach to social and political change. Nevertheless, art that adopts and adapts forms of activism tends not to be actively calling for such change; rather, contemporary artists, as we shall see, are more likely to explore the potential for alternative models of political engagement – for the artist, audience and public alike – to emerge within cultural practices.

The clearest examples of art's relationship to activism and protest can be observed in actual protests by artists, such as those held by the Songzhuang art colony against the demolition of an art district in south-east Beijing in March 2013. We could also include artist-cum-activists who protest against cultural institutions and their policies on the arts. Liberate Tate, a group that was founded in January 2010 during a workshop on art and activism (which, ironically, was commissioned by the Tate), objects to the Tate's continued involvement with British Petroleum and its sponsorship of major events. Interestingly, the group style their protests as 'performances'; these include, on 7 July 2012, the installation of a blade from a wind turbine in Tate Modern's Turbine Hall.[1]

For other artists, however, the activist element of their work is often implicit in the work itself and its mode of production. In Anri Sala's *Dammi i Colori* (2003) [66], a 15-minute video about a public

[65] CHEMI ROSADO-SEIJO – El Cerro (The Hillside), October 2002, 2003.
Colour photograph, 94.8 × 249.2 cm (37¾ × 98 in.)

Since 2002, Chemi Rosado-Seijo has been collaborating with the
inhabitants of El Cerro – a small settlement in the municipality of
Naranjito, Puerto Rico – on a project to paint their houses different
shades of green. Based on the aesthetics of abstract art, the project
is designed to reflect the sense of community that is shared by those
who live in the settlement.

[66] ANRI SALA – Dammi i Colori, 2003.
Video, colour, stereo sound, 15 min. 25 sec.

[67] THOMAS HIRSCHHORN – <u>Gramsci Monument</u>, 2013.
Installation, Gramsci Theater, Forest Houses,
Bronx, New York

[68] THOMAS HIRSCHHORN – <u>Bataille Monument</u>, 2002.
Installation, Documenta 11, Kassel

As part of Documenta 11, visitors to the exhibition
were transported, via taxi, to a working-class,
Turkish neighbourhood of Kassel, where Hirschhorn
and locally based participants had built a monument
to Georges Bataille. Over the course of the
exhibition, workshops, performances and screenings
were organized around the work and theories of the
French philosopher.

renewal project in the city of Tirana in Albania, the subject of social change was explored through a community-based form of activism that involved tenants repainting a housing block in brightly coloured geometric patterns. The project was conceived by Edi Rama, the then mayor of Tirana and a one-time artist himself. It was hoped that by injecting colour into the tired-looking streets of Tirana, the attitudes of its people would improve and with them the city's prospects for infrastructural change. A similar attempt at rejuvenation was behind Chemi Rosado-Seijo's project *El Cerro* (2002) [65], in which the artist encouraged residents of the eponymous settlement in Puerto Rico to have their houses repainted in different shades of green. The intention was to bring a sense of unity to what had been previously been a run-down and declining economy.

As a social practice, art is able to generate a common visual language capable of engaging the broader political realm. Moreover, in the act of engaging a constituency (of spectators, say, or participants), it can generate forms of political community. In the summer of 2013, and with the assistance of local residents, Thomas Hirschhorn constructed a 'monument' to the Italian political theorist Antonio Gramsci (1891–1937) in Forest Houses, a New York City Housing Authority development in the Morrisania area of the South Bronx. Composed of a series of temporary structures, including a stage, a workshop, an 'Internet Corner', a lounge and a bar (all of which were overseen by the local residents), *Gramsci Monument* [67] offered workshops, lectures and open-microphone events coordinated by the residents of Forest Houses,

alongside lectures on Gramsci and field trips organized by the project's 'ambassador' and curator, Yasmil Raymond. The work also has a dedicated website, which contains texts, notes, pictures and videos documenting the life of the project, from the preliminary sketches to the final installation and the eventual dismantling. *Gramsci Monument*, which followed *Spinoza Monument* (1999) in Amsterdam, *Deleuze Monument* (2000) in Avignon and *Bataille Monument* (2002) [68] in Kassel, is typical of the community-based, activist practice that underwrites Hirschhorn's projects, many of which take place in areas marked by social and economic inequality.

This sense of art giving shape to political values and engaging communities in a common realm of visual experience resonates with an individual and community-based understanding of how public space can be used as a location for rethinking (as opposed to enforcing) political and social values. Nonetheless, it is often the case that political activism and artistic activism are understood to be indistinguishable – a point of concern for some and celebration for others. Speaking of *Gramsci Monument*, Hirschhorn has observed that his projects are not about helping communities as such; rather, they are about 'showing the power of art to make people think about issues they otherwise wouldn't have thought about ... I tell them, "This is not to serve your community, per se, but it is to serve art, and my reasons for wanting to do these things are purely personal artistic reasons."'[2]

The conundrum here is that in taking a stance as a political or social activist, an artist can often disavow the aesthetic intention behind their

[69] BOB AND ROBERTA SMITH – Off Voice Fly Tip
(I wish I could have voted for Obama), 2009.
Mixed media, dimensions variable

[70] BOB AND ROBERTA SMITH – Make Art Not War, 1997.
Commercial paint on plywood, support 153.7 × 152.4 ×
4.8 cm (60½ × 60 × 2 in.)

[71] SHARON HAYES – Yard (Sign),
2009. Installation of 152 lawn
signs, dimensions variable

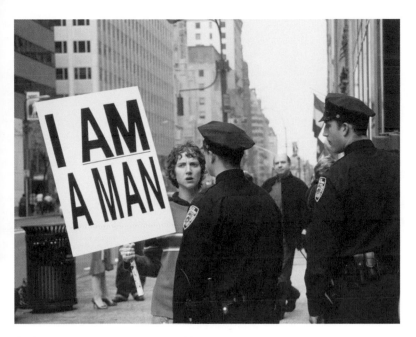

[72] SHARON HAYES – Above: In the Near Future, New York, 2005. Multiple-slide-projection installation, 9 actions, 9 projections, 223 original slides (729 in total), projection dimensions variable. Edition of 1 (+ 1 AP). Right: In the Near Future, London, 2008. 35mm multiple-slide-projection installation, 3 actions, 3 projections, 243 slides, projection dimensions variable. Edition of 1 (+ 1 AP)

[73] CHTO DELAT? – Angry Sandwich People or in Praise of Dialectics, 2006. Performance

Angry Sandwich People was prompted by the largely ignored centenary of the Russian Revolution of 1905 and the workers' march on the Winter Palace in St Petersburg that started it. The performance was conceived and carried out with the cooperation of activists from St Petersburg in an attempt to explore the legacy of a failed revolution and the nature of grass-roots activism.

work in the name of politics.[3] Artistic practices can thereafter be co-opted by political rhetoric, and further discussion of art's relationship to the political is reduced to a question of how effective it is at calling for and initiating social change – an ambition that is often absent from both the artist's and the artwork's avowed intentions. While works by Sala and Oda Projesi, as well as such projects as Hirschhorn's *Gramsci Monument*, advocate activist forms of social change through engagement, they do not do so with the clear objectives traditionally associated with activism, nor should their work be held to account by the degree to which it effects change.

This is to acknowledge a number of further concerns that arise in any discussion of art and activism. For one thing, art can often co-opt activist practices for its own (often ironic or playful) ends. *Make Art Not War* [70], by Bob and Roberta Smith, is a text piece from 1997 that reworks a popular political slogan. Bob and Roberta Smith's DIY approach to making art, with its protest-like and symbolic system of representation, which is often more humorous than political, encourages the viewer to question the intentions – avowed and repressed – behind political and activist-based sloganeering. This work, and others like it, such as *Off Voice Fly Tip (I wish I could have voted for Obama)* (2009) [69], further promote debate about the impact of artistic practices within the public and political sphere – the latter being a key element in many of the works currently under discussion.

A similar intent to play with the historical slogans of political activism can be found in Sharon Hayes's *Yard (Sign)* (2009) [71], a homage, in part, to Allan Kaprow's *Yard* (1961). To create the work, Hayes collected scores of banners featuring disparate political messages, including 'Ron Paul, President '08', 'Kirby Sheriff', 'McCain Palin', 'Sanchez, Counsellor', 'Re-elect Conway' and, more amusingly, 'You Stole Our Obama Sign, We Bought Another Sign'. Hayes's work offers an insightful analysis of the language of protest and activism by reinscribing historical signs into the present and therefore reassessing their potential to mean something to someone, or indeed anyone.

In the Near Future (2005–9) [72] saw Hayes stage performances on the streets of, among other cities, London, New York, Vienna and Warsaw. In locations associated with specific public demonstrations, and among placards bearing slogans from historical protests (including 'We condemn U.S. aggression in Vietnam' and 'I Am a Man'), Hayes interspersed her own banners featuring such invented slogans as 'Nothing will be as before'. In this work, as in *Yard (Sign)*, Hayes investigated individual and collective memories of activist protests and questioned what historical resonances activism produces over time.

Julia Meltzer and David Thorne's *FREE THE, DEMAND YOUR, WE WANT, ALL POWER TO THE, WE MUST …* (2002) [74] is a collection of political stances and slogans taken from an archive of political posters. The work was produced following three months of research at the Center for the Study of Political Graphics in Los Angeles. In a three-sided space measuring roughly 2.5 × 3 metres (8 × 10 feet), six posters display well-known political slogans – 'Silence = Death', for example – while a voice utters some of the archive's other slogans through a

[75] CARSTEN HÖLLER – The Baudouin/Boudewijn Experiment:
A Deliberate, Non-fatalistic, Large-Scale Group Experiment
in Deviation, 2001. Performance

[74] JULIA MELTZER AND DAVID THORNE – FREE THE, DEMAND YOUR,
WE WANT, ALL POWER TO THE, WE MUST, STOP THE, END ALL, DON'T,
FUCK THE, THE PEOPLE WILL, YOU CAN'T, THOSE WHO, WOMEN ARE,
IF YOU, RESISTANCE IS: some positions and slogans recollected
from an archive of political posters, 2002. Installation,
3 walls, 6 mounted digital prints resting on shelves,
1 bullhorn, 243.8 × 304.8 cm (96 × 120 in.). Democracy When?
Activist Strategizing in Los Angeles, Los Angeles
Contemporary Exhibitions, 4 May – 15 June 2002

[76] SEULGI LEE – BÂTON, 2009. Wood, silk, diameter 5 ×
510 cm (2 × 200% in.) each. Installation view of the solo
show IDEM (DITTO), La Ferme du Buisson, France, 2009

[77] ~~Buuuuuuuuu~~ – <u>One minute smile against Berlusconi</u>, 2012.
1,300 videos uploaded to YouTube by participants

[79] ~~THE YES MEN~~ – <u>Dow Chemical</u>, 2004.
Performance

[78] ~~YINKA SHONIBARE~~ – <u>White Flag at Half Mast</u>, 2007.
Commission for the Jubilee Flagpole, Hayward Gallery,
South Bank Centre, London

bullhorn. In collating and deconstructing the nomenclature of protest, Meltzer and Thorne render it abstract, if not politically ineffective.

Described by one critic as 'passive activism', Carsten Höller's *The Baudouin/ Boudewijn Experiment: A Deliberate, Non-fatalistic, Large-Scale Group Experiment in Deviation* (2001) [75] took place in the Atomium in Brussels.[4] The work, in which 100 people remained inside the Atomium for twenty-four hours, was not documented and would seem actively to deny any role in activism or indeed politics. Nevertheless, the experiment stems from the personal dilemma faced by King Baudouin (reigned 1951–3), who, as a staunch Roman Catholic, opposed the parliamentary bill intended to legalize abortion in Belgium. Thanks to a constitutional loophole, however, the Belgian parliament declared him unfit to rule for one day in order to pass the law without his signature.[5] This instance of exception, a key feature of political modernity, would also appear to offer an apt metaphor for art that engages with the symbolism and methods of activism: it remains an expectant bystander on the margins of protest and yet is still fully able to engage with the issues from that often overlooked, if not surreptitiously ironic, position of potential interaction.

Artists who engage with activism, such as those noted above, tend to employ the aesthetics of activism, including placards and slogans, gatherings and marches, while simultaneously excluding any didactic intent, instructional ambition or, indeed, overt form of advocacy from their work. This abstraction of protest and activism is present in Seulgi Lee's *BÂTON* (2009) [76], a collection of seventeen long sticks wrapped in colourful silk and positioned against a wall. Given the size of the sticks, there is a suggestion that they should be used in some functional manner. On further investigation, we find that the objects have been taken from everyday situations and are indeed intended as tools for public use. Perhaps, the artist seems to imply, they could be used to hold up banners during a parade, a protest or even a ritualistic ceremony.

In 2006 the Russian collective Chto Delat?, or 'What is to be done?', invited local activist groups and, to use their term, 'engaged' low-income workers to commemorate the Russian revolution of 1905 in Stachek Square in St Petersburg. Co-opting workers who normally wear sandwich boards advertising local businesses, the collective had them wear signs printed with the words of a Bertolt Brecht poem. This theatrical protest, titled *Angry Sandwich People or in Praise of Dialectics* [73], focused on grass-roots political movements that have their own aesthetics of protest, one based in pickets, fliers, political pamphleteering and a recurring sense of the importance of public space in activist practices.

For the Vienna-based collective Buuuuuuuuu, the act of smiling carries with it the potential for protest and activism. *One minute smile against Berlusconi* (2012) [77] was a web-based project that asked people worldwide to record themselves smiling in silence for one minute as a sign of protest against the then Italian premier, Silvio Berlusconi. In many of Buuuuuuuuu's projects, the act of protest takes the form of members of the public being encouraged to perform simple, often ironic actions online. In the case of *One Minute Smile Against Berlusconi*, the Internet

played an integral role, simultaneously empowering the individual and politicizing their private sphere. The collective's website offers a window on to political protests and activism of the intimate kind, while offering itself as a tool, as in Lee's and Bob and Roberta Smith's work, for participation in such protests.

Conceived by the Yes Men, *Dow Chemical* (2004) [79] was an elaborate hoax aimed at Dow Chemical, the multinational corporation whose subsidiary Union Carbide was responsible for the Bhopal disaster in 1984. This tragic event killed thousands and left more than 120,000 people requiring lifelong care as a result of exposure to methyl isocyanate and other deadly chemicals. On the twentieth anniversary of the disaster, the Yes Men's Andy Bichlbaum, purporting to be a Dow Chemical spokesperson, appeared on BBC World News and announced that the company planned 'to finally, at long last, fully compensate the victims, including the 120,000 who may need medical care for their entire lives, and to fully and swiftly remediate the Bhopal site'.[6] The impact was immediate, wiping $2 billion off Dow Chemical's market value – a clear indication that corporate responsibility does not necessarily sit well with the neo-liberal demands of investment and accumulative-based models of capital. Within two hours the hoax was discovered, eliciting a press release from Dow Chemical in which the company denied any intention to compensate the victims. This, however, merely served to generate further negative publicity.

Produced for the Manchester International Festival, Jeremy Deller's *Procession* (2009) [80] involved a collaboration between the artist and various community groups in a celebration of the use of public space. The community groups, none of which necessarily represented a particular political stance, walked through the city holding aloft banners that read, variously, 'The Unrepentant Smokers', 'Joy in People', 'Carnival Queens' and 'Here We Are Now, Entertain Us'. While the event was largely festive in mood, it also highlighted the civil nature of society and its constituent parts, from non-governmental and community organizations to men's and women's groups, private voluntary organizations, sports groups, environmental activists, cultural groups, religious organizations and community-based art projects. Such bodies not only make up civil society but also, by definition, occupy a space beyond governmental control and corporate interests.

It is here that we can observe not only how protest and activism co-opt communities but also how activism has in turn been co-opted into institutional programmes. For the 7th Berlin Biennale in 2012, the two curators, Artur Zmijewski and Joanna Warsza, invited members of the various Occupy movements to take up residency on the ground floor of the Kunst-Werke Institute for Contemporary Art in the Mitte district of Berlin. The resulting project was criticized in some quarters for institutionalizing activism and thus containing it, but praised in others for offering a staging post of sorts for considering the relationship between art institutions and various forms of protest and conflict.

Such issues were central to Mark Wallinger's *State Britain* (2007) [81], which recreated the camp set up by peace campaigner Brian Haw opposite the Houses of Parliament. Consisting

[80] JEREMY DELLER – Procession, 2009.
Performance. From top to bottom: Carnival Queens
with decorated cars; The Unrepentant Smokers with
a banner designed by David Hockney and made by
Ed Hall; 'Love' banner by Ed Hall, a replica of a
banner used in the Peterloo demonstration of 1819

Commissioned for the 2009 Manchester International
Festival, Procession brought together an unlikely
collection of people and organizations, including
a marching band made up of Scouts and an Asian-
British pipe band. Participants marched with
banners dedicated to a similarly diverse range of
groups and individuals, such as the Unrepentant
Smokers and Ian Tomlinson, whose death during
the G20 protests earlier that same year sparked
protests across the United Kingdom.

[Pages 92–93] [81] MARK WALLINGER – State
Britain, 2007. Mixed-media installation,
approx. 5.7 × 4.3 × 1.9 m (18¾ × 14 × 6¼ ft)

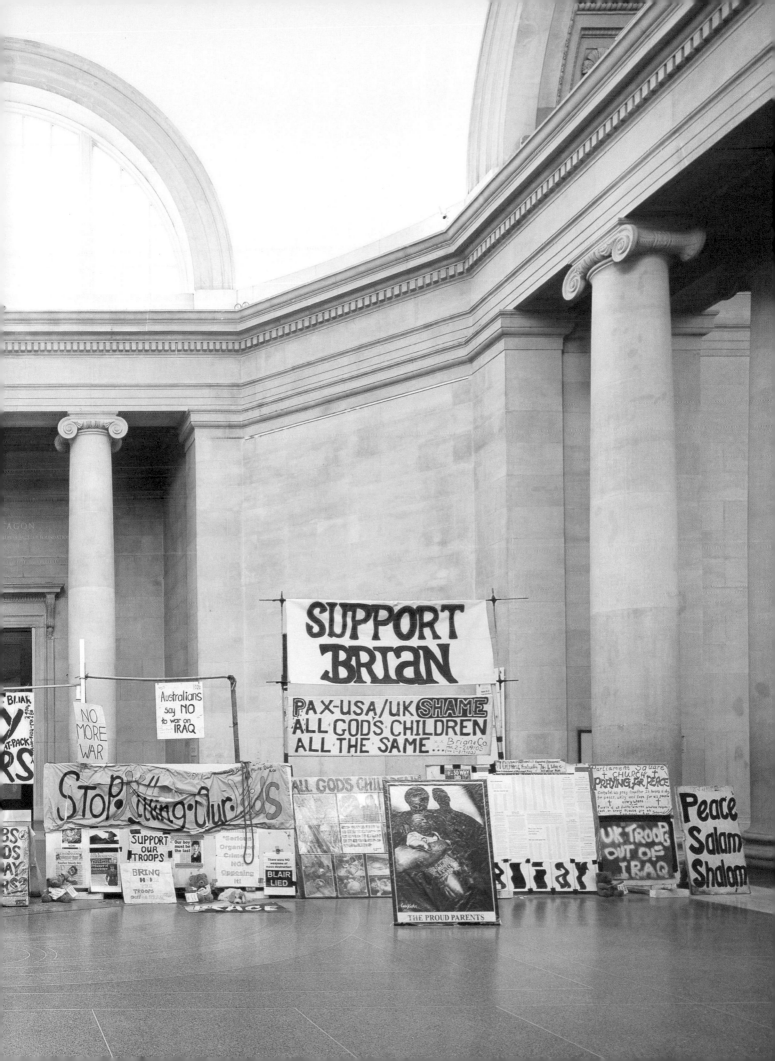

[82] PAUL CHAN – <u>Baghdad in No Particular Order</u>, 2003.
Single-channel video, colour, sound, 51 min.

The inspiration for this work, one of three single-channel
videos, was Chan's involvement with the Iraq Peace Team, an
initiative developed by the Iraqi activist group Voices in
the Wilderness, which used non-violent means to challenge
the US campaign for war in Iraq. The group's efforts were
recognized in 2003 when it was nominated for the Nobel
Peace Prize.

[83] PAUL CHAN – <u>On Democracy by Saddam
Hussein</u>, edited by Paul Chan, 2012.
Publication

of reconstructed placards, flags, teddy bears, photographs, defaced images of Tony Blair and devout Christian messages that had accumulated during Haw's residency on Parliament Square (from 2001 until his death in 2011), Wallinger's *State Britain* effectively re-made everything that the Metropolitan Police had confiscated from the camp in 2006. The location of Wallinger's reconstruction is key here: displayed in the Duveen Galleries at Tate Britain, a public institution that straddled the exclusion zone (a radius of 1 kilometre/0.6 miles from Parliament Square) placed on protest camps in Westminster as a direct result of Haw's protest, the work existed in defiance of that zone and, while it could be understood as a law-defying act, points to the potential of visual culture to reinvigorate debates about the rights of the individual to protest in both public and private spaces.[7]

The events surrounding the invasion of Iraq by allied forces in 2003 have produced a variety of reactions from artists. While some overtly disagreed with the politics of the war, others have explored how it polarized people. In the same year as Wallinger created *State Britain*, Yinka Shonibare hung a white flag, a symbol of both peace and commemoration, at half mast in Jubilee Gardens on London's South Bank. *White Flag at Half Mast* (2007) [78] was the inaugural commission for the Jubilee Flagpole, and, in defiance of the scheme's intention to enliven the 8.5-hectare (21-acre) site, Shonibare's contribution was a simple white flag. More significantly, perhaps, it could also be seen from the Houses of Parliament, the very building in which parliamentary approval to invade Iraq was given on 18 March 2003.

Paul Chan's *Baghdad in No Particular Order* (2003) [82] is the second single-channel video in the artist's 'Tin Drum' trilogy.[8] The impetus for the work was Chan's participation in the Iraq Peace Team, an initiative of the Iraqi activist group Voices in the Wilderness that was set up to challenge the US campaign for war using non-violent means (the efforts of Voices in the Wilderness were subsequently recognized when it was nominated for the Nobel Peace Prize in 2003). In *Baghdad in No Particular Order*, we are given a glimpse of everyday life in the city just months before the US-led invasion. Scenes of children dancing merrily, a caged monkey dozing in a hotel lobby and a Sufi poetry performance, as well as the quotidian activity of the local cafe, play out over time, their subjects apparently oblivious to the coming war and the devastation about to befall the city. A later work by Chan, *On Democracy by Saddam Hussein, edited by Paul Chan* (2012) [83], consists of a small publication containing three speeches delivered between 1977 and 1978 by the then vice president of Iraq, Saddam Hussein (Chan had been jokingly given a copy of Hussein's book from which the speeches are taken by a colleague). Given Hussein's death in 2006 and the devastation in Iraq, the speeches take on a relic-like quality that is at once politically perverse and eerily familiar in tone.

In *Get Rid of Yourself* (2003) [84], the Bernadette Corporation – whose core members include John Kelsey, Bernadette Van-Huy and Antek Walczak – explored the activist narrative of anti-globalization alongside the militant-intellectual approach of the Black Bloc anarchist group and the thinking of the founders of *Tiqqun*, a French philosophical journal

launched in 1999.[9] Containing footage of the attacks on the World Trade Center in 2001 and the anti-globalization protests in Genoa in the same year, *Get Rid of Yourself* also features actress Chloë Sevigny distractedly recounting, among other things, a recipe for a Molotov cocktail. As a film-essay, *Get Rid of Yourself* appears to question the efficacy of left-wing activism in the face of an all-consuming culture of capital. In turn, it also appears to advocate a movement that would anonymously embody newer, more selective forms of political activism in order to subvert both state-controlled agendas and certain forms of self-surveillance.

Conflict, as we shall see in the next chapter, has an immediate effect on those involved in it. Ahmed Basiony's *30 Days of Running in the Place* (2010) [85] was a performance piece in which, over the course of thirty days, the artist ran on the spot for one hour every day in a specially constructed room outside the Palace of Arts in the gardens of the Cairo Opera House. This work proved to be Basiony's last: on 30 January 2011, while filming the events of the Egyptian Revolution, he was shot dead. Following his death, his artistic work was shown alongside footage he had taken of the protests in Tahrir Square, raising questions about the extent to which his political views and activism were being prioritized over his artistic output, and, in turn, to what degree the emotional reactions to his untimely death proscribed further forms of interpretation. The conjunction here between art and activism is indicative of the manner in which art can often be co-opted for political ends or subsumed into its often narrow agenda.

If art is indeed increasingly being positioned as 'political', capable of potentially altering opinion and reconfiguring engagement with various communities and our sense of our place within them, then one question remains urgent: is it now the case that art, by utilizing elements of activist practice, can not only effect social debate but also offer unique ways of engaging with such debate? In their appeal and broad reach, can artists engage constituencies beyond the art world and mirror, in part, the appeal of activism to a wider audience without necessarily advocating a clearly definable or quantifiable outcome, political or otherwise? In the following chapter, we shall examine further evidence of how art embodies and interprets political forms and values and, in so doing, reconfigures forms of engagement with some of the most pressing issues of our time: conflict, history and the politics of terror.

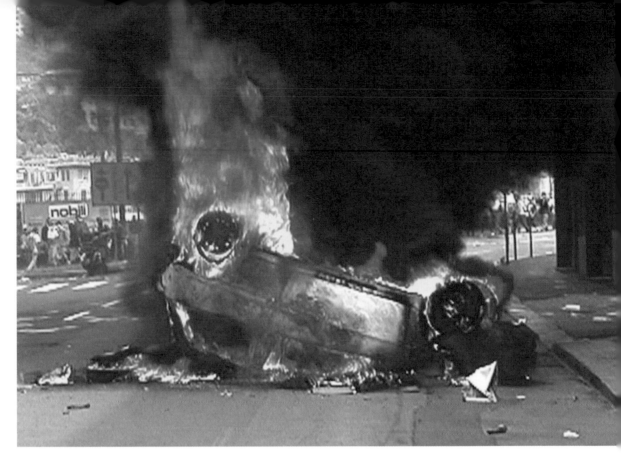

[84] BERNADETTE CORPORATION – Get Rid of Yourself, 2003.
Digital video, colour, sound, 61 min., featuring Chloë Sevigny
and Werner von Delmont

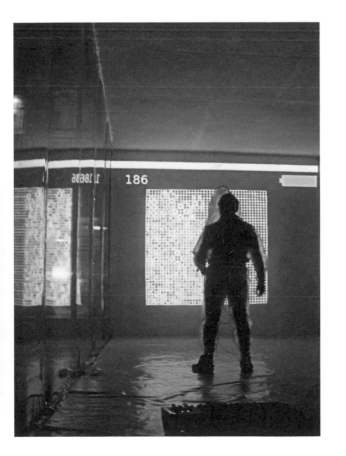

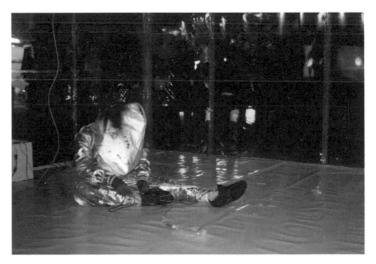

[85] AHMED BASIONY – 30 Days of Running in the Place, 2010.
Performance. Installation at FACT as part of 'Abandon Normal
Devices' festival, 2011

In this performance piece, Basiony, over the course of
thirty days, ran on the spot for one hour every day. The
footage of the performance is also the artist's final
contribution to contemporary art: while filming the events
of downtown Cairo and Tahrir Square during the Egyptian
Revolution, he was shot dead on 30 January 2011.

CONFLICT

State Power and States of Emergency

ONE OF THE FEW
GOOD THINGS ABOUT
~~MODERN TIMES~~: IF
YOU ~~DIE~~ HORRIBLY
ON ~~TELEVISION~~,
YOU WILL NOT HAVE
DIED IN VAIN.
YOU WILL HAVE
<u>ENTERTAINED</u> US.
—

KURT VONNEGUT

THE CAUSES OF CONFLICT ARE MANY AND VARIED. IN ITS IMPACT AND LEGACY, CONFLICT CAN BOTH CLARIFY AND COMPLICATE RELATIONSHIPS BETWEEN INDIVIDUALS AND COMMUNITIES, AND AMONG NATIONS AND REGIONS.

It can be historical (emanating from decades of civil war), economic (provoked by disputes over resources and their allocation), sectarian (pitching neighbouring communities against one another) and, of course, the result of political differences and perceived injustices. If, as previously proposed, the maintenance of a worldwide underclass of poorly paid, often transitory workers is an integral part of globalization, then conflict is also an increasingly prevalent feature of a market-led, neo-liberal system of capital accumulation.

Given that conflict is diverse in its origins and prolific in its effects, it is necessary to focus on specific historical contexts and examine how contemporary art responds to the political realities of particular types of conflict. This is key to understanding not only the politics of art as a practice but also the politics of image distribution and consumption in a globalized economy. The representation of conflict – the transmission of images – is intimately connected to the demands of politics, which can often change during times of so-called national emergency. Access to images of conflict is often controlled by governments and subject to legal conditions. In Alfredo Jaar's *Lament of the Images* (2002) [86], the artist recounts how, prior to the first air strike against Afghanistan by US fighter jets on the night of 7 October 2001, the US Department of Defense had purchased exclusive rights to all satellite images of Afghanistan and its neighbours. The media were subsequently reduced to using archive footage of the region, with no way of seeing the effects of the bombing or, indeed, of corroborating or refuting President George W. Bush's claim that the bombing was 'carefully targeted'.

Conflict, together with the question of how the media responds to and represents civil wars, also informs Jaar's exploration of culpability in *We wish to inform you that we didn't know* (2010) [87]. This multichannel video installation begins with BBC news coverage of a visit by President Bill Clinton to the capital of Rwanda, Kigali, ostensibly to apologize for not acting with more urgency during the genocide that engulfed the country in 1994. The internecine violence in Rwanda resulted in the death of more than a million people, approximately 20 per cent of the country's population. These deaths, many argue, were preventable; indeed, some have gone further, suggesting that the inaction of the world community made it complicit in an act of genocide. Rwanda, which does not have any oil or major resources to speak of, was, it seems, simply not a high enough priority on anyone's agenda, be it political, economic, moral or otherwise.

To the extent that Jaar's *Lament of the Images* traces the prohibitions placed on images of conflict, Joana Hadjithomas and Khalil Joreige's series

Kabul, Afghanistan, October 7, 2001.

As darkness falls over Kabul, the U.S. launches its first airstrikes against Afghanistan, including carpet bombing from B-52s flying at 40,000 feet, and more than 50 cruise missiles. President Bush describes the attacks as "carefully targeted" to avoid civilian casualties.

Just before launching the airstrikes, the U.S. Defense Department purchased exclusive rights to all available satellite images of Afghanistan and neighboring countries. The National Imagery and Mapping Agency, a top-secret Defense Department intelligence unit, entered into an exclusive contract with the private company Space Imaging Inc. to purchase images from their Ikonos satellite.

Although it has its own spy satellites that are ten times as powerful as any commercial ones, the Pentagon defended its purchase of the Ikonos images as a business decision that "provided it with excess capacity."

The agreement also produced an effective white-out of the operation, preventing western media from seeing the effects of the bombing, and eliminating the possibility of independent verification or refutation of government claims.
News organizations in the U.S. and Europe were reduced to using archive images to accompany their reports.

The CEO of Space Imaging Inc. said, "They are buying all the imagery that is available." There is nothing left to see.

Wonder Beirut: The Story of a Pyromaniac Photographer (1997–2006) [89] explores the violence done to images under the conditions of civil conflict. In 1968, we are told by the artists, a photographer by the name of Abdallah Farah published a series of postcards of Beirut. Among their subjects were the once-splendid Hotel St George, standing proud on Beirut's famed Corniche (a one-time destination for international tourists), the Phoenicia Hotel and the Minet-el-Hosn hotel district, all shown in their former glory. Then, in 1975, Farah apparently began burning the negatives of these images in a literal reflection of the destruction being wrought on Beirut by the Lebanese Civil War (1975–90). In 1997 Hadjithomas and Joreige reported that they had started working on a project with Farah, whom, they claimed, they had met at the beginning of the 1990s. Using a number of images that Farah had seemingly defaced between 1975 and 1990, Hadjithomas and Joreige published their own series of postcards and distributed them around Beirut. At this time, postcards bearing identical images, minus the defacement, could still be bought in shops and newsagents; and although the scenes depicted in these 'official' postcards – including buildings and monuments – had long been destroyed, their continued presence, alongside the artist's own creations, gave rise to a number of issues, not least the difficulties associated with representing the history of civil conflict.

In a city such as Beirut, where responses to Lebanon's civil war have ranged from collective amnesia to selective (and invariably sectarian) forms of commemoration, the subject of remembering and forgetting is not only still fraught with anxieties but also the basis of an ongoing discussion concerning the city's future. As we shall see in the chapter on history, the often elided distinction between fact and fiction has become something of a genre in contemporary Lebanese visual culture, as has the sense that meaning, even for those who experienced the civil war at first hand, remains elusive and often disinclined to emerge from within traditional narratives.

Akram Zaatari's *Letter to a Refusing Pilot* (2013) [88] concerns an incident from the Lebanese Civil War that was believed by many to be merely rumour and myth. Inspired in part by Albert Camus's 'Letters to a German Friend' (1943–4), a series of essays that emerged out of Camus's struggle against both recent and historical violence, Zaatari's video relates the tale of Israeli pilot Hagai Tamir, who, in June 1982, found himself flying above the city of Saida – 40 kilometres (25 miles) to the south of Beirut – with orders to bomb a building he knew to be a school. Tamir, however, disobeyed his orders and dropped his bombs into the sea instead. The story of this pilot who refused remained an anecdotal one for many years until Zaatari, whose father had been director of the same school for two decades, discovered that the apparent fiction was indeed real. Using family photographs, one of which shows the artist as a child in the gardens of the school, video stills, re-enactments of certain events (including the flying of paper aeroplanes from rooftops) and aerial photographs, Zaatari attempts to give substance to those narratives of civil conflict that seem actively to resist historical representation.

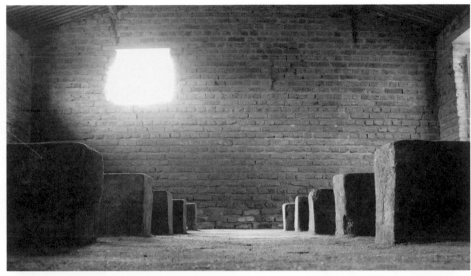

[87] ALFREDO JAAR – We wish to inform you that we didn't know, 2010. Film stills from 3-channel video installation

[Pages 104-5] [89] JOANA HADJITHOMAS AND KHALIL JOREIGE – Wonder Beirut #17, St. George Hotel, 2008. Lambda print mounted on aluminium, 70 × 105 cm (27½ × 41¼ in.)

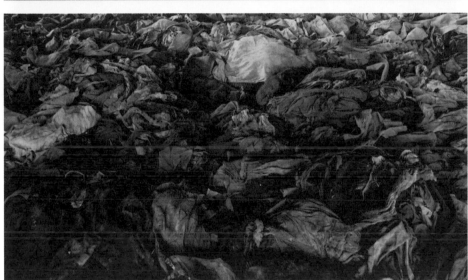

[88] AKRAM ZAATARI – Letter to a Refusing Pilot, 2013. HD video, colour, sound, 34 min.

The restrictions placed on images of conflict are not just political; they can also be aesthetic. Some images are disqualified from representing conflict because they are regarded as not war-like enough, while others are deemed not to conform to an agreed aesthetic for conflict-based images. Aernout Mik's *Raw Footage* (2006) [91] consists of film footage from the various civil wars that were fought in the former Yugoslavia in the 1990s. Projected on to two adjacent screens, *Raw Footage* avoids the pitfalls of media sensationalism and instead concentrates on the day-to-day experiences of those who lived through the conflict: soldiers go about their non-military-related business, militia women apply make-up, young people chat in cafes and prisoners-of-war stand in line. Through the accumulation of such scenes, the everyday monotony of war is brought home in all its drudgery and mundane brutality.

For *Collateral Damage* (2001) [90], Gianni Motti requested access to the images of the Yugoslav wars that the Agence France-Presse news agency had been unable to sell. In the various photographs that he looked at, one group in particular caught his eye: those labelled 'too aesthetic'. For media outlets, these dramatic images of bomb smoke drifting across a verdant countryside apparently had more in common with the tradition of landscape photography than with photojournalism. Such images were therefore deemed to be at odds with more marketable and sensational images of war – ones that the public, weaned on a diet of conflict imagery, would be able to 'understand'. Written into historical, political and aesthetic frames of reference over time, images of conflict appear to have

become a carefully defined and officially sanctioned genre in their own right.

In June 2008 Adam Broomberg and Oliver Chanarin travelled to Afghanistan to serve as journalists with the British military. In place of their cameras, however, they took a roll of photographic paper contained in a simple, light-proof cardboard box. Their trip to Afghanistan coincided with a series of incursions and counter-attacks that inflicted considerable losses on British soldiers stationed in Helmand province, with a number of deaths occurring over the first four days of their time there. In response to each of these events, and others, the artists exposed a 7-metre (23-foot) section of the photographic paper for a period of 20 seconds; the resulting series of images, *The Day Nobody Died* (2008) [92], was named after the fifth day of their visit. In choosing not to employ a camera to record images of death and conflict, and by thereby avoiding the journalistic impulse to produce images that conform to media-friendly agendas, Broomberg and Chanarin questioned the ease with which we have access to the trauma of conflict and its aftermath.

The deconstruction of the representation of conflict is central to Harun Farocki's *War at a Distance* (2003) [93]. Examining how technology was developed in the context of the Gulf War (1990–1), and the increasingly advanced methods that are used to document warfare in general, Farocki suggests that mass destruction, in wars and civil conflicts as well as in terms of lives and livelihoods, demands significant and ongoing advances in visual technology. A key component of such advances is the role of image storage and processing in mapping out targets and recording the

[90] GIANNI MOTTI – Collateral Damage (detail), 2001.
Series of 10 colour photographs, each 68.8 × 86.8 cm (27 × 34 in.)

[91] AERNOUT MIK – Raw Footage, 2006. 2-screen video and sound installation (images from found documentary material: Reuters and ITN, ITN Source), digital video on DVD

[92] ADAM BROOMBERG AND OLIVER CHANARIN – The Day Nobody Died, 2008.
From left to right: The Repatriation, June 16, 2008 (detail);
The Day of One Hundred Dead, June 8, 2008 (detail); The Fixer's Execution,
June 7, 2008 (detail). Unique C-type, 76.2 × 600 cm (30 × 236¼ in.)

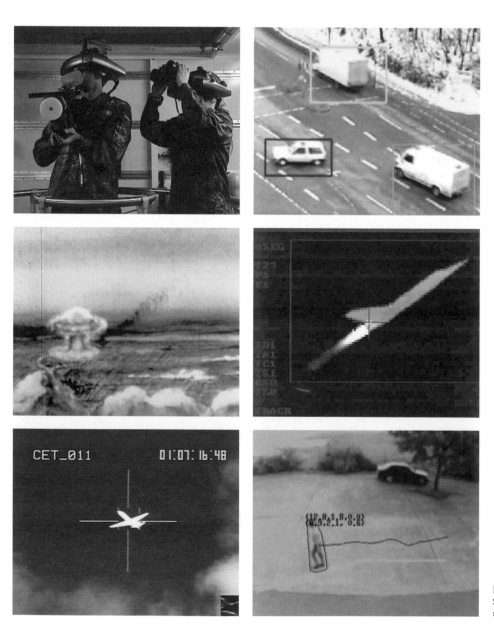

[93] HARUN FAROCKI – War at a Distance,
2003. Video, colour/black and white,
sound, 54 min.

impact of bombing. The more advanced the technology, the better the intelligence and, in turn, the more 'surgical' the strike can be – in theory at least.

Farocki's *War at a Distance* outlines what some commentators have referred to as 'postmodern war', a scenario in which the reality of war and conflict has become virtualized for both the protagonist (who sits in a room ordering attacks via a computer) and the audience (who also sit in a room, but in their case consuming images on a television screen).[1] Here, the short-circuiting of reality, by means of virtualization and modes of consumption, removes everyone but the victims from the often fatal consequences of conflict.

The deployment of so-called smart bombs and surgical strikes, which, the public was told, would help to minimize 'collateral damage', was first mooted at the outset of the Gulf War. The use of technology in that war led to a confusion between the virtual (in which there are no casualties) and the real (in which there are undoubtedly casualties). In Omer Fast's *5,000 Feet Is the Best* (2011) [94], the virtualization of conflict is exposed through a series of interconnected narratives. In one of these narratives, a man in a hotel room discusses his role as an operator in charge of the drones – also known as unmanned aerial vehicles, or UAVs – that are increasingly used to bomb targets from a distance. Apparently, 5,000 feet is the optimal height for a drone to pick up heat signatures from people below and then bomb them with relative impunity.

The artefacts of conflict, the actual weapons and munitions used, are the art materials of Gonçalo Mabunda, an artist who takes AK-47s, rocket launchers, machetes, bullets, pistols and other such items of warfare and refashions them into masks and thrones. These one-time objects of destruction were recovered in 1992 at the end of the sixteen-year civil war in Mozambique, which left 1 million people dead from fighting or starvation, and more than 5 million without a home. Mabunda's thrones, including *The Tip Worker Throne* (2013) [96], recall the function of such objects as seats of power and judgement, while his masks, which draw on traditional African art, reference the debt owed by such artists as Braque and Picasso to the African masks they saw in Paris in the early part of the twentieth century. It is no coincidence that many of those masks would have been looted or simply abandoned during times of colonial conflict.

The raw materials for Pedro Reyes's project *Palas por Pistolas* (Guns for shovels; 2007–) [97] were the guns handed in by residents of Culiacán, a city in north-western Mexico renowned for gun violence and drug trafficking. Reyes launched a campaign via a local television station calling for residents to exchange their weapons for vouchers that could be used to purchase electrical items. He then had the weapons flattened, melted down at a foundry and refashioned into 1,527 shovels, which were subsequently used to plant the same number of trees across the city. Conflict, in the context of drug-related violence and death, is here transformed into a horticultural project that gives a different level of visibility to the often hidden weapons of destruction.

The relationship between artist and the act of spectating or viewing is key to addressing an important question in contemporary art practices and the politics of

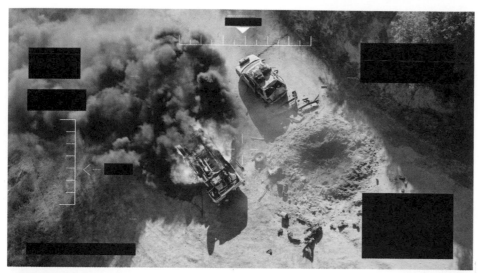

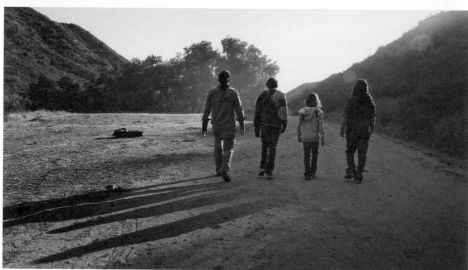

[94] OMER FAST – 5,000 Feet Is the Best, 2011.
Digital video, colour, sound, 30 min. Edition of 6 (+ 2 AP)

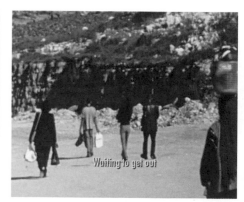

[95] ELS OPSOMER – _Imovie[one]_: The Agony of Silence, 2003.
DVD projection, colour, English text, 11 min. 58 sec.

[96] GONÇALO MABUNDA –
The Tip Worker Throne, 2013.
Decommissioned welded arms,
105 × 85 × 67 cm (41¼ × 33½ × 26⅜ in.)

[97] PEDRO REYES – Palas por Pistolas
(Guns for shovels), 2007–. 1,527
collected guns melted into steel to
fabricate 1,527 shovels, to plant 1,
527 trees. Installation view,
La Biennale de Lyon, 2009

representing and engaging with conflict: how can art as a practice reflect on – and therefore re-imagine – the historical trauma associated with conflict without merely repeating the spectacle associated with war and civil insurrection? To this we must add a second question: how can art avoid fetishizing the objects and locations of conflict?

These questions have found particular relevance in the ongoing civil unrest in Iraq and the long-running conflict between Israel and Palestine. Els Opsomer's _Imovie[one]_: The Agony of Silence (2003) [95] is a video letter produced by the artist during an eight-day visit to Tel Aviv, Jerusalem, Ramallah, Birzeit and Gaza. The 'letter' in question is to her friends, and appears as subtitles on the screen together with a series of photographs of the various cities she visited and the often nondescript roads and areas she encountered during her stay. Very little happens in this film, a fact that paradoxically heightens the sense of tension; indeed, the anxiety mounts as the camera probes and reveals the potential for violence and latent conflict in the most innocuous of locations. This refusal to use images of a sensational nature recalls the aesthetic practice at work in Aernout Mik's exploration, discussed earlier, of the politics of representing the conflict in the former Yugoslavia. However, what if no images of conflict exist to be examined, deconstructed and re-presented?

Ariella Azoulay's Unshowable Photographs/Different Ways Not to Say Deportation (1948) (2010) [99] explores precisely such a conundrum. A series of twenty-four collages, composed of drawings and texts, Azoulay's work focuses on the events surrounding the creation of the state of Israel in 1948. The drawings are based on photographs of some of these events that Azoulay found in the archive of the International Committee of the Red Cross (ICRC). Prohibited by the ICRC from showing the photographs, accompanied as they were by French commentary that was blatant in its disdain for a 'two camp' solution to what would become known as the Israeli–Palestinian conflict, Azoulay made drawings of the photographs and exhibited each one together with two columns of text. One was a precise description of the image, its facts and circumstances, while the other was a list of italicized questions addressed directly to the ICRC concerning the state of emergency in Palestine and the organization's role in a crisis that worsens by the day.

The re-framing of conflict is integral to Reza Aramesh's work, which the artist refers to as 'actions'. Aramesh takes his source material from the world's various conflict zones, the very same zones that often crop up in our daily glut of print, online and television news. For Action 51. Kerem Shalom, Israel – February 17, 2008: Palestinian prisoners sit blindfolded on the ground after they were captured (2008) [98], Aramesh selected a press photograph of Palestinian prisoners being guarded by Israeli soldiers at a border crossing between the Gaza Strip and Israel. With the help of volunteers, Aramesh restaged this image in the environment of Cliveden, a former stately home in the south of England now run as a luxury hotel. What was once familiar – if not over-exposed in terms of media representation – becomes unfamiliar and unsettling, and, in turn, reinvested with an uncanny immediacy.

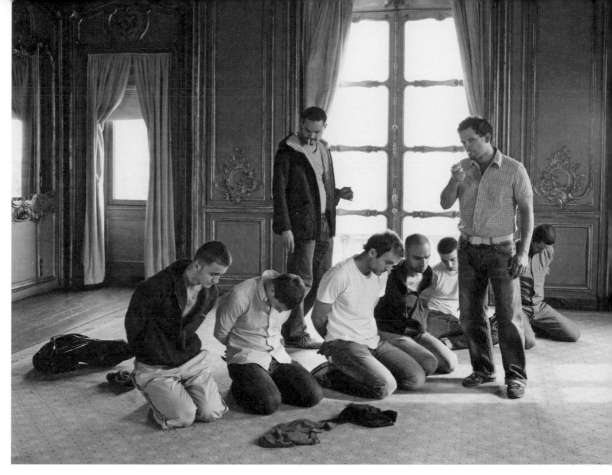

[98] REZA ARAMESH –
Action 51. Kerem Shalom,
Israel – February 17,
2008: Palestinian
prisoners sit blindfolded
on the ground after they
were captured, 2008.
Framed hand-printed
silver gelatin print,
124 × 159 cm
(48¾ × 62½ in.)

Unshowable Photographs: Different Ways NOT to Say Deportation
by Ariella Azoulay

Région de Tul karem. Femmes et enfants faisant partie d'un transfert de 1100 personnes quittant la zone juive pour gagner la zone arabe, sous les auspices du CICR.

V-P-PS-N-0-4-2679

There was nothing accidental about the photographer capturing a line of women and children with his camera – this was the nature of the community exiled from Tantura to Fureidis a mere few weeks earlier, and deported from Tul Karem on the day the photograph was taken. The men – "of recruitable age" – were arrested and transferred to prison camps, and over one-hundred of them (historians debate the exact number) were massacred. Numerous photographers were allowed to come and document the "willing transfer" of those one-thousand women, under the auspices of the Red Cross that even supplied the buses to transport them most of the way. In spite of the aid the women received, one of the Red Cross officials who gave a neutral description of their fate could not refrain from reflecting their despair as they marched the one-and-a-half kilometer distance to the border.

And what about all those who had not managed to stack such a heavy load on their heads? And even if they did manage to squeeze a whole world into that sack, would that suffice to fill their basic needs once they arrived at their encampment? And their bare feet – when, if at all, would they be able to soak them in some warm water, sooth them from the exhausting march? And when one of the girls burst into tears, was she allowed to halt the advance of the caravan and to attend her, give her support and attention? What child would not cry, having been evicted from home and after her father were taken and vanished all of a sudden, and this child was now forced to march – adult like – the distance of one-and-a-half kilometers toward the unknown? Would she ever see that father again? How could one understand the disappearance of all the men of the community? Were any explanations offered? Or was the question superfluous?

[99] ARIELLA AZOULAY – Unshowable
Photographs/Different Ways Not to Say
Deportation (1948), 2010. Publication

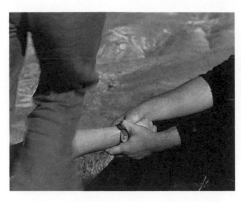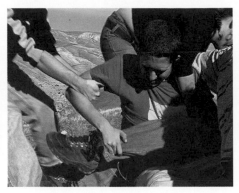

[100] YAEL BARTANA – <u>Wild Seeds</u>, 2005.
2-channel video and sound installation, video projection, colour,
soundtrack by Daniel Meir, 6 min. 39 sec.

Filmed in the West Bank, <u>Wild Seeds</u> shows a group of young Israelis –
some of whom would go on to refuse service in the Israel Defense Forces –
playing a game based on the forced ejection of Jewish settlers from the
Israeli outpost of Gilad in 2002. An adjacent screen displays such words
and phrases as `traitor` and `this is our land`.

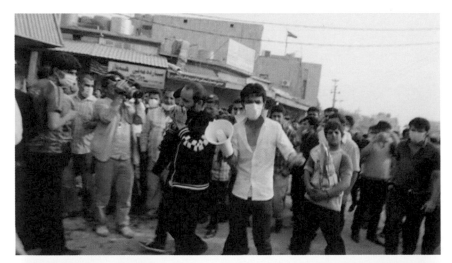

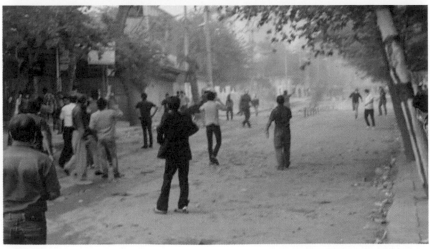

[101] HIWA K – <u>This Lemon Tastes of Apple</u>, 2011.
Video, colour, sound, 12 min. 9 sec.

The title of this work refers in part to the
chemical attack on Halabja, a city in the
Kurdistan region of Iraq, in 1988. Survivors of
the attack, which was carried out under Saddam
Hussein's brutal regime, reported that the gas
smelled of apples. It also refers to the more
recent use of tear gas against protesters in
the Kurdish city of Sulaymaniyah, where those
affected by the gas used lemons to counteract
its effects.

The Israeli artist Yael Bartana has likewise restaged elements of civil conflict, in her case in direct reference to the contentious issue of Israeli settlements in the occupied territories. In the short video *Wild Seeds* (2005) [100], young Israelis – some of whom would later refuse service in the Israel Defense Forces – play a game based on the forced ejection of Jewish settlers from the colony of Gilad in 2002. Although Bartana's work does not adopt a specific position on the subject of Israeli settlements, it does allude to the extent to which Israeli public opinion is sharply divided on this and similar issues. In an interview with the writer and curator Galit Eilat, Bartana observed that 'Israel is under a state of emergency, but it is a social and civic state of emergency. The government's emergency policy causes neglect of social problems and gaps, pushing the public agenda to the margins.'[2] Here, an ongoing and seemingly intractable conflict has apparently been used by successive governments to draw attention away from their failure to improve social conditions and living standards.

Hiwa K's *This Lemon Tastes of Apple* (2011) [101] documents an intriguing scenario based on another form of restaging, if not provoking, conflict. On 17 April 2011, during the final days of civil unrest in Sulaymaniyah, a city in the Kurdistan region of Iraq, Hiwa K produced a film of himself walking through the city's streets. The unrest in the city had gone largely unreported by the international media, and was finally quashed by armed forces under the control of the local government. Hiwa K, playing Ennio Morricone's theme tune from *Once Upon a Time in the West* on the harmonica, picks up on this unrest, and his presence in the city quickly becomes a focal point for protests against unpopular local politicians. As the volume rises, the song transforms into a rallying cry against a regional government that had recently used tear gas on its citizens. The use of such gas was not lost on Hiwa K, whose relatives had survived the 1988 chemical attack on the city of Halabja, also in the Kurdistan region of Iraq, where they had been subjected to the brutal regime of Saddam Hussein. The title of Hiwa K's work is in part a direct reference to this attack, the survivors of which reported that the gas smelled of apples. It also refers to the more recent deployment of tear gas against the protesters in Sulaymaniyah, who used lemons to counteract the effects of the gas.

In response to the war in Iraq, Wafaa Bilal, whose own brother had been killed in a missile strike on a checkpoint in their home town of Kufa in 2004, produced *... and Counting* (2010) [102], a 24-hour performance piece in which the artist's body became a canvas for addressing the invisibility of Iraqi casualties in the United States. Bilal had the names of Iraq's major cities tattooed on his back and, for every casualty, a small dot close to the city in which they had fallen. To draw attention to the different standards of recognition, 5,000 dead American soldiers were represented by red permanent ink, while the 100,000 Iraqi casualties were represented by dots of green UV ink, invisible unless looked at under ultraviolet light.

In common with Hiwa K's work, Siah Armajani's *Fallujah* (2004–5) [103] takes as its starting point one of the many tragic events that mark the history and legacy of the war in Iraq. Fallujah is the Iraqi city that was obliterated by

an American-led offensive in November 2004. Ostensibly targeting insurgents believed to be hiding in residential areas, the offensive had a devastating impact on the city, leaving hundreds of civilians dead and thousands more homeless. In response to this tragedy, Armajani built an impenetrable, two-storey sculpture that suggests a house damaged by war. Taking inspiration from Picasso's anti-war painting *Guernica* (1937), Armajani included in his sculpture a series of objects that directly reference the Spanish artist's work: groups of flames towards the top of the structure, a rocking horse, a dangling light bulb and some upturned furniture.

Picasso returns in Goshka Macuga's *The Nature of the Beast* (2009–10) [104], in which the image of *Guernica* is pivotal to a tableau recalling the events leading up to the invasion of Iraq in 2003. *The Nature of the Beast* addresses two historical moments, one belonging to the history of the Whitechapel Gallery in London, the other a key event in the United Nations Security Council's deliberations over whether or not to sanction an invasion of Iraq. The Whitechapel Gallery had exhibited *Guernica* in 1939 in support of an anti-fascist rally that was taking place in London's East End. Decades later, on 5 February 2003, the tapestry copy of the painting that had been on display at the United Nations since 1985 was hidden from view during the then US Secretary of State Colin Powell's speech about Iraq's weapons of mass destruction.[3] For the duration of this now infamous speech, a blue curtain was used to cover the tapestry, which had originally been displayed as a deterrent to war, rather than an apologia for further conflict.

Inspired by these two events, Macuga created a room in which members of the public could hold meetings, discussions and debates free of charge. Most strikingly, behind the central table of her installation hung the *Guernica* tapestry, which had been removed from the United Nations in March 2009 and rehoused in the Whitechapel Gallery. In Macuga's work, the tapestry served as a backdrop to both collective and artistic efforts to prevent future conflict through active engagement with the politics of decision-making and the potential inherent in collective political action.

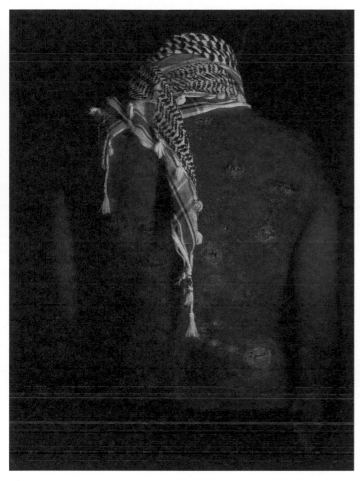

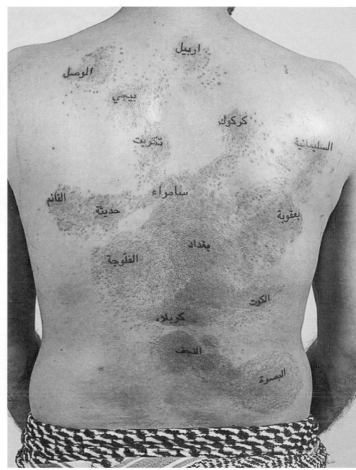

[102] WAFAA BILAL – ... and Counting, 2010. Performance

[103] SIAH ARMAJANI – Fallujah, 2004–5.
Glass, laminated maple, mattress, plywood,
mirror, coat, hat and cane, 5 × 3.3 × 3.8 m
(16½ × 11 × 12½ ft)

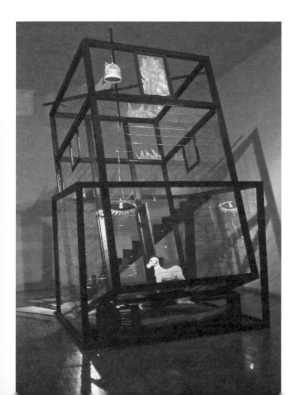

[104] GOSHKA MACUGA – The Nature of the Beast,
5 April 2009–4 April 2010. Installation

TERROR

Terrorism, Torture and the Spectacle of Images

WHETHER OR NOT
WE CONTINUE TO
ENFORCE A UNIVERSAL
CONCEPTION OF
HUMAN RIGHTS
AT MOMENTS OF
~~OUTRAGE~~ AND
~~INCOMPREHENSION~~,
PRECISELY WHEN
WE THINK THAT
OTHERS HAVE TAKEN
THEMSELVES OUT OF
THE ~~HUMAN~~ COMMUNITY
AS WE KNOW IT, IS
A TEST OF OUR
VERY ~~HUMANITY~~.
-
JUDITH BUTLER

THE ATTACKS ON THE WORLD TRADE CENTER AND THE PENTAGON ON 11 SEPTEMBER 2001 HAVE RESULTED IN A PROFOUNDLY POLITICIZED DISCUSSION ABOUT TERROR AND TERRORISM.

These events and their aftermath have come to define the early part of the twenty-first century. Their impact has been global, from the United States, Britain and mainland Europe to Iraq, Afghanistan and the neighbouring regions of central Asia and the Middle East. These same events have also ushered in a nominal state of emergency across North America and Europe, a state of affairs that continues to define the political landscape for many.[1] For some commentators, terrorism is the single biggest challenge facing democratically elected governments worldwide. For others, however, it is the political reaction to terrorism – the suspension of due legal process and the constitutional rule of law, the institutionalization of torture, the withdrawal of civil rights, the use of mass surveillance and the routine collection of information on innocent citizens, arbitrary detention without trial – that has done more to weaken democracy than any terrorist or act of terror. The continued existence of the US military prison at Guantánamo Bay, with its difficult-to-determine status and the far-from-resolved fates of its inmates, further confirms that

legal process is relative and, in times of apparent, self-proclaimed emergency, its systems of checks and balances can be suspended to suit political ends.

The politics of language also continue to complicate any straightforward access to the truth regarding terror, terrorism and torture, three terms that have become causally linked. Read through the prism of an ill-defined 'war on terror', kidnapping has become 'extraordinary rendition', assassination has mutated into 'targeted killing', subjects and one-time citizens have become 'ghost detainees' and 'enemy combatants', and torture is now tolerated as an 'enhanced interrogation technique'. The anxiety surrounding language is likewise mirrored in the concerns raised about the production, consumption and censorship of images. In the days following 9/11, news-media outlets worldwide repeatedly showed images of the hijacked planes crashing into the Twin Towers, so much so that there were calls to limit the use of these images. For a time, news outlets also showed footage of a man falling to his death from one of the towers. Such broadcasts were subsequently censored in the United States, but not elsewhere.

These concerns over the use of images of terror and terrorism reveal a deeper worry: that global media outlets, operating under the demands of a 24-hour news cycle, are effectively complicit in representing such events as spectacle and, in so doing, changing how we perceive the political aspect of terror and the aftermath of terrorism. The realities of terror, when transmitted in the form of images, can be produced, repeated and altered, and this induces an innate anxiety about the proliferation of such images. It is this anxiety that is

[105] GERHARD RICHTER – September, 2005.
Oil on canvas, 52 × 72 cm (20¼ × 28¾ in.)

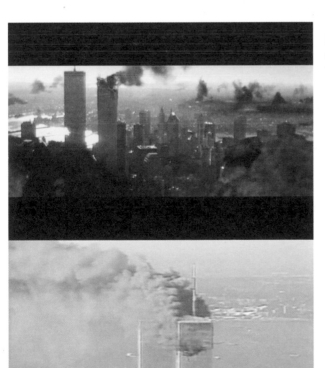

[106] MICHAŁ KOSAKOWSKI – Image Collage
No. VI: Armageddon (1998) VS. MSNBC (Sept.
11, 2001), 2008. From the film Just Like
the Movies. Video, colour, sound, 21 min.

In Just Like the Movies, Kosakowski
explores our familiarity with images of
disaster by 'recreating' the events of
9/11 using footage taken from a range of
pre-2001 Hollywood films. A series of
accompanying collages, consisting of
stills from the sampled films and images
of news footage of the attacks, shows the
uncanny resemblance between the fictional
and the real.

addressed in Hans-Peter Feldmann's *9/12 Front Page* (2001) [107], a work in which the artist exhibited the published front pages of more than a hundred newspapers as they appeared on 12 September 2001. The serial nature of Feldmann's work, the interplay between repetition, public memory and the mediation of images, further reveals concerns about the over-production and consumption of media-based representations of terror.[2]

In its use of these front pages, all of which featured near-identical photographs, *9/12 Front Page* also speaks to the sense of simultaneity and instantaneousness – brought about by advances in technology – that defines the production of news. Feldmann's work also highlights the extent to which terror and images of terrorism have both a commodity value within news media and a symbolic value within political discourse. It would be worth enquiring, as a significant number of artists have since done, into the role that the constantly repeated images of 9/11 played in galvanizing support for the wars in Afghanistan and Iraq.

On 11 September 2001 Gerhard Richter and his wife were travelling to New York when, at 8.45 a.m., their flight was diverted by the Federal Aviation Authority. A hijacked aeroplane had just crashed into the World Trade Center. Richter later painted *September* (2005) [105], but refused to exhibit the work for some time, and even threatened to destroy it. For an artist who had confronted some of the most traumatic events in German history, including the Second World War and – in his seminal cycle of paintings from 1988, *18 Oktober, 1977* – the arrests and deaths of the Red Army Faction (originally known as the Baader-Meinhof gang), 9/11 perhaps

represented an all-too-personal reminder of the iconic status that certain images can assume over time. It may also have reminded him of the demand placed on art to explore ways of avoiding the voyeurism often implied in such images.

September's source material – which can be viewed in *Atlas*, a collection of photographs, newspaper cuttings and sketches that Richter has been assembling since the mid-1960s – consists of four images, one of which is obviously taken from a newspaper, perhaps even one of the newspapers used by Feldmann in *9/12 Front Page*. However, in contrast to Feldmann, who displayed the images as they were published, without any intervention other than framing, Richter abstracts his work by blurring its surface with a squeegee. The colours, already subdued, become muted, while the original reference points – burning towers about to collapse – become almost unrecognizable. The relatively small size of Richter's work, together with the near abstraction of its reference points, adds to the sense that this apparently unremarkable painting is defying, and therefore questioning, the spectacle of the events on which it is based and its relentless reproduction. History, and the trauma associated with these events, seems to be defying both representation and simplistic interpretation.

In Mounir Fatmi's *Save Manhattan 01* (2003) [108], we have an attempt at visual reconstruction, in this case of the actual towers of the World Trade Center, or at least their shadows. Composed of a stack of books, all of which – with the exception of the two copies of the Koran – were written after the events of 11 September 2001, *Save Manhattan 01* is fully realized only when a light is shone

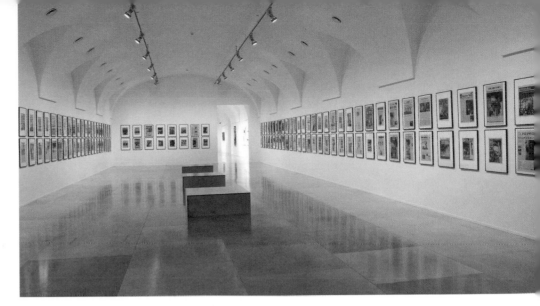

[107] HANS-PETER FELDMANN – 9/12 Front Page, 2001. Installation

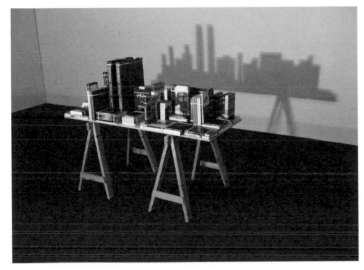

[108] MOUNIR FATMI – Save Manhattan 01, 2003.
Books, lighting, drop shadow, dimensions variable.
Installation at Stenerson Museum, Oslo, 2005

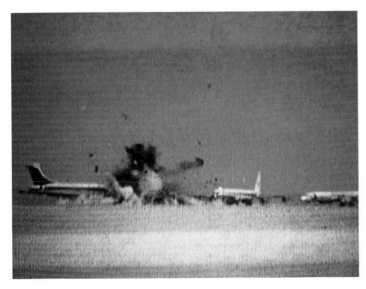

[109] JOHAN GRIMONPREZ – dial H-I-S-T-O-R-Y, 1997. DVD, 68 min. loop, disk for unlimited printing,
technical manual, license, in-flight magazine with printed folder, dimensions variable

directly on to it. It is then that we can see that it is not so much the books that are of interest as the shadows they cast – shadows that clearly form the outline of the Manhattan skyline pre-9/11, with the World Trade Center (formed by the copies of the Koran) intact and still in its original place. Fatmi's work, in its attempt to restore Manhattan to its pre-9/11 state, would appear to offer a palliative to the trauma associated with the collapse of the city's iconic Twin Towers.

In Michal Kosakowski's film *Just Like the Movies* (2006) [106], the politics of representing the events of 9/11 are considered alongside the tendency in mainstream Hollywood films to sensationalize terror and their effect on our perception of reality. Kosakowski's film, a 'recreation' of the attacks on the World Trade Center, consists of footage taken from a selection of Hollywood blockbusters. However, despite the uncanny contemporaneity of the chosen films, they were all produced and released before the events of 11 September 2001. Accompanying the film is a series of collages that juxtapose images culled from news reports of the attacks with stills from the sampled movies. In one, a shot of a burning World Trade Center sourced from the US news channel MSNBC is contrasted with a similar image from the movie *Armageddon* (1998).

Just Like the Movies not only reveals the extent to which the World Trade Center had appeared in disaster movies in the years preceding 2001, but also registers with such commentators as Slavoj Zizek, who has argued that the events of 9/11 had already been inscribed in film and effectively revealed an innate, if repressed, desire for the ultimate viewing experience.[3] Zizek's comments may seem extreme, but it remains the case that it has become increasingly difficult to distinguish between images of the fictional and of the real. In the case of images of war and conflict, we could argue that this is as much a question of politics as it is of aesthetics; that is, it could be said that the fictional has been used to 'prepare' an audience for the real event of terror. Indeed, in October and November 2001, representatives from the White House approached executives in Hollywood with the aim of coordinating how film studios might get across to viewers a favourable message concerning the 'war on terror'.

There is, nevertheless, an obvious need to determine what is indeed fact and what is fiction in relation to acts of terror. The phenomenon of terror as spectacle and its subsequent fictionalization, if not valorization, are explored in *dial H-I-S-T-O-R-Y* (1997) [109], a film by Johan Grimonprez that examines the history of Cold War-era hijackings since 1969. Using archive and found footage, home videos, and interviews with the Palestinian hijacker Rima Tannous Eissa and the Japanese Red Army (JRA), recorded in 1969 and 1970 respectively, Grimonprez's film proposes a startling yet convincing thesis: that the rise in the number of hijackings, or 'sky-jackings' as Grimonprez refers to them, at this time was intimately associated with the realization that the event would be televised and attract a significant amount of global media attention. The one way to be sure to get your message across was to hijack a plane, confident in the knowledge that the world's media would thereafter relay what you had to say. The fatalistic logic of this thesis is all the more perturbing for its simplicity.

In *United Red Army (The Young Man Was, Part 1)* (2012) [112], Naeem Mohaiemen explores the events surrounding the 1977 hijacking by the JRA of Japanese Airlines Flight 472 to Dhaka, Bangladesh. Based largely on recorded conversations between the lead hijacker and the negotiator in the Dhaka control tower, Mohaiemen's film largely takes place in the dark. We see footage of the release of hostages (in particular, that of a Hollywood actress on her truncated honeymoon), an interrupted episode of *The Zoo Gang* (a children's animated television series the artist remembers watching at the time) and the Japanese government announcing their compliance with the hijacker's ransom demands of $6 million and the release of nine JRA prisoners. As we listen to the painstaking negotiations unfold, it becomes clear that this work is concerned less with the hijacking itself than it is with understanding the impact this event had on Bangladesh, a country then grappling with its own internal problems.

Following the events of 9/11, information and its retrieval has become a governmental priority that, somewhat paradoxically, has led to less material being made available to the public. In 2004, with the help of the American Civil Liberties Union and the National Security Archive, Jenny Holzer began examining declassified government and military documents made available under the US Freedom of Information Act. The result of this work was *Redaction Paintings*, a series of painted versions of these often heavily censored documents, some of which include evidence of prisoner abuse in American detention camps.

Holzer's paintings were created in response to the war in Iraq and how the 'war on terror' has effectively produced an information-less zone in relation to events and issues considered 'sensitive' or detrimental to the public interest and national security. In one of these paintings, *Homicide* (2007) [113], a disturbing prisoner autopsy report – registered by doctors from the Armed Forces Institute of Pathology – is rendered in full. The doctors' clinical descriptions of what can only be described as human brutality point to the underground practice of torture and the increasing information gap between the people and the state in the wake of 9/11.

In a similar vein, Trevor Paglen's *Seventeen Letters from the Deep State* (2011) [110] consists of photocopies of a series of letters from the US State Department. Each letter is signed by someone called Terry A. Hogan, who is seemingly authorizing acts of 'extraordinary rendition', the apprehension and transfer from one country to another of anyone deemed an 'enemy combatant' or a danger to national security. Seen together, the signatures on these documents are notably different from one another, and evidence subsequently unearthed by both journalists and lawyers indicates that Hogan never existed.

Seventeen Letters from the Deep State is related to another project by Paglen, *Limit Telephotography*, an ongoing series consisting of photographs taken by the artist using optics designed for astronomy and astrophotography. The subjects of these images are zones that, for reasons of both secrecy and security, remain largely invisible to the unaided eye. In *Unmarked 737 at 'Gold Coast' Terminal, Las Vegas, Nevada; Distance ~*

[110] **TREVOR PAGLEN** – Seventeen Letters from the Deep State, 2011. Pigment print, 2.6 × 3.2 m (8½ × 10½ ft)

[111] **TREVOR PAGLEN** – Unmarked 737 at 'Gold Coast' Terminal, Las Vegas, Nevada; Distance ~ 1 mile, 10:44pm, 2007. C-print, 76.2 × 91.4 cm (30 × 36 in.)

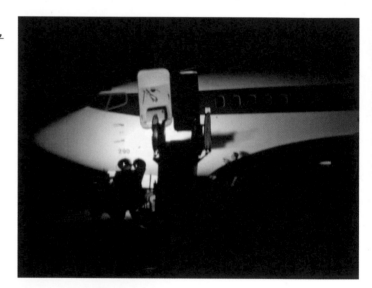

[112] **NAEEM MOHAIEMEN** – United Red Army (The Young Man Was, Part 1), 2012. Video, colour/black and white, sound, 70 min.

[113] JENNY HOLZER –
Homicide, 2007.
Text: US government
documents, oil on
linen, 12 elements,
335.3 × 194.3 cm
(132 × 76½ in.)

1 mile, 10:44pm (2007) [111], we are given exact details of the location and time that the photograph was taken, but less information about what is actually going on in the image. This photograph, captured from a mile away, shows the fuselage of a 'Janet' aeroplane, whose flight path, designation and cargo remain unknown and subject to classification by the American government. 'Janet' is an acronym of 'Just Another Non-Existent Terminal', and it is rumoured that some of these flights are used for so-called special rendition, a practice whereby suspected terrorists are transported to countries where torture is condoned. Here, a sense of deviation, in terms of suspended due legal process and lawful representation, once again appears to be the rule rather than the aberration in relation to the politics of modern-day terrorism.

In their approach to terror and the politics that surround it, a number of artists have chosen to investigate its physical and psychological aspects, including torture and the experience of terror. Consisting of a series of corridors with cells attached to them, Gregor Schneider's *White Torture* (2005–7) [114] is concerned with a form of psychological torture involving sensory deprivation and isolation. The installation was inspired in part by images downloaded from the Internet of Camp 5 at Guantánamo Bay. One door leads into a cell with a green steel cage in it, another into a pitch-black corridor, and yet another into a white corridor; all the while, a soundtrack of cell doors being opened and closed plays in the background. Schneider's installation is extremely disorientating, as might be expected from a work that was designed to explore torture techniques used to confuse individuals and render them more susceptible to interrogation.

In Wafaa Bilal's *Dog or Iraqi* (2008) [115], visitors to a website were invited to vote on whether the artist or a dog named Buddy should be subjected to waterboarding, a form of torture in which water is poured over a cloth covering the face of the restrained individual, causing them to experience the sensation of drowning. Apart from death, brain damage, lung failure, extreme pain, oxygen deprivation and other physical side-effects, waterboarding can inflict long-term psychological damage. In accordance with the result of the vote, it was Bilal who was waterboarded, at an undisclosed location in upstate New York. In the short clip that documents the event, the artist is shown panicking and retching after only a few moments, leaving us to imagine what repeated and lengthy subjection to such torture could do to a person.

Krzysztof Wodiczko's *... OUT OF HERE: The Veterans Project* (2009) [116] is set in a dark and foreboding space that may or may not represent the inside of a warehouse or military base. Images of dirty and partly broken windows are projected high on the walls, and seem to emphasize the interiority of the space rather than what lies beyond it. Voices can be heard, including that of President Barack Obama, as well as the sound of Iraqi – possibly Baghdad-based – women and children playing and laughing. Then, following the sound of a ball smashing through a window pane, we hear an approaching helicopter. 'Get the kids out of here!' a voice calls amid gunfire and confusion. 'The kid's hit!' shouts another – to which the chilling response is, 'Leave the kid.'

[114] GREGOR SCHNEIDER –
White Torture, 2005-7.
Passageway No. 1, 1,500 ×
200 × 230 cm (590⅜ × 78¾ ×
90½ in.), at K20 K21
Kunstsammlung Nordrhein-
Westfalen, Düsseldorf,
17 March – 15 July 2007

The prison cells in this
installation were inspired
by downloaded images of Camp
5 at Guantánamo Bay, Cuba.
Surrounded by a series of
doors and corridors, viewers
were able to experience the
disorientation associated
with incarceration and torture.

[115] WAFAA BILAL – Dog or Iraqi, 2008.
Performance

As an Iraqi-born artist living in relative
security in the United States, Bilal often
devises scenarios that question his own
'comfort zones' in relation to the conflict
zones he has left behind. In this work, he
invited viewers to vote on whether he, an
Iraqi citizen, or a dog should be subjected
to the form of torture known as waterboarding.

[116] KRZYSZTOF WODICZKO – ... OUT
OF HERE: The Veterans Project, 2009.
7-channel video, colour, sound, 8 min.
19 sec. loop, dimensions variable.
Installation view at ICA Boston, 2009

Examining the trauma of war and the
legacy of violence, and made in
collaboration with several veterans
of the Iraq War, ... OUT OF HERE exposes
the viewer to the sheer terror of
conflict through its aural components,
including the sound of gunfire and
US patrol vehicles.

[117] LUIS CAMNITZER – The Waiting Room, 1999. Installation

This sparse installation explores the world of the political prisoner in terms of actual confinement and the potential to become a victim of torture and state-sponsored murder. In a wider sense, however, the work refers to more overt forms of social and cultural disillusionment.

[118] JOSH AZZARELLA – Untitled #13 (AHSF), 2008. Archival digital C-print, 50.8 × 76.2 cm (20 × 30 in). Edition of 7 (+ 3 AP)

[119] ARAHMAIANI – 11 June 2002, 2003. Installation

In June 2002, while en route to Canada, the Indonesian
artist Arahmaiani was arrested by immigration officers at
Los Angeles airport and questioned for four hours. This work
refers to the period after her eventual release, when she
was confined to a hotel and placed under surveillance.

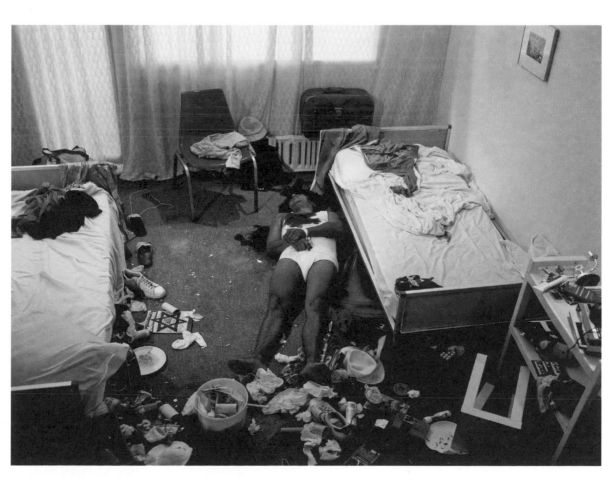

[120] CHRISTOPH DRAEGER – Black September, 2002.
Installation

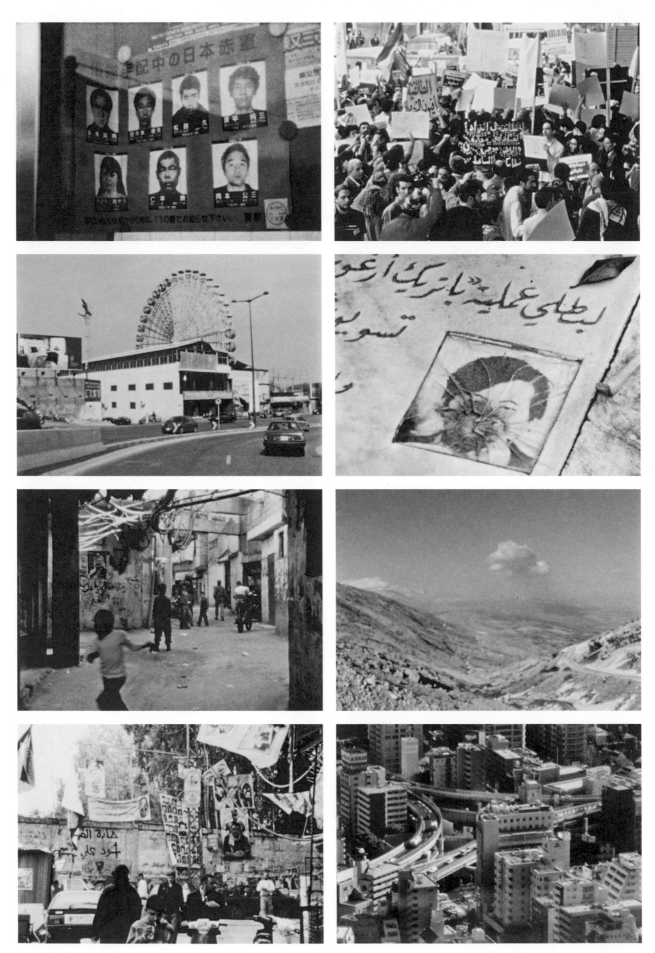

[121] ERIC BAUDELAIRE – *The Anabasis of May and Fusako Shigenobu, Masao Adachi and 27 Years Without Images*, 2011. Super 8 and HD video, colour, sound, 66 min.

Wodiczko's immersive work attempts to position the viewer at the heart of terror and death. It invites us to consider the realities of imminent danger and leaves the rest to our imagination. Again, this is not so much an anti-war gesture as a concerted effort to get beyond the mere spectacle of terror. In Luis Camnitzer's *The Waiting Room* (1999) [117], a similarly immersive environment encourages the viewer to imagine the story behind the objects contained therein. The 'waiting room' in question, as installed at the Liverpool Biennial in 1999, appears to be a basement in a building, with naked lights hanging starkly from the ceiling. Various objects litter the floor, some of which could be used to inflict pain. The distinction between perpetrator and victim becomes blurred as we step into a space that mimics a torture chamber or holding cell and yet contains no victim as such other than the viewer, who could easily double, in their imagination at least, as a perpetrator.

In *Untitled #13 (AHSF)* (2006) [118], a work by Josh Azzarella, we are confronted with an image that is both readily familiar and yet, through the absence of a crucial element, disconcertingly unfamiliar. It resembles a photograph, taken in the notorious Abu Ghraib prison during the war in Iraq, of a hooded detainee being forced to stand on a small wooden box, his arms extended and electrodes attached to his fingers.[4] In Azzarella's work, however, where the prisoner once stood is now an empty space, with only the wooden box and a disinterested soldier nearby to remind us of what is not there. The absence of the unfortunate figure on the box induces us to re-imagine his presence as it was, and

which we have grown accustomed to. It is this sense of becoming desensitized to such images of terror and violence that both Azzarella and Wodiczko appear to be questioning and re-negotiating as a space in which to re-inscribe the import of terror.

For *11 June 2002* (2003) [119], the Indonesian artist Arahmaiani created a small, cell-like room in which she carefully arranged, among other things, a hotel bed, a copy of the Koran, some underwear and a selection of photographs. The installation relates to the time when the artist, en route to Canada and awaiting a flight at Los Angeles airport, was arrested by immigration officers because she did not have a visa for the stopover. Arahmaiani was questioned for four hours and threatened with detention in a cell. She was finally allowed to stay in the hotel room that she had reserved earlier, but under close surveillance. As in the case of Steve Kurtz and the Critical Art Ensemble (see page 21), artists are far from immune to the terror legislation that was hastily passed in the US Congress and signed into law by President George W. Bush on 26 October 2001.

The events and repercussions of 11 September 2001 tend to obscure the fact that terrorism has a long history. In *Black September* (2002) [120] Christoph Draeger reconstructed the so-called Munich massacre, in which eleven Israeli athletes, nine of whom had initially been taken hostage, were killed by Palestinian terrorists during the 1972 Olympics. Widely covered by the media, this act of terrorism was the first to be transmitted live on television to a worldwide audience. For his reconstruction, Draeger recreated the Israeli athletes' hotel room

and employed actors to re-enact probable scenarios based on witness accounts and media coverage of the event. Draeger also utilized archive footage of news reports and updates, as though they were live transmissions being viewed by the hostages and their captors. Fact and fiction are not so much confused in Draeger's work as they are rendered relative to and contingent on media reports.

Directed by Eric Baudelaire, *The Anabasis of May and Fusako Shigenobu, Masao Adachi and 27 Years Without Images* (2011) [121] is a feature-length experimental documentary that retraces the history of the Japanese Red Army. Based on the recollections of three of its members – JRA leader Fusako Shigenobu, her daughter, May, and the radical avant-garde film-maker Masao Adachi – the film relates how, having been founded in Beirut in the early 1970s, the JRA operated alongside Palestinian terrorist groups for almost thirty years before being sent back to Japan. The work is shot on Super 8 and relies almost entirely on the voices of its protagonists; the camera, meanwhile, is focused on their surroundings in Beirut and Japan.

Robert Kusmirowski's *Unacabine* (2008) [123] is a reconstruction of the cabin in which Theodore Kaczynski, otherwise known as the Unabomber, lived from 1971 until his arrest in 1996. Kaczynski, labelled a domestic terrorist by the FBI, was responsible for the deaths of three people and the maiming of twenty-three others in a terror campaign that lasted from 1978 until 1995. He is also the author of *Industrial Society and Its Future*, the so-called Unabomber Manifesto, in which he castigates industrial society for its detrimental impact on the environment. Kusmirowski's reconstruction of Kaczynski's cabin serves as a comment on both the bucolic ideal of nature in the American psyche and the anxiety-inducing spectre of terror that seems to pervade contemporary politics.

How terrorism and terror are mediated and, in time, forgotten is the subject of Anastasia Khoroshilova's *Starie Novostie (Old News)* (2011) [122]. By means of a mixed-media installation, the artist revisits the events surrounding the Beslan school hostage crisis of September 2004, in which a school in Beslan in North Ossetia (part of the Russian Federation) was seized by a group of armed Islamic separatists, mostly from Ingushetia and Chechnya. The terror induced by the siege, which led to the deaths of more than 380 people, including 186 children, was further compounded by what many considered to be the Russian government's mishandling of the situation and the campaign of misinformation and censorship that followed. Khoroshilova's installation revisits the people affected by these events, many of whom lost children in the siege, and asks what happens to their story – and the aftermath of terror – when an insatiable and largely indifferent media has moved on.

[122] ANASTASIA KHOROSHILOVA – Starie Novostie (Old News), 2011. Mixed-media installation. Installation view at Biblioteca Zenobiana del Temanza, 54th Venice Biennale

In September 2004 an armed group of Islamic separatists from Ingushetia and Chechnya stormed a school in Beslan in North Ossetia, part of the Russian Federation. The resulting siege and rescue attempt led to the deaths of more than 380 people, including 186 children. Here, Khoroshilova revisits these events and the people whose lives they touched.

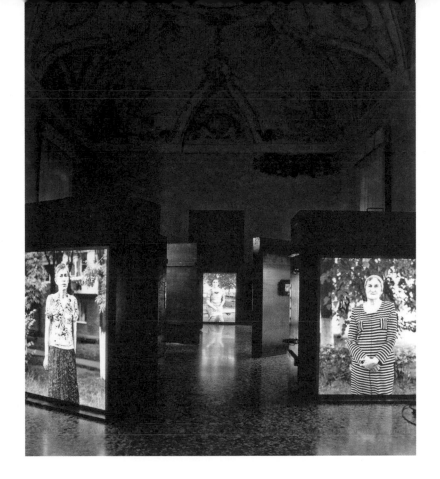

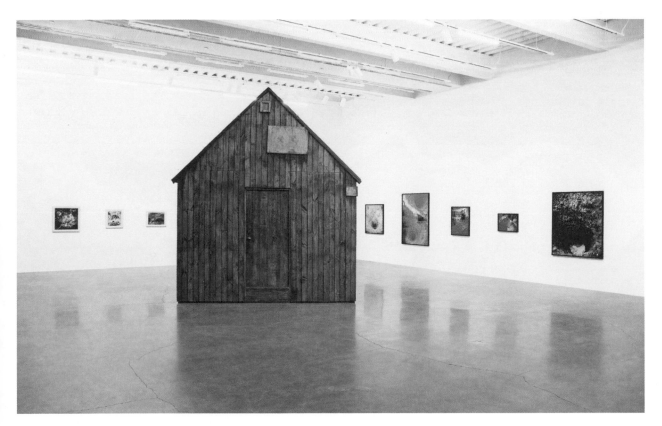

[123] ROBERT KUSMIROWSKI – Unacabine, 2008. Gallery view of After Nature, New Museum, New York, 2008

HISTORY

The Future of Re-visiting the Past

~~REMEMBRANCE~~
RESTORES
~~POSSIBILITY~~ TO
THE PAST, MAKING
WHAT HAPPENED
~~INCOMPLETE~~ AND
COMPLETING WHAT
NEVER WAS.
–
GIORGIO AGAMBEN

FOR MANY IN SOUTH AMERICA, PARTICULARLY CHILE, '11 SEPTEMBER' REFERS NOT TO THE EVENTS OF 2001, BUT TO 11 SEPTEMBER 1973, THE DAY ON WHICH SALVADOR ALLENDE, CHILE'S DEMOCRATICALLY ELECTED PRESIDENT, DIED IN A *coup d'état*.

Allende's death prefaced seventeen years of military rule under General Augusto Pinochet, a period that saw widespread repression, murder, 'disappearances', human-rights violations and torture, including of children, become the norm. Indeed, the history of South America at this time can be read as a litany of state-sponsored terror. The so-called Dirty War in Argentina, which ran from 1976 until 1983, resulted in the death or disappearance of an estimated 30,000 people. From the early 1970s until 1996, Guatemala endured numerous massacres and the large-scale displacement of its indigenous people. In 1968 a state of emergency was declared in Uruguay, followed by the suspension of civil liberties in 1972. And in Colombia, during the genocide of members of the Patriotic Union party between 1984 and 1994, some 3,000 to 5,000 people were killed and thousands more tortured and 'disappeared'.

These events, all unique and historically specific, nevertheless have something in common: the deaths, violence, disappearances and torture have left a legacy of trauma that continues to have widespread political implications for the countries affected. In this context, art, and culture in general, has contributed to a process of negotiating the past and coming to terms with it in a way that politics – in the interests of those implicated in human-rights abuses, for example – is often less inclined to do. This is not, however, about proposing a cathartic function for art, whereby, as is often the case, it is expected to ameliorate past injustices through representational forms. Rather, the artists examined in this chapter contest the elisions and erasures of a politically determined version of history and, in doing so, reveal how current political concerns not only prescribe how we understand the past but also attempt to dictate future responses to historical events.

In Mel Chin's film *9-11/9-11, Chile/U.S.A.* (2007) [124], an animated tale of two separate events in two different cities, the reference to Chile's '9/11' is made explicit. Both events – the untimely death of Salvador Allende in Santiago in 1973 and the deaths of almost 3,000 people twenty-eight years later in the United States – speak to history as a source of recurring trauma. But, importantly, these events are viewed through the stories of the individuals caught up in them. This use of individualized, personal narratives, to counter the hegemonic, broad sweep of historical documentation, is key to understanding how history unfolds in many of the artworks included in this chapter.

This personalization of traumatic events is a feature of Iván Navarro's installation *Where Are They?* (2007) [125], which was exhibited at the Centro

[124] MEL CHIN – 9-11/9-11, Chile/U.S.A., 2007.
Hand-drawn animated film written and directed by Mel Chin, 24 min.

[125] IVÁN NAVARRO – Where Are They?, 2007. Fluorescent light, wood, mirror,
one-way mirror and electricity, printed vinyl, floor covering, scaffold,
flashlights. Centro Cultural Matucana 100, Santiago, Chile

[126] MARCELO BRODSKY – Buena Memoria: The Classmates, 1996.
Altered colour gigantograph print, 116.8 × 175.3 cm (46 × 69 in.)

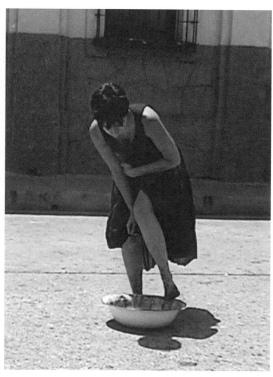

[127] REGINA JOSÉ GALINDO – Who Can Erase the Footprints?, 2003. Performance. Guatemala City, Guatemala

In an act of protest against a former Guatemalan dictator, Galindo walked between two of the country's most politically symbolic buildings. With every few paces she dipped her feet into a bowl of human blood, leaving behind her an incriminatory trail of footprints.

Cultural Matucana 100 in Santiago. After receiving a booklet and a torch, visitors were invited to explore, detective-like, the full extent of the installation. The booklet contained the names of more than 300 civilian and military collaborators of Augusto Pinochet, together with details of the human-rights violations attributed to each of them. A walkway took visitors over the floor below, an area of 800 square metres (8,600 square feet) on which the names of the collaborators had been written. Visitors were encouraged to seek out some of the names listed in the booklet, including that of Augusto Pinochet, who died, untried before any court, in 2006.

Returning to his homeland of Argentina in the mid-1990s, equipped with his camera and a photograph of his eighth-grade school class taken in 1967, Marcelo Brodsky set about tracking down the other people in the photograph. In *Buena Memoria: The Classmates* (1996) [126], Brodsky enlarged the photograph and annotated it, noting where his classmates had ended up. While some had married and become parents, and others had gone into exile, two members of the class had been disappeared during Argentina's Dirty War – as had Brodsky's own brother, Fernando Rubén Brodsky – and were presumed dead.

In this act of tapping into a collective memory, Brodsky brings to the fore the moment when that which no longer exists as anything but trauma can nonetheless be reified in visual culture and understood, in part at least, through forms of visual representation. Moreover, in embodying this absence, Brodsky contests any officially sanctioned version of the events surrounding the disappearances, expressing a

shared will to remember that is indelibly political in its call for people to organize themselves collectively in a search for the truth.

In *Who Can Erase the Footprints?* (2003) [127], Regina José Galindo had herself filmed walking from Guatemala City's Constitutional Court to the steps of the National Palace. With every few paces she dipped her feet into a bowl of human blood as an act of protest against the recently launched presidential candidacy of Efrain Rios Montt, the ruler of Guatemala between 1982 and 1983. Under his leadership, thousands of Guatemalans were persecuted, killed or went missing in a military-led regime. By the time of Rios Montt's second (and ultimately unsuccessful) bid for office in 2003, the memory of these events, for different reasons, appeared to have been erased from the nation's memory.[1] Galindo's performance, in its confrontational style, refused to submit to such amnesia. In the video, we see a row of confused security guards unsure of how to respond to the artist's slow and deliberate movements as she makes her way across the steps of the Constitutional Court, symbolically staining the city of Guatemala in her wake.

Art's ability to resolve certain issues, and in particular debates around disappearances and victims of violence, is not only questionable but also raises a simple question: do artists set out to right historical injustices? It is arguable that the works here do nothing more than suggest ways in which individuals and communities may use their own political values and readings of history to address such issues. Drawing on the troubled history of Colombia, Oscar Muñoz's video *Project for a Memorial* (2005) [128]

shows the artist's hand painting portraits of disappeared people on a stretch of pavement. Instead of paint, however, he is using water, which evaporates in the heat before each portrait is fully realized. Aesthetically, Muñoz's water paintings become a metaphor for the disappeared of his native country and the difficulties involved in keeping their memory alive and politically meaningful.

The political will to remember is evident in Sue Williamson's *Tony Yengeni – 'wet bag' torture – Jeff Benzien* (1998) [129]. Part of the artist's *Truth Games* series, the work features three photographs, one of which is of Captain Jeffrey Benzien, a security policeman who admitted to assaulting eight men and causing the death of another before South Africa's Truth and Reconciliation Committee, a tribunal set up to bring together the perpetrators and victims of abuse under apartheid. A second photograph, taken during the tribunal, shows Benzien re-enacting his favoured form of torture, which he used on such anti-apartheid activists as Tony Yengeni, the subject of the third photograph. Williamson's work has an interactive component: Perspex rectangles containing the phrases 'like an animal', 'what kind of human being' and 'I got the job done', among others, can be moved across the work to either reveal or conceal parts of the photographs. Here, history is presented as performative, subject to slippages of meaning, not to mention a form of politics based on the abuse of power.

Yael Bartana's work often foregrounds the context and symbols of traumatic historical events in an attempt to provide a greater understanding of such events. In the summer of 2009 she oversaw the assembly of a kibbutz in Muranów, an area of Warsaw that was once part of the city's infamous ghetto. The construction of the kibbutz was documented in *Wall and Tower* (2009) [130], the second film in Bartana's 'Polish' trilogy. Together with the other two films in the trilogy, *Mary Koszmary (Nightmares)* (2007) and *Kamach (Assassination)* (2011), *Wall and Tower* was shown in the Polish pavilion at the 54th Venice Biennale in 2011, the first time that a non-Pole had been invited to represent the country. Referencing the Homa u-Migdal, or 'wall and tower', method of construction used by early Jewish settlers in British-administered Palestine, the film makes for discomfiting viewing, concerning as it does a site associated with deportation and death rather than nation-building, and, as a result, making an explicit connection between these two moments from history.

The historical context of the Israeli–Palestinian conflict preoccupies Emily Jacir's *Material for a Film* (2004–7) [131], a complex, multilayered work that examines, through a detailed reconstruction of his life, the figure of the Palestinian intellectual Wael Zuaiter. Assassinated in 1972 by an Israeli hit squad for his purported involvement in the kidnapping and killing of Israeli athletes at that year's Olympics in Munich, Zuaiter had for many years been engaged in the translation of *One Thousand and One Nights* from classical Arabic into Italian, a project that remains incomplete. By means of extensive research, Jacir has produced an archive of materials – alongside her own photographs – relating to both Zuaiter and his project, including snapshots and letters. These and other such quotidian items also appear in a

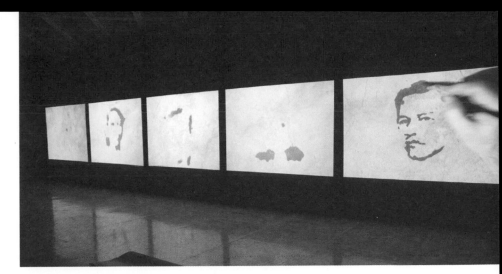

[128] OSCAR MUÑOZ – <u>Project for a Memorial</u>, 2005.
5 videos, colour, silent, 7 min. 30 sec.

[129] SUE WILLIAMSON – <u>Tony Yengeni – 'wet bag' torture – Jeff Benzien</u>,
1998. From the series <u>Truth Games</u>. Laminated colour laser prints, wood,
metal, plastic, Perspex, 80 × 120 × 6 cm (31½ × 47¼ × 2¼ in.)

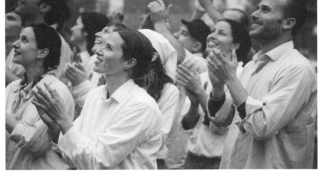

[130] YAEL BARTANA – <u>Wall and Tower</u>, 2009. Shot on RED,
HD video projection, colour, sound, 13 min.

[131] EMILY JACIR – Material for a Film,
2004-7. Multimedia installation, 3 sound
pieces, 1 video, texts, photos, archival
material. The Hugo Boss Prize 2008.
Solomon R. Guggenheim Museum, New York,
6 February – 15 April 2009

[132] ZARINA BHIMJI – Out of Blue, 2002.
Super 16 colour film, DVD transfer,
single-screen installation with sound,
24 min. 25 sec.

[133] SVEN AUGUSTIJNEN –
Spectres, 2011. Film,
colour, sound, 104 min.

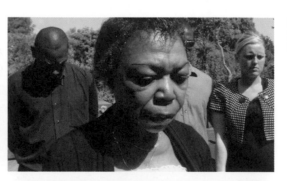

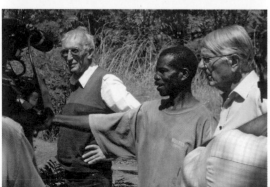

film, in which we encounter different layers of Zuaiter's life, ranging from the personal to the literary (his ongoing translation of *One Thousand and One Nights*, for example) and the events surrounding his untimely death in Rome.

The issue of erasure is key to any exploration of the politics involved in historical narratives and the representation of the past. Art embodies certain moments in time and history, and can therefore give form to the more elusive aspects of the various historical crises brought about by violence. Zarina Bhimji's *Out of Blue* (2002) [132] takes the viewer on a journey through the Ugandan countryside, visiting fields, abandoned streets and buildings, graveyards, military barracks, police cells and, finally, a disused airport. The film's elegiac ruminations on loss and the violence of history register not only the historical moment when the dictator Idi Amin seized control of Uganda in 1971, and the subsequent murder of 300,000 Ugandans, but also the moment when he expelled the entrepreneurial South Asian minority, including Bhimji's parents, from the country.

In Sven Augustijnen's film *Spectres* (2011) [133], the history of such familiar Belgian landmarks as Brussels' Royal Park and Mont des Arts neighbourhood is set in stark contrast to the country's colonial past. In a key scene, the film focuses on an event in the history of what is now the Democratic Republic of the Congo (DRC) that continues to resonate: the death of Patrice Lumumba, the country's first democratically elected prime minister who was executed by secessionist rebels, allegedly with the assistance of the British, American and Belgian governments. Lumumba had opposed the Belgian-backed secession of the mineral-rich Katanga province, the source of Belgium's wealth during its colonial era – much of which went into the building of Brussels – and the cause of untold misery for those involved in the civil wars that have since been fought over the DRC's resources.

Chalk (2000) [134] is one of nine deceptively simple paintings by the Belgian artist Luc Tuymans that together make up the series *Mwana Kitoko: Beautiful White Man*. Based on film footage and photographs of King Baudouin's first visit to the Belgian Congo in 1955, this modest series examines the colonization of what later became known as Zaire and is now the DRC. In *Chalk*, Tuymans makes reference to a story about a colonial police officer who was responsible for making unwanted dead bodies, including that of Patrice Lumumba, 'disappear' using acid. Believing Lumumba would one day become a mythological figure, the policeman extracted two of his teeth before carrying out his grisly task. According to Tuymans, the policeman passed away while he was working on the series, and is believed to have thrown the teeth into the North Sea.

The recovery of histories lost to such tragic events as slavery and genocide is central to Benin-born artist Romuald Hazoumè's *La Bouche du Roi* [135], a project realized between 1997 and 2005. Referring to the estuary of the Mono River, a one-time portal for the extensive slave trade in Benin, *La Bouche du Roi* has a number of interrelated components, including an installation of plastic containers of the sort used to transport oil in modern-day Benin. The artist uses the topmost parts of the containers – which

resemble stylized faces – to create a series of 'masks' symbolizing the slaves who did and did not survive the crossing to the Americas. The arrangement of these masks, some of which are personalized with various items, is based on the plan of a slave ship as described by the anti-slavery campaigner Thomas Clarkson in his influential treatise 'An Essay on the Slavery and Commerce of the Human Species' (1786).[2]

In 1840 J. M. W. Turner painted *The Slave Ship* (*Slavers Throwing Overboard the Dead and Dying – Typhoon Coming On*). The subject of the painting was the slave ship *Zong*, the master of which, on the ship's arrival in Jamaica in late 1781, had dozens of slaves – both dead and alive – thrown into the shark-infested seas. This nefarious practice was regularly employed by slave traders to claim insurance monies for slaves who had become so enfeebled by the journey that they could not be sold. In Kara Walker's *Grub for Sharks: A Concession to the Negro Populace* (2004) [136], Turner's painting is revisited, as is the history surrounding its production. Walker's installation, the central portion of which depicts a swirling mass with a disembowelled figure at its core, imitates a cyclorama, a form of panoramic history painting popular in the nineteenth century. However, despite some resemblances to Turner's painting, *Grub for Sharks* is more to do with Walker's perennial interest: the antebellum American South and the historical narrative of slavery that marks the past and indeed present of such US states as Georgia, where Walker grew up as a teenager.

Amar Kanwar's *oeuvre* is concerned with the history behind the sociopolitical and ecological conditions that affect the Indian subcontinent. Using stories and first-hand accounts, his work adopts an oblique approach to sectarian violence and border conflicts. In the multichannel installation *The Lightning Testimonies* (2007) [137], the voices of those affected address the subject of the sexual violence that has been visited on women in the Indian subcontinent during times of conflict. Kanwar's work is not just about abuses of power and the indignities inflicted on individuals during such times; rather, it also suggests strategies of resistance and transformation to counter the erasure of memory.

Erasure and recovery can have a literal counterpart in artistic engagements with history. To understand Dan Perjovschi's *Erasing Romania* (2003) [138], it is important to acknowledge the context of an earlier work by the same artist. In *Romania* (1993), Perjovschi had the title of the work tattooed on his arm on the occasion of the first national festival of performance in Timisoara (the city in which the anti-Communist revolution in Romania began in 1989). Ten years after having the tattoo applied, a period in which both the political landscape in Eastern Europe and the views of the artist had changed significantly, Perjovschi had it removed. Using laser bombardment – a procedure that, instead of removing the tattoo, disperses the ink through the skin and throughout the body – Perjovschi underwent this 'erasure' during the exhibition *In den Schluchten des Balkan* (In the gorges of the Balkans), which was held at the Fridericianum in Kassel, Germany. The recent history of Romania, according to Perjovschi, is not so much indelibly recorded on his body as dispersed throughout it.

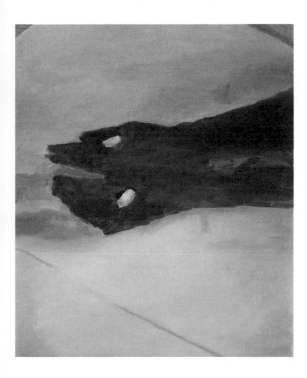

[134] LUC TUYMANS – Chalk, 2000. From the series Mwana Kitoko: Beautiful White Man. Oil on canvas, 72.5 × 61.5 cm (28¾ × 24¾ in.)

Tuymans's near-abstract image refers to one of the more grisly stories surrounding the execution in 1961 of Patrice Lumumba, the Democratic Republic of the Congo's first democratically elected prime minister. It is said that after Lumumba's death, two of his teeth were extracted as a keepsake by the man charged with disposing of his body. These teeth, the former prime minister's last remains, were allegedly later thrown into the sea.

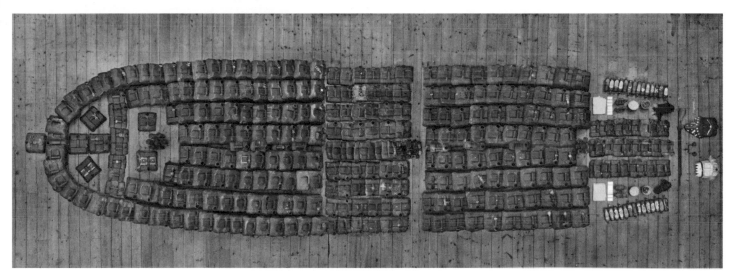

[135] ROMUALD HAZOUMÈ – La Bouche du Roi, 1997–2005. Mixed-media installation, dimensions variable

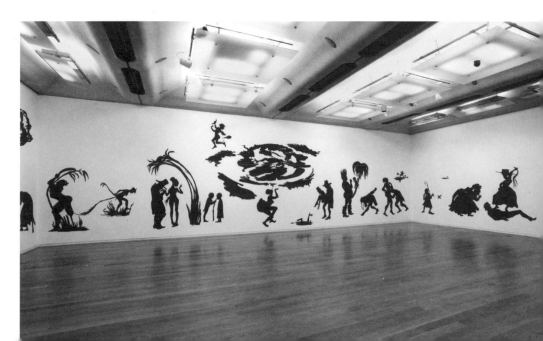

[136] KARA WALKER – Grub for Sharks: A Concession to the Negro Populace, 2004. Installation, cut paper on wall, dimensions variable. Installation view at The First Cut, Manchester Art Gallery, Manchester, 2012

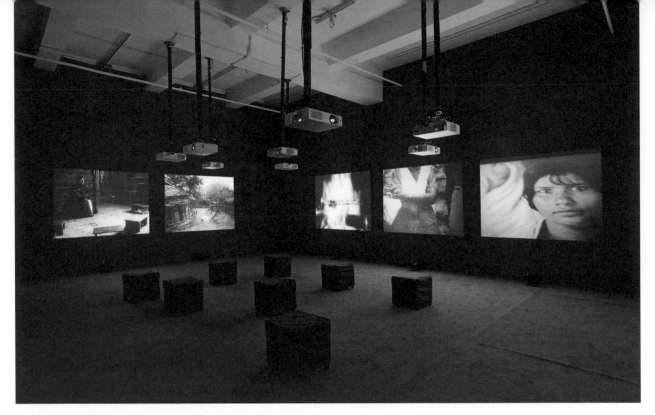

[137] AMAR KANWAR – The Lightning Testimonies, 2007.
8-channel digital video, colour/black and white, sound, 32 min. 31 sec.

The Lightning Testimonies is a multi-channel video installation that
explores the history of the Indian subcontinent through the testimony
of those affected by sexual violence. A central theme of the work is the
body as a site of historical abuse, and yet also the site of an ongoing
resistance to such abuse.

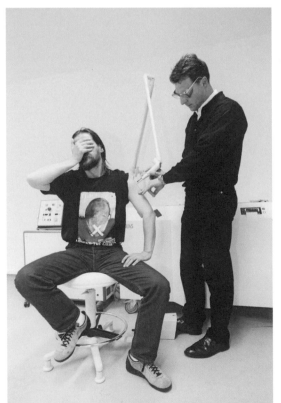

[138] DAN PERJOVSCHI – Erasing Romania, 2003.
Performance

Motivated by a lack of agency and a sense of
hopelessness, Dan Perjovschi had the word `Romania`
tattooed on to his arm in 1993. Ten years later, in
the context of a post-revolutionary Eastern Europe,
he had the tattoo removed in an act of frustration at
how little had changed in the intervening period.

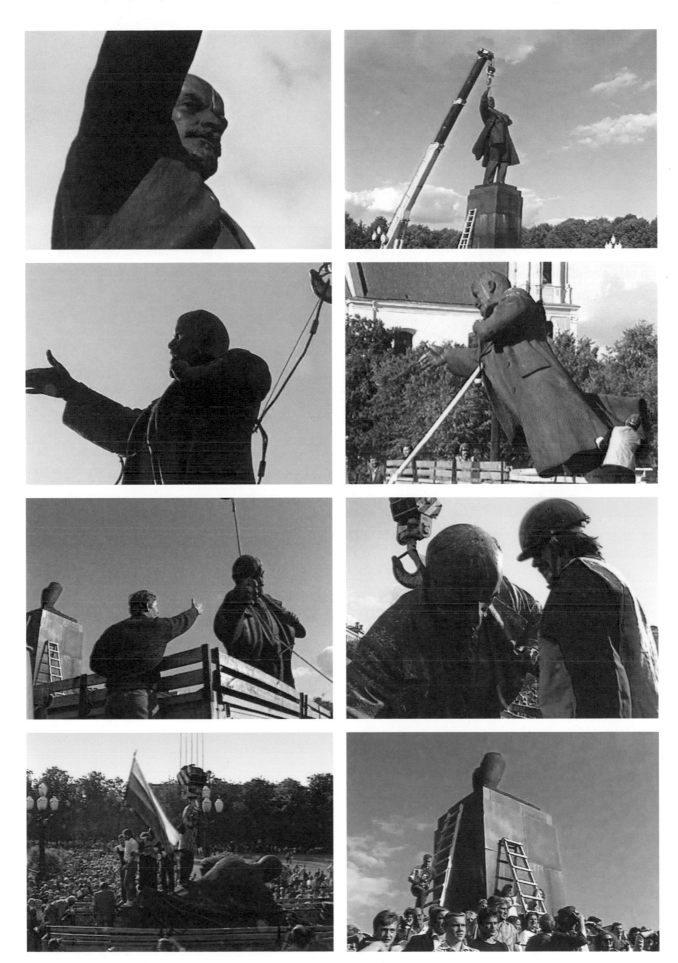

[139] DEIMANTAS NARKEVICIUS – Once in the XX Century, 2004.
Betacam transferred to DVD, colour, sound (ambient), 8 min.

History in reverse, or art as a means of stopping time and reversing it, is a feature of *Once in the XX Century* (2004) [139], a work by Deimantas Narkevicius that offers two different perspectives on the removal of a monumental public sculpture of Lenin in Lithuania in 1991. Using video footage acquired from the Lithuanian national television archive and a freelance reporter, Narkevicius creates a version of the episode that differs considerably from the one widely broadcast by CNN and other major networks at the time. Instead of editing the footage to symbolize the Soviet Union's disintegration and the failure of Communism (visualized in the public dismantling of a statue of Lenin), Narkevicius presents what appears to be a celebration to honour the erection of a sculpture of Lenin. We watch as the monument is carefully erected on its plinth in a narrative that questions any triumphalism in the wake of Communism.

The recovery of different, often conflicting versions of history continues to occupy contemporary art practices worldwide. Seen as the intellectual centre of the Arab world in the 1960s, Lebanon has also been the location of a civil war and, in 2006, a devastating incursion by Israeli forces. Ziad Antar takes the events of the latter as his starting point for a series of deceptively simple photographs titled *Products of War* (2006) [141]. Focusing on the everyday remnants of that war – an empty food can, a broken chair, a child's tricycle – Antar shows how such objects are transformed by conflict into historical artefacts, witnesses to the unfolding events. Similarly, in Lamia Joreige's video and installation piece *Objects of War* (1999–) [140], the civil war in Lebanon is understood through a selection of personal, sometimes idiosyncratic objects belonging to those who lived through the conflict. In discussing the personal significance of such items as cassette tapes, a blue plastic container (similar to the type used for transporting water), a group photograph, a candle, a notebook and a torch, the subjects of Joreige's video recall their own histories of the war.

Civil war as a subject of history, or, more specifically, the re-presentation of the events surrounding it, from aerial bombardment to car bombs, has long preoccupied the work of Walid Raad. Raad came to prominence under the umbrella of the Atlas Group, a self-styled collective whose purpose, if it can be described as such, was to create an archive that would offer an alternative history of the Lebanese Civil War. In *My neck is thinner than a hair: Engines* (2001) [143], the Atlas Group explored the public and private events surrounding the 3,641 car bombs detonated in Beirut between 1975 and 1991, a period broadly commensurate with the civil war. Taken by amateurs and professionals, the photographs that constitute this work present a history of the war that is different from the official one. The Atlas Group, however, not only re-presented existing documents but also produced new ones that supplemented, perhaps even supplanted, the very idea of an official history of the war.

In Vietnamese artist Dinh Q. Lê's *So Sorry* (2004) [142], we see three young women dressed in white *áo dài* (traditional Vietnamese costume) waiting patiently at a bus stop. In white lettering, akin to the typeface often used on postcards, Dinh Q. Lê has added the

[140] LAMIA JOREIGE – Objects of War, 1999–. Installation, video and objects, dimensions variable

[141] ZIAD ANTAR – Products of War, 2006. Far left: Tricycle, 2006. Inkjet print, 73 × 50 cm (28¾ × 19¾ in.). Edition of 6. Above: Chair, 2006. Inkjet print, 50 × 73 cm (19¾ × 28¾ in.). Edition of 6. Left: Soldier Food, 2006. Inkjet print, 50 × 73 cm (19¾ × 28¾ in.). Edition of 6

[142] ĐINH Q. LÊ – From the series Vietnam: Destination
for the New Millennium. Above: Come Back to My Lai, 2005.
C-print, 78.2 × 101.6 cm (30 × 40 in.). Above, right:
So Sorry, 2004. C-print, 120 × 160 cm (47¾ × 63 in.)

[143] THE ATLAS GROUP (1989–2004) – My neck is thinner
than a hair: Engines, attributed date 2001. Inkjet print
(archival inks and paper), 25 × 35 cm (9¾ × 13¾ in.)

[144] AN-MY LÊ – From Small Wars, 1999–2002.
Clockwise from top left: Small Wars (Ambush
#1); Small Wars (Vietcong Camp); Small Wars
(Rescue). Silver gelatin prints, 67.5 ×
96.5 cm (26½ × 38 in.). Editions of 5

An-My Lê's work explores the history and
legacy of the Vietnam War through images of the
conflict's key battles being re-enacted in the
forests of modern-day Virginia. In a related
work, 29 Palms (below), Lê shows US soldiers
'rehearsing' in the California desert before
their deployment to Iraq and Afghanistan.

[145] AN-MY LÊ – From 29 Palms, 2003–4.
Above: 29 Palms: Embassy Reinforcement II.
Right: 29 Palms: Resupply Operations. Silver gelatin
prints, 67.5 × 96.5 cm (26½ × 38 in.). Editions of 5

words, 'So sorry to hear that you are still not over us. Come back to Vietnam for closure!' Through the juxtaposition of romanticized imagery of Vietnam with an ironic register that alludes to the devastation wrought by the United States during the Vietnam War, Dinh Q. Lê explores the ongoing, often repressed tension between these two countries and the historical legacy of the war.

In An-My Lê's *Small Wars* (1999–2002) [144], this sense of history as a traumatic, barely repressed memory is examined through photographs of Vietnam War re-enactments being carried out in South Carolina. Lê participated in these re-enactments, which took place in the forests of Virginia at weekends. More recently, the artist has produced *29 Palms* (2003–4) [145], which documents the military base of the same name in the Californian desert where soldiers train before being deployed to Iraq or Afghanistan.

Mariam Ghani's *A Brief History of Collapses* (2011–12) [146], a two-channel video installation, engages with a symbol of Afghanistan's more distant history, namely the ruins of Darul Aman Palace on the outskirts of Kabul. Built in a neoclassical style in the 1920s as part of King Amanullah Khan's efforts to modernize Afghanistan, the building has been gutted by fire (in 1969 and 1978), bombed by Mujahideen forces and, more recently, attacked by the Taliban. And yet still it stands, a testament to modernizing ambitions and a palimpsest on which war and conflict have been indelibly imprinted. The current plan is to refurbish the building as the seat of a future Afghan parliament, a democratic ideal that seems as distant today as it did during the reign of Amanullah Khan.

Confronted with the violence and death of the past, artistic practices have been both championed and criticized for engaging with history, especially, as we shall see in the next chapter, in the case of the Holocaust, an event often seen as a direct riposte to the very idea of historical progress. In 2005, in the Austrian town of Rohrbach, Sanja Iveković realized a project based on a photograph, rather than a building. The photograph in question was an anonymous found image of a group of Roma people awaiting transport to a concentration camp. For *Rohrbach Living Memorial* (2005) [148], the artist invited the inhabitants of Rohrbach to re-enact the scene depicted in the photograph. Iveković's work effectively re-opened the debate around Austria's attempts to examine the racist policies that led to the extermination of Roma and Sinti people during the Nazi period.[3] As we have seen, the same debate also informed Christoph Schlingensief's provocative *Please Love Austria* (page 74).

In Miroslaw Balka's monumental *How It Is* [149], installed in the Turbine Hall at Tate Modern in 2009, the artist attempted to recreate the sheer terror associated with the history of transportation and incarceration. The structure, resembling an outsized shipping or railway container, measured 13 × 10 × 30 metres (43 × 33 × 98 feet). In common with the immersive works of Krzysztof Wodiczko and Luis Camnitzer (pages 129 and 130 respectively), *How It Is* tended to induce anxiety in the viewer as they entered into what was effectively a cavernous void with seemingly no end in sight. Balka has noted that the work is about disappearance and deportation, and its many references to the

[146] **MARIAM GHANI** – <u>A Brief History of Collapses</u>, 2011–12.
2-channel video, colour, 7.1-channel audio installation, 22 min. loop

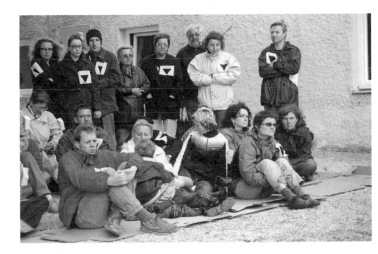

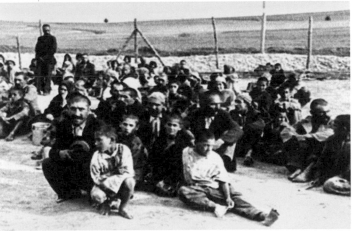

[148] **SANJA IVEKOVIĆ** – <u>Rohrbach Living Memorial</u>, 2005.
Public action/installation, Rohrbach, Austria

[147] **OMER FAST** – <u>Spielberg's List</u>,
2003. 2-channel video projection,
colour, sound, 65 min.

deportation of Polish Jews reveal additional concerns about appropriate forms of commemoration in the face of such historically resonant atrocities.

Omer Fast's *Spielberg's List* (2003) [147] is a two-channel video installation that consists, in part, of a series of interviews between Fast and some of the residents of Kraków who had been hired as extras for Steven Spielberg's Academy Award-winning film *Schindler's List* (1993). Many of the people interviewed are too young to remember the Nazi period, but some do have memories of the Jewish ghetto and the concentration camp. Their recollections of shooting the film are purposefully intermingled with these disturbing and painful memories of the Second World War. This deliberate confusion is intensified on the adjacent projection, where scenic footage of the surviving film set, built near the remains of the actual German labour camp, is intercut with footage of that camp.

Conducted in Polish, the interviews in Fast's film are accompanied by two sets of subtitles, one provided by a translator at the time of the interview, the other created retrospectively. The differences, albeit subtle, between the two translations shed light on the subjective nature of interpretation, particularly of the past, and the politics of representing and revisiting history through visual forms. Fast's film, in its ambition and scope, rearticulates the parameters of political debates about history and its interpretation and, in so doing, proposes that the will to remember and negotiate the past is the expression of a collective will not only to refuse forgetfulness but also to question official accounts of history. As we have seen elsewhere, the involvement of art practices in the examination of history directly challenges what may be seen, said and indeed understood. Moreover, they reveal the political intransigencies that mark present-day debates about the past and how it will come to be understood in the future.

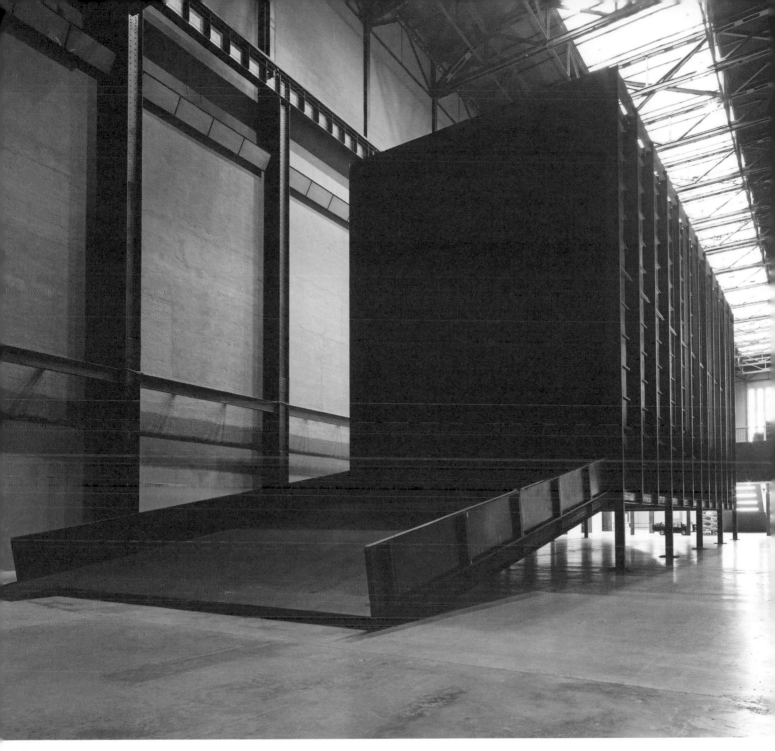

[149] MIROSŁAW BAŁKA – How It Is, 2009–10.
Installation, steel, 13 × 30 m (42⅔ × 98⅔ ft).
The Unilever Series, 13 October 2009–5 April 2010,
Turbine Hall, Tate Modern, London

Commissioned for Tate Modern's Turbine Hall as part of the
Unilever Series, How It Is takes its title from a Samuel
Beckett novel of the same name. Bałka's monumental work
is essentially a vast chamber that recalls both the shell
of the building that surrounds it and the sense of dread
associated with entering a concentration camp or prison.

The Politics of the Exception

AND YOUR ~~VISIONS~~
ARE YOUR ~~EXILE~~
IN A WORLD WHERE
A ~~SHADOW~~ HAS NO
~~IDENTITY~~, NO
~~GRAVITY~~. YOU WALK
AS IF YOU WERE
SOMEONE ELSE.
—

MAHMOUD DARWISH

THE TERM 'BIOPOLITICS' CONTINUES TO GENERATE POLITICAL CONTROVERSY AND SOCIAL DEBATE. IN ITS MOST FUNDAMENTAL USAGE, IT DESCRIBES THE APPLICATION OF POLITICAL POWER TO ALL ASPECTS OF LIFE, BOTH PRIVATE AND PUBLIC, IN AN ATTEMPT TO MANAGE AND MONITOR THE BEHAVIOUR OF INDIVIDUALS AND POPULATIONS.

Surveillance would be the most obvious example of biopolitics in action; however, passport checkpoints and borders, be they physical or virtual, also moderate the behaviour and movement of people. The application of biopolitics to everyday life is not merely restrictive; its broad frame of reference also delineates and produces such social types as the criminal, the so-called insane, the economic migrant, the refugee, the political prisoner and the protestor.[1] The presence of these figures in the contemporary political landscape – some based in formal citizenship, some not – has given rise to one of the most significant features of modernity: the camp.

This chapter focuses on those artists who have engaged with the politics of camps in all their forms – concentration, refugee, death, internment, transit – and how their work highlights the plight of those living in them. It also considers the question of why the camp has become such a permanent and significant feature of our modern political landscape. Of all the forms of exception that have been introduced into contemporary politics, clandestinely or otherwise, it is the camp that provides one of the most visible reminders that modernity is based on the rule of 'political exceptionalism', that is, the designation of certain groups and individuals as exceptions to the norm, thereby subjecting them to laws and rights that are often markedly different from those enjoyed by the majority.

As we saw in Omer Fast's *Spielberg's List* (page 155), the trauma of the concentration camps continues to manifest itself in contemporary anxieties. While Fast's film examined how re-enactment can confuse the interpretation of history and open it up to other, less obvious readings, the work of Artur Zmijewski takes a more confrontational approach. In *80064* (2004) [150], Zmijewski convinces a ninety-two-year-old survivor of Auschwitz, Józef Tarnawa, to have his prison number – the title of Zmijewski's film – re-tattooed on his arm. Throughout, Tarnawa recalls the inhumanity and degradation of the camps. However, the film seems more interested in how the act of re-tattooing Tarnawa's concentration-camp number might be perceived. At one point, Tarnawa, who expresses his misgivings about the process from the outset, complains that the newness of his tattoo will lead others to disbelieve his story of the camps. Veracity gives way to repetition here, and the new tattoo seems at odds with the truth of the Holocaust as it is currently understood in historical terms.

[150] ARTUR ZMIJEWSKI – 80064, 2004. Single-channel video,
projection or monitor, colour, sound, Polish with English
subtitles, 11 min. Edition of 3 (+ 1 AP + 1 EP)

In 2004 Artur Zmijewski encouraged a Holocaust survivor to have
his original camp number, the eponymous 80064, re-tattooed on
his arm. The film documents the often disturbing testimony of
the survivor and the apparent indifference of the artist as he
questions his subject's reluctance to have the tattoo reapplied
and, when it is, to accept the new tattoo as authentic.

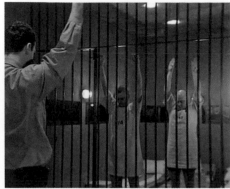
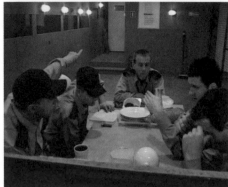

[151] ARTUR ZMIJEWSKI – Repetition, 2005. Single-channel video, projection or monitor, colour, sound, Polish with German, English or Italian subtitles, 74 min. 15 sec. Edition of 3 (+ 1 AP + 1 EP)

Repetition involved the re-staging of Philip Zimbardo's infamous 1971 Stanford prison experiment. Designed to explore 'cognitive dissonance', the experiment has become a byword for unsound psychological investigation and, for some, an uncanny foretelling of the abuses carried out at Abu Ghraib prison in Iraq three decades later.

[152] YASMINE EID-SABBAGH – From A photographic conversation from Burj al-Shamali camp, 2001–11. Above: Fatmeh Soleiman's work presented in Al-Husun camp, Jordan, April 2009, photo Yasmine Eid-Sabbagh. Right: Hossein Hassan al-Youssef (Saida, 1980) A series, 2007–2008, photo Fatmeh Soleiman. Multidisciplinary project

In *The Game of Tag* (1999), a video in which a group of people chase one another around a former Nazi gas chamber, Zmijewski examined the continued sensitivities that surround the modern-day uses and depictions of concentration camps. This sensitivity, and the concept of the camp, was further explored in *Repetition* (2005) [151], in which the artist built a 'prison camp' in Warsaw's historical district of Praga in order to restage Philip Zimbardo's infamous Stanford prison experiment, conducted at Stanford University in 1971.

Zimbardo's experiment, in which student volunteers were randomly assigned the role of either 'guard' or 'inmate' in a mock prison, explored, among other things, the effects of cognitive dissonance, the discomfort experienced as a consequence of holding two or more conflicting belief systems. The participants in Zmijewski's restaging of the experiment signed a waiver that placed them in an invidious position: while they could opt out at any moment, and thereby forfeit further payment, they were nonetheless bound by the rules of the role play while they continued to take part. As in Zimbardo's original experiment, the 'guards' began to brutalize their wards despite the fact that, beyond the confines of their makeshift 'prison', such behaviour would have been deemed unacceptable, if not immoral.

While we would not want to draw a direct comparison between those who entered the concentration camps and those who participated in Zmijewski's *Repetition*, it is worth noting that both groups were designated as 'exceptional', in the sense of unusual, not typical, and were thereafter suspended between various social classifications and subject to different legal systems and moral obligations. Indeed, any Jew entering a concentration camp had already been deprived of his rights as a citizen by the *Nürnberger Gesetze* (Nuremberg Laws) of 1935, which, in deploying a pseudoscientific approach to biological antecedents and dubious classifications of progeny, effectively denaturalized the Jews on the grounds of race. The camp is thus a space of exception, and those entering it, such as refugees, are placed in an exceptional, invariably detrimental relationship to legal procedure and political discourse.

The role of the artist in the representation of camps and refugees is a complex one. It is arguable, for example, that artistic representations of camps and refugees merely reinforce the often sensationalist and exceptional way in which they are depicted by the media. Representation, in the form of photographs or films, can also ameliorate, or become an ineffective substitute for, states of non-representation, be they legal, economic or political.[2]

For Yasmine Eid-Sabbagh, who lives and works with refugees, the politics of representing camps involves not only going in to camps and engaging with the communities she encounters there, but also, in the project *A photographic conversation from Burj al-Shamali camp* (2001–11) [152], giving cameras to the people she meets together with the means to produce and display the images they capture. A recent incarnation of Eid-Sabbagh's project was *How Beautiful Is Panama!*, a touring exhibition of the photographs taken by the residents of Burj al-Shamali, a camp in southern Lebanon. In 2008 the photographs – taken by, among others, Ahmad al-Khalil,

Susan al-Khatib, Yasser Ibrahim, Fatmeh Soleiman, Nisreen Musherfih and Ali al-Ali – toured other camps in Lebanon, Jordan and Syria.[3] None of the photographs' attributes – their specific locations within the camp, their subjects, their framing, their exposure – were down to Eid-Sabbagh's role. As such, the project exposed the often exclusive, rare-fied practice of aesthetic production, and invited into the process the very voices that are often excluded from it.

Marwan Rechmaoui's series *UNRWA* (2011–13) grew out of a similar inter-est in the representation of camps. In collaboration with the Arab Resource Collective, a non-governmental organ-ization (NGO) working in Palestinian refugee camps, Rechmaoui asked residents of all ages to map their local surroundings.[4] He then had these maps enlarged and reproduced on a range of materials that were difficult to come by in those camps, such as concrete, corrugated metal, and rice and sugar bags. *Shatila 3* (2013) [154], for example, consists of mixed media on concrete, directly referencing the use of concrete in the construction of the camp's build-ings. Indirectly, the work also recalls the infamous massacre of Palestinian and Lebanese Shia in the Sabra and Shatila refugee camps in 1982.

While the camp may be a predomi-nantly localized phenomenon, it can also encompass an entire region. In Ursula Biemann's *X-Mission* (2008) [153], the artist notes that Palestinian refugees and the camps they inhabit are repre-sentative of the 'exception within the exception'. Featuring interviews with a lawyer, a journalist, an architect, an anthropologist and a historian, the film utilizes multiple layers of visual media –

embedding videos within videos, for example – in order to understand the camp as an evolving, decentralized site of both physical and mental cohabita-tion. The use of video for interviews and on-location footage, alongside the downloading of other footage and links to wider networks, reflects the fact that the camp is a complex, fluid space – and not, as it were, a static, fixed model of incarceration.

That Palestine as a whole has come to be seen as an instance of exception is evidenced by the fact that 4.9 million Palestinian refugees are registered with the United Nations Relief and Works Agency (UNRWA). Even the name 'Palestine' is contentious, and is used interchangeably with the State of Palestine (proclaimed on the 15 November 1988), the Palestinian ter-ritories and the occupied Palestinian territories (the last two denomina-tions specifically referring to the West Bank, including East Jerusalem, and the Gaza Strip). The issuance of a passport to Palestinians is likewise subject to confusion, inasmuch as it is issued by the Palestinian Authority and subject to restrictions placed on it by the Israeli government; as a result, it is commonly referred to as a travel document rather than a passport. Moreover, the question of what constitutes Palestine remains far from resolved, even within the Palestinian Authority. The project *State of Palestine* (2012) [155] stems from a conversation between Khaled Jarrar and his friends about the difficulties of travelling from Israel into Palestine. Subsequently, Jarrar created a document resembling an American 'green card' that enables those entering Palestine to live, work and feel welcome in the region.

[153] URSULA BIEMANN – X-Mission, 2008.
Video essay, colour, sound, 40 min.

[154] MARWAN RECHMAOUI – Shatila 3,
2013. From the series UNRWA, 2011–13.
Mixed media on concrete, 90 × 140 cm
(37¾ × 57¾ in.)

In a collaborative project involving
the Arab Resource Collective, a non-
governmental organization working in
Palestinian refugee camps, Rechmaoui
asked residents of the camps to map and
represent their local surroundings.
The artist then reproduced these maps
on such basic materials as concrete,
corrugated metal, and rice and sugar
bags – all materials that are both hard
to come by in the camps and symbolic of
the day-to-day realities of those who
live there.

[155] KHALED JARRAR – Right: State
of Palestine #1, 2012. C-print on
Diasec, diameter 120 cm (47¼ in.).
Far right: State of Palestine Stamp,
2012. C-print on Diasec,
100 × 118.5 cm (39¼ × 46¾ in.)

[157] YAZAN KHALILI – Colour Correction II/Camp Series, 2007-10. Archival digital print with silk-screen glaze, 177.5 × 115 cm (70 × 45¾ in.)

[158] AHLAM SHIBLI – Unrecognised no. 1, ʿArab al-Naʿim, Palestine/Israel, 2000. From the series Unrecognised (ʿArab al-Nʿaim), 1999-2000. Chromogenic print, 80 × 91 cm (23⅝ × 35¾ in.)

The villages in Shibli's photographs, like many others in the Negev region of Israel, are both unrecognized in political terms and unrecorded on any official maps. In depicting these villages, Shibli's work goes some way to representing them as actual spaces in which people continue to live and work, often in dire conditions.

[158] JAWAD AL MALHI – House No. 197, 2009.
Digital print on paper, 70 × 600 cm
(27½ × 236¼ in.)

[159] RENZO MARTENS – Episode III, 2009.
Video, colour, sound, English subtitles,
88 min.

The difficult-to-define, exceptional aspect of Palestine explored in Jarrar's *State of Palestine* can also be found in the internal politics of its camps. Yazan Khalili's *Colour Correction II/Camp Series* (2007–10) [157] is from a group of images, taken from various vantage points, of the al-Amari refugee camp, located 2 kilometres (1¼ miles) to the south of Ramallah. This particular image looks down on to the roofs of al-Amari, producing a slightly vertiginous effect. To add to this disorientation, Khalili has 'corrected' the colour scheme, replacing the original sand-like hues of the buildings with shades of pink, blue, purple and green. Such an act of alteration draws our attention to the less-than-colourful conditions endured by those who call the camp home. In this respect, the series as a whole is an attempt to inject a sense of hope and desire into a multifaceted landscape where dispossession and displacement are the norm.

House No. 197 (2009) [156] consists of a series of panoramic views of Shufhat refugee camp in Jerusalem, home to the artist Jawad Al Malhi for more than thirty years. Taken from a neighbouring Israeli settlement otherwise inaccessible to Palestinians, Al Malhi's photographs document the transformation of Shufhat from different vantage points. Having lived in the camp, Al Malhi understands its layout and uses this knowledge to build a picture of the camp's internal structure. According to the artist, the work 'explores the nature of the space, in particular the accumulative and chaotic nature of the space of the camp. It looks at the experience of claustrophobia and containment within the camp environment via the architectural formations, which speak of the presence of generations of refugees.'[5]

To the extent that each of the preceding works examines the physical fact of the camp, Ahlam Shibli's *Unrecognised ('Arab al-N'aim)* (1999–2000) [158] starts from the point of view of its non-representation. As an artist, Shibli is interested in witnessing and re-presenting the nature of conflict, and in this series of photographs she records how the inhabitants of 'Arab al-N'aim live an uncertain day-to-day existence in what is effectively a refugee camp in all but name. Unrecognized by Israel, this village, and others like it in the Negev region of the country, not only is *not* recognized in political terms, but also does not appear on any official maps. Refused the right to live in their birthplace, these villagers inhabit a zone in which non-representation, be it in terms of political or legal recourse, has become a fact of life.

For *Episode III* (2009) [159], the third in a series of films by Renzo Martens (see also *Episode I*, page 19), the artist spent two years filming in the Democratic Republic of the Congo. One of the key scenes in *Episode III* concerns the work of aid and relief agencies in refugee camps across the world. At one stage, the artist quizzes a representative of the United Nations High Commissioner for Refugees (UNHCR), a body set up in 1951 following Europe's post-Second World War refugee crisis, as to why its logo is emblazoned across tents and other items of aid. The question is never fully answered, although the representative acknowledges that it has to do with visibility. The implication, for Martens at least, is that there is an explicit politics of poverty at play within the UNHCR and the various humanitarian NGOs. Or, to put it another way, there is an industry

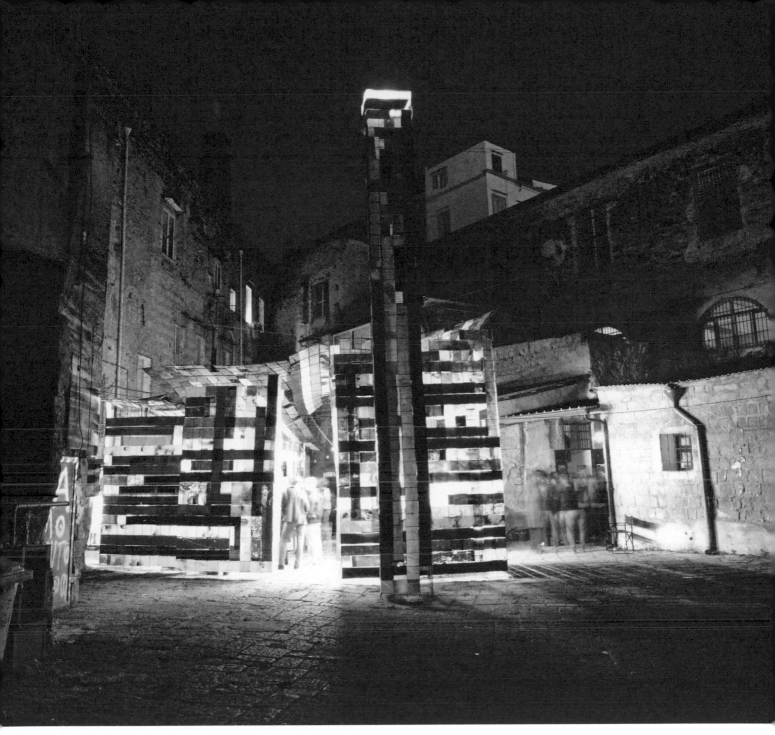

[160] THOMAS KILPPER – A Lighthouse for Lampedusa!, 2007–. Metal grid,
~~wire, coloured plastic strips, photographic and light apparati~~ 8 × 5 × 9 m
(26¼ × 16½ × 29½ ft). Installation at Lanificio Naples, 2010

Lampedusa is a small island located to the south-west of Sicily. It is
also a major destination and place of refuge for migrants making the
arduous journey from North Africa to Europe. The countless deaths of these
migrants in the waters around the island has become a political issue. For
Kilpper, the proposal for a lighthouse to guide the incoming ships was a
simple matter of communicating the perilousness of the migrants' journeys
and providing a space within which to discuss the global events that are
impacting on the island and its inhabitants.

[161] CHRISTOPH BÜCHEL AND GIANNI
MOTTI – Guantánamo Initiative, 2004-5.
Installation

of workers and corporations involved in 'poverty alleviation', and branding plays a significant role in their visibility, if not their long-term sustainability.

Here, it is worth noting the existence of some of the world's many other refugee camps, from those in Mali and Chad (for refugees from Darfur) to the Sahrawi refugee camps in Algeria, the northern border camps of Iraq and the camps emerging along the borders of Lebanon and Jordan, where it is estimated that some 2.4 million Syrians are now living as a result of the country's civil war. Similarly, in the post-revolutionary climate of 2011, the Italian island of Lampedusa has effectively become a staging post-cum-camp for North Africans seeking to migrate to Europe, a pattern that has been repeated in other makeshift camps across the southern part of the continent.[6]

A *Lighthouse for Lampedusa* (2007–) [160] was conceived by Thomas Kilpper in response to the worsening issue of immigration from North Africa to Europe and the lack of a political will to address it. Lampedusa, a small island located to the south-west of Sicily, has become the first port of call for thousands of migrants escaping civil unrest. Those who survive the perilous journey by sea are either detained in camps or, as is increasingly the case, turned away by European officials and returned to North Africa, regardless of the many dangers they face there. Frustrated by failing political efforts to reach a solution, Kilpper has proposed the construction of a lighthouse on Lampedusa, to serve as a symbol of welcome and to provide much-needed orientation at sea. Designed to host a diverse and transnational programme of exhibitions, concerts and other cultural events, the ground floor of the lighthouse will be a site of communication, negotiation, listening and learning for both the indigenous inhabitants of the island and those who arrive there by sea every day.

In its exploration of the institutional aspects of the camp, Artur Zmijewski's *Repetition*, discussed earlier, may also be read in the context of Abu Ghraib prison in Iraq and the US military prison at Guantánamo Bay. The very status of the camp as an institutional structure within and yet beyond legal and political control was key to the abuses carried out there. On the occasion of the 51st Venice Biennale in 2005, Christoph Büchel and Gianni Motti staged *Guantánamo Initiative* [161] to draw attention to the interstitial nature of this so-called detention centre and the suspension of legal process under the 'state of emergency' that brought it into being. Requesting from the Cuban government a new lease for Guantánamo, so as to transform it into a cultural centre, the artists displayed treaties and documents in an attempt to expose what they regarded as the illegitimacy of the lease signed in 1903 granting the United States permission to use the land as a naval station. They also displayed forty-seven annual rent cheques – all of which the Republic of Cuba has refused to cash – that have been issued by America to the Cuban government since 1959.[7]

A central component of Ayreen Anastas and Rene Gabri's *Camp Campaign* (2006) [162] was the question, how can the camp at Guantánamo Bay exist? Setting off from New York City on a road trip across the United States, Anastas and Gabri continued to ask this question, transforming it

into an investigation. They encouraged their audiences to explore the many associations of the word 'camp', including 'detention', 'internment', 'refugee', 'relief' and even 'holiday'. The artists also visited some actual camps, such as a Native American reservation in New Mexico, a camp set up in the aftermath of Hurricane Katrina in New Orleans and a Second World War internment camp, while also initiating meetings with legal experts, political activists and other artists. Their van was their mobile studio, billboard and library; it was also the place from which they updated the *Camp Campaign* website with recordings of their discussions and meetings, as well as new research material.

We should also include here the encampments that were jerry-built in New York City in September 2011 as part of the Occupy Wall Street (OWS) movement and – one month later and out of solidarity with OWS – outside St Paul's Cathedral in London.[8] Going by name alone, we could also consider the landing strip near Warm Springs, Nevada, known as 'Base Camp', where CIA aircraft take Las Vegas-based workers to and from a collection of highly secret military bases. Such bases, as documented by Trevor Paglen, are 'part of a hidden military geography that is known in military and defense industry circles as the "black world"'.[9] Under the title 'Experimental Geography', Paglen uses photography to represent that which often remains unseen, including so-called black sites, the location of such secret military 'non-places' as detention and torture camps.

Paglen's *The Salt Pit, Northeast of Kabul, Afghanistan* (2006) [163] is a unique photograph of one of these sites. The 'Salt Pit' is an example of the secret prison camps set up by the CIA for the processing of 'ghost detainees'. Synonymous with allegations of torture and homicide, the camp came to wider international attention following the abduction and torture of Khalid el-Masri, a German citizen who, having been mistaken for an al-Qaida suspect in Macedonia, was handed over to the CIA, flown to Kabul and detained in the Salt Pit, where he was systematically tortured. Using el-Masri's testimony, Paglen travelled to the region in 2006 and took a photograph of the Salt Pit, purportedly the first and, to date, only photograph of the site. Another Paglen photo of a black site – one whose name remains unknown – is labelled simply *Black Site, Kabul, Afghanistan* (2006) [163].

The camp occupies an exceptional space in modernity: it can exist within national borders and beyond them. It therefore exemplifies the political, if not biopolitical, need for demarcations to exist not only between people (of different nationalities, for example) but also among people. This is what makes the camp such a significant phenomenon: it can service the demands of political nationalism and political exceptionalism at one and the same time. Far from being an aberration on the modern political landscape, it has come to define a certain political philosophy. The camp, and in particular its threat of incarceration, can also be applied to anyone considered a danger to national security, whether that is proven in a court of law or not. It is in the representation of the camp and other such spaces that we can see the camp inmate for what he is: the abandoned subject of modernity that reveals the potential fate of every individual, be they a citizen or a non-citizen.

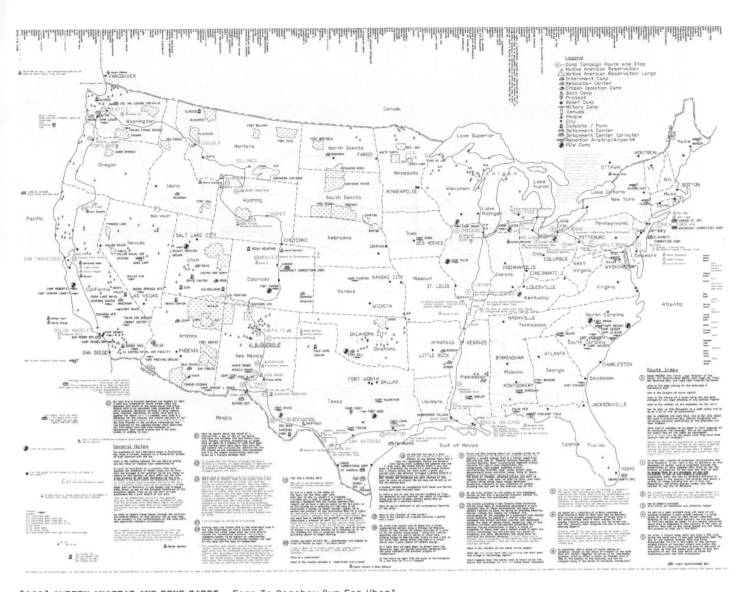

[162] AYREEN ANASTAS AND RENE GABRI – _Fear Is Somehow Our For Whom?
For What? and Proximity to Everything Far Away_, 2006. Poster as
part of Camp Campaign

[163] TREVOR PAGLEN – Above: _Black Site, Kabul, Afghanistan_, 2006. C-print, 61 × 86.4 cm (24 × 34 in.).
Right: _The Salt Pit, Northeast of Kabul, Afghanistan_, 2006. C-print, 61 × 91.4 cm (24 × 36 in.)

ENVIRONMENTS

Ecologies of Engagement

WHAT IS THE
USE OF A
~~HOUSE~~ IF YOU
HAVEN'T GOT
A ~~TOLERABLE~~
~~PLANET~~ TO
PUT IT ON?
—

HENRY DAVID
THOREAU

CLIMATE CHANGE
HAS GIVEN RISE TO
A NEW EPOCH IN
THE HISTORY OF THE
EARTH, ONE IN WHICH
HUMAN ACTIVITY
HAS SHIFTED FROM
BEING A 'BIOLOGICAL
AGENT' – IMPACTING
ON A SPECIFIC AND
LARGELY LOCALIZED
ENVIRONMENT –
TO BECOMING A
'GEOLOGICAL AGENT'
CAPABLE OF RADICALLY
ALTERING THE WORLD'S
RELATIVELY STABLE
CLIMATE PATTERNS.

Although there continue to be voices raised in opposition to the facts of climate change, the Intergovernmental Panel on Climate Change, an internationally recognized body set up in 1988 (and awarded the Nobel Peace Prize in 2007), has observed that 'warming of the climate system is unequivocal' and 'most of the observed increase in global average temperatures since the mid-20th century is very likely due to the observed increase in anthropogenic greenhouse gas concentrations.'[1] The continued use of fossil fuels risks producing a global calamity of unprecedented proportions, the beginnings of which we are already witnessing in rising sea levels, the melting of polar ice caps, drought, food shortages, extreme weather, soil erosion,

habitat loss and the arrival on the political horizon of a relatively new figure: the climate refugee.

Given the ramifications of climate change and its undoubted effects on populations, it can nevertheless be difficult to visualize its full impact. It is therefore unsurprising that contemporary artists – through the use of information technology, activism, direct action, education programmes, community-based projects, research seminars and installations – endeavour to give form to the effects of climate change. In these practices, the act of representation, the visualization and interpretation of what are often difficult-to-digest realities, is also a decidedly political gesture, inasmuch as it reveals and embodies information that, in a time of imminent crisis, can be utilized to effect individual and collective action.

Founded by Michael Faulkner in the mid-1990s, D-Fuse is a group of London-based artists who explore the politics of production and sustainability. For their immersive installation *Small Global* (2006–) [165], the group carried out an investigation into the environmental depletion brought about by globalization and demands of economic expansion. Utilizing a series of information-based graphics, *Small Global* explores the seemingly unstoppable rise of McDonald's – one of the most widely recognized symbols of global mass consumption – tracing and mapping the company's exponential growth against an equally in-depth depiction of environmental destruction.

In Helen Mayer Harrison and Newton Harrison's *Greenhouse Britain* (2007–9) [164], we see an equally ambitious endeavour to map the effects of rising water levels on the coastline of

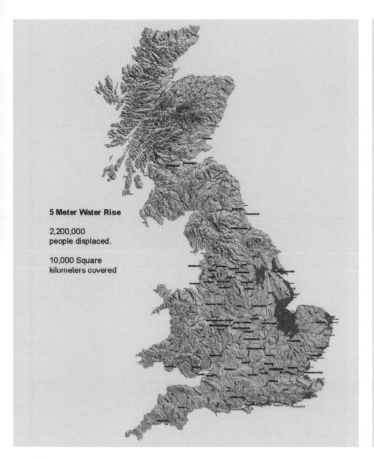
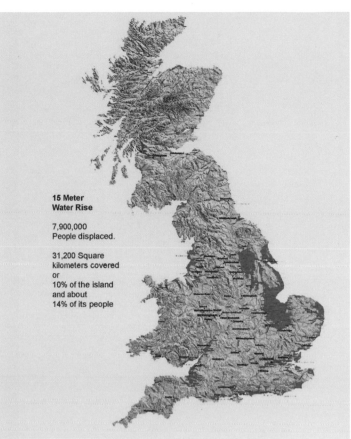

5 Meter Water Rise

2,200,000
people displaced.

10,000 Square
kilometers covered

**15 Meter
Water Rise**

7,900,000
People displaced.

31,200 Square
kilometers covered
or
10% of the island
and about
14% of its people

[164] HELEN MAYER HARRISON AND NEWTON HARRISON Greenhouse Britain, 2007-9. Installation

Greenhouse Britain attempted to raise public awareness of climate change by presenting the
subject in manageable, largely visual terms. Composed of a number of elements, including
topographical models of the British Isles showing the effects of rising water levels, the
project was funded by a grant from the Department for Environment, Food and Rural Affairs.

[165] D-FUSE – Small Global, 2006–.
Projected video, surround sound, dimensions variable

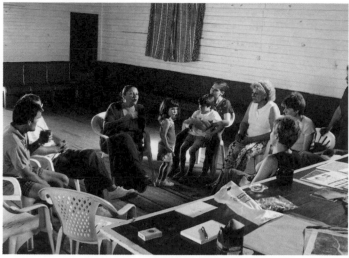

[166] ALA PLÁSTICA – <u>Exercise of Displacement:</u>
<u>Rio Santiago</u>, 2004–. Collaborative project

[167] ALA PLÁSTICA – <u>Magdalena Oil Spill</u>, 1999–2003.
Above: <u>Evidence, Oil Spill</u>. Right: <u>Interview with</u>
<u>Magdalena reed harvesters</u>. Collaborative project

[168] SUBHANKAR BANERJEE –
<u>Gwich'in and the Caribou</u>, 2007. From
the series <u>Land-as-Home: Arctic</u>, 2000–.
Photograph, 45.7 × 61 cm (18 × 24 in.)

Subhankar Banerjee is a photographer,
educator and activist. In the series
<u>Land-as-Home: Arctic</u>, Banerjee
addresses issues of human rights and land
conservation in the frozen north through
images of everyday life there. It is, of
course, such quotidian events as these
that are in danger of disappearing owing
to the effects of climate change and
environmental degradation.

the United Kingdom. Operating as both a virtual, online project and a physical installation, the work includes a topographical map of Britain with six projectors positioned above it showing water levels slowly rising, storm surges happening and levels retreating. Together with several other projects by the Harrisons, *Greenhouse Britain* is an attempt to raise public awareness of the effects of global warming by presenting a complex topic in visually accessible yet cautionary terms.

Exercise of Displacement: Rio Santiago (2004–) [166] is the work of the Argentinian arts and environmental organization Ala Plástica. Produced in conjunction with the Austrian group Cartografia, it is effectively a collaborative exercise that involves the participants living and working with communities in Río Santiago in Argentina. Using ecological, social and artistic means, the project is focused on developing a civic plan to regenerate a heavily polluted and economically disadvantaged region of the country. In *Magdalena Oil Spill* (1999–2003) [167], Ala Plástica documented the pollution of the Rio de la Plata caused by a collision between a German ship and a Royal Dutch Shell oil tanker in 1999. Working with environmental activists, the group produced a detailed account of environmental despoliation with a view to effecting a clean-up of the affected ecosystem and reparation for local communities.

The involvement of local communities in the development of eco-activism and regional biodiversity is key to the work of Platform, which, for more than twenty years, has brought together environmentalists, artists, educators and activists to work on and discuss ecological projects with indigenous groups. Combining art, education and research, Platform's projects include *Unravelling the Carbon Web* (2000–) [170], an investigation into fossil-fuel dependency and its social and environmental costs. In more specific terms, the project examines the impact of such companies as British Petroleum and Shell, two of the world's largest oil producers, on Iraq, Nigeria and the regions of the former Soviet Union, among other countries.

Climate change has radically altered the lives of many across the world, notably those living in so-called least developed countries and the Third World. Many of these individuals, who already face a daily struggle to survive, are having to contend with new forms of displacement and ever more injurious forms of insecurity. In some estimations, the growing number of conflicts and disasters linked to climate change could result in the displacement of more than a billion people, the single largest upheaval in living conditions and human existence ever seen.

Artist, educator and activist Subhankar Banerjee's project *Land-as-Home* (2000–) consists of two large-scale series, *Arctic* and *Desert*. Both are concerned with a number of interconnected issues, not least the shelter and food that the earth affords its inhabitants and how these basic elements of life are under threat from industrialized societies. For the *Arctic* series, Banerjee collaborated with environmental organizations in Arctic Alaska and the Gwich'in and Iñupiat communities who live there, focusing, in turn, on the tradition of sustainable land use. In *Gwich'in and the Caribou* (2007) [168], we see two

[169] GEORGE OSODI – <u>Tapioca Drying Utorogu Gas Flare</u>, 2006. From the series <u>Oil Rich Niger Delta</u>, 2003–7. C-print, 80 × 120 cm (31½ × 47¼ in.)

Between 2003 and 2007, George Osodi researched and photographed the Niger Delta, a region of great importance to the Nigerian oil business – and one of the most polluted river deltas in the world. The political and environmental unrest surrounding the extraction of oil from the delta continues to affect the successive generations of people who have the misfortune to live there.

THE CARBON WEB

www.platformlondon.org

[170] PLATFORM – From <u>Unravelling the Carbon Web</u>,
2000–. Multidisciplinary project

[171] THE YES MEN – <u>Niger Delta Hoax</u>, 2010.
Performance

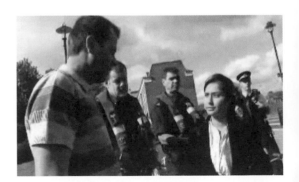

[172] MARK MCGOWAN – <u>Operation Plastic</u>, 2007.
Performance

members of the Gwich'in community skinning caribou, an image that reflects on the broader issue of their struggle to save the calving ground of the caribou from oil and gas development.

The oil rush in the Niger Delta, which started in the 1990s, continues to be a source of conflict and antagonism for local farmers and communities across the region. The tensions that exist there are largely caused by disputes between oil companies and the area's indigenous populations, including the Ogoni and the Ijaw. From 2003 until 2007, a period broadly commensurate with the emergence of armed groups in the region, the photographer George Osodi documented the lives of the Niger Delta's inhabitants and its exploitation by multinational corporations. In the resulting series of images, *Oil Rich Niger Delta* (2003–7) [169], we see environmental degradation and human rights violations across the region. In their hellish appearance, the photographs are both surreal and banal: children play football in the light of a gas flare; a white skull lies in a pool of oil; communities with nowhere else to go inhabit landscapes befouled by oil; women fish in polluted lakes; and families struggle to survive in a zone that seems to exist beyond national and international law. In one telling image, a young girl in the Sangana region of the Niger Delta, one of the most polluted in sub-Saharan Africa, stands next to a piece of graffiti that reads, 'Trust nobody'.

In a similar vein, but taking a very different approach, is the Yes Men's *Niger Delta Hoax* (2010) [171], a video consisting of a 4-minute apology on behalf of Royal Dutch Shell for the injustices brought about by its extraction of oil in the region. In the video, a

man called Bradford Houppe, apparently from the 'Ethical Affairs Committee' at Royal Dutch Shell, holds a press conference in The Hague in which he apologizes for the company's poor environmental record and its treatment of the Niger Delta.[2] To date, representatives of the company have yet to comment on its all-too-public 'apology'.

A similarly mischievous, but nonetheless telling, form of opportunism was in evidence when, in *Operation Plastic* (2007) [172], Mark McGowan filled two fishing nets with plastic recovered from a London waste centre and attempted to 'dump' them into the River Thames. This quantity of plastic is but a fraction of what is disposed of each week by the centre, and yet it is chastening to consider the environmental implications being explored in this work. The tears of the work's title are a reference to 'mermaid's tears', the microscopic pieces of plastic that can be found on almost all the world's beaches. Used in plastics manufacturing and officially known as nurdles, these tiny pellets eventually enter the food chain and are therefore as much a part of us as they are a part of the sea they pollute.

Developed by Ayşe Erkmen for the Turkish Pavilion at the 54th Venice Biennale, *Plan B* (2011) [173] was a large-scale installation designed to explore water-purification processes. In a vast room overlooking a canal, visitors were entangled in a network of brightly coloured pipes that together made up an elaborate yet fully functioning water-purification unit. The various components of the unit were placed at a considerable distance from one another to exaggerate the water-filtration process. In actually transforming water from the

canal into water that visitors could drink, the work drew attention to an abstract and largely invisible process that is nevertheless vital to our existence. As a solution to the issue of water shortage and purification, however, it was a temporary and knowingly futile gesture, rather than an actual resolution to the problem.

The purity of water is a key element of *The Land Foundation* (1998–) [174], a project co-founded by Rirkrit Tiravanija and Kamin Lertchaiprasert and originally called *The Land*. In 1998 the artists bought a disused rice field in Sanpatong, a village near Chiang Mai in north-west Thailand, and began cultivating it so it could start to produce rice again. Water-purification systems were developed, and members of the project set about creating a self-sufficient and sustainable community, including a studio, a gallery and a meditation hall, based around ecologically responsible practices. Since its inauguration, the project has welcomed such artists as Tobias Rehberger and Philippe Parreno, while the land itself has started to produce rice once more.

Water also features heavily in Ursula Biemann's installation *Egyptian Chemistry* (2012) [175], which addresses the geopolitics of water pollution, crop cycles, nitrate production, hydropower and land reclamation. Egypt has long been associated with large-scale land-reclamation and engineering projects, and the video element of Biemann's work traces the impact that humans have had on the flow of the Nile and its ecology. In so doing, *Egyptian Chemistry* not only presents active research through the collection of water samples at specific sites along the river, but also investigates who controls the power of water, be it in political, economic or social terms.[3]

For Basia Irland, the in-depth archiving of an environment also depends on community-based activities. *Apothecary for Creeks and Other Living Beings* (2013) [176] was a site-specific project that involved the artist gathering samples of medicinal plants from Glen Helen in Ohio and recording them through drawings and video. Working alongside ecologists and botanists, and travelling with a customized backpack, Irland often works with local communities; her previous projects have involved artists, members of government, Native American leaders, farmers and everyday water consumers. The ritualistic elements of walking and gathering involved in the preparation of her inventories recall earlier botanical expeditions carried out by explorers. However, rather than exploiting the resources that she finds, Irland creates a social record of the area in which she is working, as well as a more scientific account of the social and environmental costs of unchecked development and industrial pollution.

Tue Greenfort's *Diffuse Einträge* (2007) [177] also analysed a body of water, albeit the proportionally smaller Lake Aasee in Münster. Although this artificial lake is located in a popular park, swimming is forbidden owing to the high level of phosphates in the water. These phosphates, which enter the lake as run-off from the intensive farming that surrounds the city, encourage the growth of algal blooms that, in turn, can produce a substance poisonous to humans. Greenfort's intervention, presented as part of Sculpture Projects Münster in 2007, utilized a liquid manure pump to take water from the lake and then enrich it with iron(III) chloride, which – as a local scientific committee had already

[173] AYŞE ERKMEN – Plan B, 2011. Installation,
water purification units with extended pipes and cables

Plan B was a sculptural installation developed by Erkmen for the Turkish
Pavilion at the 54th Venice Biennale. The resulting 'sculpture' was in
fact a fully functioning water purifier, which took water from the nearby
canal and turned it into drinking water.

[174] RIRKRIT TIRAVANIJA – The Land
Foundation, 1998–. Rice-fields project

The Land Foundation is an ongoing
community-based environmental project.
Consisting of a self-sustaining
environment for the cultivation of rice
in northern Thailand, it involves local
farmers, students and invited arts
practitioners from around the world.

[175] URSULA BIEMANN – <u>Egyptian Chemistry</u>, 2012.
Multimedia video installation

[176] BASIA IRLAND – <u>Apothecary for Creeks and Other Living Beings</u>, 2013.
Glen Helen, Ohio, 2013. Wood, carrying strap, vials, 45 medicinal plants

[177] TUE GREENFORT – <u>Diffuse Einträge</u>,
2007. Modified manure-spreading
machine, 100-litre tank filled with
iron(III) chloride, water fountain

discovered – has a neutralizing effect on phosphates. Once the water had been treated, Greenfort's pump sprayed it back into the lake.

For all its apparent remedial effects, *Diffuse Einträge*, like Erkmen's *Plan B*, was a knowingly ineffective solution to a very real environmental problem. This inbuilt ineffectiveness raises two issues: the ineffectiveness of many of the measures used to tackle environmental degradation, and the sense that art practices – in their temporary forms of intervention – need to be equally mindful of their own inadequacy as actual solutions to problems affecting the environment. This ineffectiveness, however, does not detract from the way in which contemporary art practices develop strategies for raising awareness of environmental issues and, in so doing, how they agitate for a solution, political or otherwise, to these issues.

On the evening of 8 February 1996, a western hemlock tree fell across a ravine in an area of primary forest 72 kilometres (45 miles) from Seattle. Because it had not fallen to the ground, which would have accelerated its decomposition, the tree was still in relatively good condition by the time artist Mark Dion had located it for his project *Neukom Vivarium* (2006) [178], a mixed-media installation located in the Olympic Sculpture Park in Seattle. Having housed the fallen tree in a custom-built greenhouse, Dion used it as a so-called nurse log, allowing it to give rise to an ecosystem that includes fungi, insects, bacteria, lichen and various plants, all of which visitors are invited to inspect. Described by the Seattle Art Museum, which oversees the park, as a hybrid work of sculpture, architecture, environmental education and

horticulture, *Neukom Vivarium* brings together art and science. This conjunction resonates with Dion's own belief that both nature and sculpture should not be seen as objects, but as processes in the making.

Given the political and pedagogical components of much of the work under discussion here, it would be easy to overlook those artists who explore environmental issues in more tangential ways. In 2004 Simon Starling travelled 70 kilometres (43½ miles) across the Tabernas Desert in southern Spain on an improvised, fuel-cell powered bicycle. One of the only true semi-deserts in Europe, the Tabernas was the setting for many of Sergio Leone's spaghetti westerns. It is also home to a research facility developing the use of solar energy for the desalination of seawater. Described as a kind of 'process painting', Starling's *Tabernas Desert Run* (2004) [179] consists of a perspex vitrine containing a painting of a prickly pear cactus – grown using the water that was generated as a waste product by the bicycle's fuel cells – and the bicycle itself. As such, the work references not only Sergio Leone, who introduced cacti into the area in the making of his films, but also the often laboured, if not cumbersome, advancements involved in green technology.

In Chu Yun's *Constellation No. 3* (2009) [180], the viewer enters an almost pitch-black room studded with small dots of light that give an impression of the night sky. Gradually, as our eyes start to adjust to the darkness, we begin to distinguish the outlines of such familiar objects as stereos, televisions and computers, all displaying blinking LED lights. In deliberately choosing older models of such objects, Chu refers back to a

[178] MARK DION – Neukom Vivarium, 2006. Mixed-media installation

Mark Dion's work turned a western hemlock tree that had fallen across a ravine in 1996 into a living ecosystem. The tree was transported from the ravine to the Olympic Sculpture Park in Seattle, where it became the centrepiece of an interactive, multimedia display designed to educate visitors about their environment.

[179] SIMON STARLING – Tabernas Desert Run, 2004. Production photograph, fuel-cell-powered bicycle, Tabernas Desert, Almeria, Spain

[180] CHU YUN – Constellation No. 3, 2009. Installation, dimensions variable

In Constellation No. 3, we are invited to enter a pitch-black room encrusted with star-like lights. As our eyes adjust, we realize that, rather than anything celestial, we are looking at the blinking LED lights of such familiar, everyday gadgets as stereos, televisions and computers.

[181] GUSTAV METZGER – Stockholm June
(Phase 1), 2007. Installation view at
8th Sharjah Biennial

Conceived for Documenta V in 1972, Stockholm
June (Phase 1) was eventually adapted and
realized for the 8th Sharjah Biennial in
2007. It involved the capture and containment
of 120 cars' worth of exhaust fumes, produced
over a period of one week.

REDUCE
ART
FLIGHTS

FREIBURG
BASEL
MULHOUSE

13.06.2013
WWW.REDUCEARTFLIGHTS.LTTDS.ORG

[182] GUSTAV METZGER – Reduce Art Flights,
2007–13. Campaign poster

As an international business, the art world
relies heavily on aeroplanes and other modes
of travel and transport. Reduce Air Flights
was a campaign that, in a playful and indirect
way, encouraged the art world to consider
reducing its consumption of fossil fuels.

[183] HALIL ALTINDERE – Oracle, 2010. From the Mesopotamian Trilogy.
4 photographs, each 50 × 75 cm (19¾ × 29½ in.), video, 10 min. 20 sec.

[184] HALIL ALTINDERE – Mirage, 2008. From the Mesopotamian Trilogy.
3 photographs, each 80 × 120 cm (31½ × 47¼ in.), video, 7 min. 20 sec.

time before the amount of energy used by these stand-by lights had become a matter of public concern. Writing about this piece in *Forgetting the Art World* (2012), Pamela M. Lee observes that the artist 'has made a pointed and instructive work. It is uncanny for all those winking lights, seductive in its glittering appeal and sinister in its revelation.'[4]

Initially planned to coincide with the United Nations Conference on the Human Environment held in Stockholm in 1972, Gustav Metzger's *Stockholm June (Phase 1)* [181] was eventually adapted and realized for the 8th Sharjah Biennial in 2007. Metzger's work, the first of numerous attempts by the artist to address the gradual destruction of the environment, involved the capture and containment of exhaust fumes from 120 cars, all running for a period of one week. In the original conception of the work, the intention was to destroy the cars, either by allowing them to self-combust or by means of the artist's direct intervention.

Metzger, whose work has long been associated with so-called auto-destructive art, has also taken an interest in the part the art world plays in environmental degradation and pollution. In *Reduce Art Flights* (2007–13) [182], the artist launched a campaign that urged the art world to consider its over-reliance on aeroplanes for transporting artists, curators and other practitioners, while also drawing attention to the amount of fuel needed to transport artworks in general. This project returns us to a point made earlier: that to understand fully the politics of the art world as a system, we need also to observe the extent to which it is irredeemably associated with systems of globalization, including transport,

modes of exchange and diverse knowledge economies.

The Sewage Pond's Memoir (2011) [185], an installation consisting of photographs and the projection of a video filmed over a period of just under two years, represents a continuation of Ravi Agarwal's commitment to contemporary environmental issues in his practice as an artist and environmentalist. Agarwal describes *The Sewage Pond's Memoir* as a project that confronts the idea that all is well with nature simply because it appears to be undamaged. 'It is being destroyed', Agarwal observes, 'even if it seems it is still intact.'[5] The work focuses on the forest of the Delhi Ridge, an ancient ecosystem that has for centuries sustained high levels of pollution but is facing an even greater threat from the dumping of both sewage and rubbish, as well as the problems caused by illegal constructions.

Halil Altındere's *Mirage* (2009) [184] and *Oracle* (2010) [183] both explore a long-running political dispute between the Turkish government and Kurdish villagers in the Southeastern Anatolia Region of Turkey. The dispute concerns areas of land earmarked for flooding as part of the government's Güneydoğu Anadolu Projesi (GAP), a regional development programme that includes the building of a series of dams to generate electricity and provide new sources of irrigation for agribusiness. Exploring the political and social implications of water as an economic asset, *Mirage* features such images as men being held aloft in the bucket of a bulldozer, their hands raised in prayer for rain, and others kneeling on the desert-like ground as they are baptized with a brand-name bottled water. Elsewhere, the politics

of the control of water are examined through surreal images of destruction, including, in *Oracle*, the eerie sight of a minaret protruding from the middle of a lake, the only visible remnant of the submerged village of Halfeti, flooded in the 1990s as part of GAP.

Amar Kanwar's *The Sovereign Forest* (2012) [186] is a multimedia installation that incorporates a range of distinct yet interrelated components, including 266 varieties of rice seed, poetry, music, still and moving images, and commentary. The work takes as its starting point the Indian state of Odisha, where Kanwar has been filming and carrying out research since 1999. Located on the subcontinent's east coast, by the Bay of Bengal, the state has in recent years witnessed a number of conflicts between local communities and both the government and corporations over the rights and access to local lands and rivers. The essayistic format of Kanwar's installation, its use of narrative and discourse, is part of the artist's ongoing critique of mining in Odisha and, more specifically, its detrimental impact on local communities, in social, economic and environmental terms.

Throughout *The Sovereign Forest*, and in particular in the single-channel projection 'The Scene of Crime', we are exposed to images of land that is in the process of being acquired by the Indian government and multinational corporations. The work thus becomes a disturbing final account of that which will soon cease to exist, not unlike the rare rice seeds that make up a key component of the work. Given the current rate of environmental degradation, and the imminence of a 'tipping point' beyond which any solution will prove ineffective (if, indeed, that point has not already been passed), there is a sense that many of these artworks are dealing with environments that are no longer extant. And herein lies something of a conundrum for artists producing work about the imminence of environmental catastrophe: they are often representing environments that are beyond repair. As Mark Dion has noted in relation to his own work, 'It shows that, despite all of our technology and money, when we destroy a natural system, it's virtually impossible to get it back.'[6]

[185] RAVI AGARWAL – The Sewage Pond's Memoir, 2011.
Colour video projection with sound, 6 min. 30 sec.

and so began preparations for the trial

The Betel Leaf of Dhinkia village, Erasama
District Jagatsinghpur

[186] AMAR KANWAR – The Scene of Crime, 2011. Single-
channel film, HD video, colour, sound, 42 min. Part of
The Sovereign Forest, 2012. Mixed-media installation
including 5 films, 3 handmade books, 2 photographs,
5 small books, rice seeds

ECONOMIES

Capital and Its Distribution

THE BASIC CONFRONTATION
WHICH SEEMED TO BE
~~COLONIALISM~~ VERSUS ANTI-
COLONIALISM, INDEED
~~CAPITALISM~~ VERSUS
~~SOCIALISM~~, IS ALREADY
LOSING ITS IMPORTANCE.
WHAT MATTERS TODAY, THE
ISSUE WHICH BLOCKS THE
HORIZON, IS THE NEED
FOR A <u>REDISTRIBUTION</u> OF
WEALTH. HUMANITY WILL
HAVE TO ADDRESS THIS
QUESTION, NO MATTER
HOW DEVASTATING THE
~~CONSEQUENCES~~ MAY BE.
-
FRANTZ FANON

THE FINANCIAL CRASH OF 2007 AND THE ENSUING ECONOMIC CRISIS SAW CONFIDENCE IN THE MARKET, A SYSTEM THAT WAS APPARENTLY CAPABLE OF REGULATING ITSELF, PLUMMET.

Stemming from a 'subprime' mortgage fiasco, as well as speculative gambling on stock markets and an apparent disregard for banking regulations, the financial crisis saw investments and assets lose an unprecedented amount of their nominal value. For many, the subsequent recession was comparable to the Great Depression of the 1930s, with costly bailouts of banks and companies deemed 'too big to fail' adding to the public debt burden. While the downturn in markets seems to have been reversed and the threat of total collapse averted, the costs, across the world, are still being counted.

The causes of the financial crisis, in addition to those mentioned above, include the unchecked growth of a housing bubble, the availability of easy credit, dubious banking practices, increased global debt, deregulation and free-market ideologies (both being key to neo-liberal policies concerning growth), a misplaced trust in the market as a system of regulation, a boom in commodities, predatory lending practices and tax evasion. To this list we must add the extraordinarily one-sided distribution of capital across the globe. This phenomenon is succinctly visualized in Mladen Stilinović's *Nobody Wants to*

See (2009) [187], an installation consisting of thousands of sheets of paper on which the number 3 has been printed 600 million times. Stilinović's work presents a simple but telling fact: that the wealth of the three richest people in the world today is equal to the combined wealth of 600 million of the world's poorest.

A deceptively simple conceptual work, *Nobody Wants to See* renders visible the extreme economic disparities that exist between the wealthiest and poorest in contemporary society – disparities that, some would argue, are an inherent feature of capitalism and neo-liberal policies on wealth distribution. And despite economic recession and global financial crisis, this uneven distribution of wealth not only remains unchecked in the current climate but also, if anything, is intensifying. It is with these points in mind that this chapter begins with an examination of those artists who are revisiting key aspects of the neo-liberal financial landscape, such as the distribution of wealth, the market, bonuses, capitalism, credit, debt repayment, consumerism, offshore bank accounts and the abstract nature of money. As we have seen elsewhere in this book, this involves art practices that do not merely ruminate on or detail the current state of affairs, but actively intervene in the issues being explored.

Scripted by the artist herself, Melanie Gilligan's four-part fictional drama *Crisis in the Credit System* (2008) [188] concerns a group of financial experts and economic analysts who are asked by their employers to participate in a brainstorming and role-playing workshop. In light of the absence of trust in the current financial system, one of their tasks is to come up with a system

[187] MLADEN STILINOVIĆ – Nobody Wants to See,
2009. Installation view at Ludwig Museum,
Budapest, 2011

Nobody Wants to See consists of a single
sheet of paper bearing the number 3 next
to three stacks of paper on which the same
number has been printed 600 million times.
In a deceptively simple manner, Stilinović
thus draws our attention to the fact that the
wealth of the three richest people in the
world is equal to the combined wealth of
600 million of the world's poorest.

NOBODY WANTS TO SEE

THE THREE RICHEST MEN IN THE WORLD
OWN AS MUCH AS SIX HUNDRED MILLIONS
OF THE POOREST PEOPLE

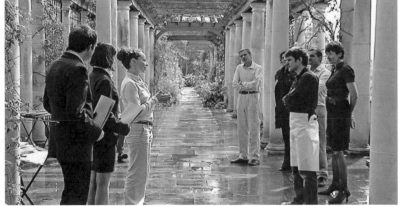

[188] MELANIE GILLIGAN – Crisis in the Credit System, 2008.
Video, colour, sound, 9 min. 56 sec.

that can measure distrust in the market and convert it into a formal investment strategy. Despite their efforts to rethink various market systems, and the promise of the workshop organizers that the participants will leave with 'optimal adaptive strategies', everyone involved in the workshop is eventually sacked. Perhaps, however, the workshop has served its purpose, and the participants are indeed in a position to adapt to the current financial climate, albeit in a period of prolonged unemployment.

Produced by Superflex, an artists' group founded in 1993 by Jakob Fenger, Rasmus Nielsen and Bjørnstjerne Christiansen, *The Financial Crisis* [189] appeared in 2009, two years after the initial crash and in the midst of the subsequent global recession. In the video, a hypnotist invites us to close our eyes and imagine different circumstances and emotional states. Over the course of four sessions – 'The Invisible Hand', 'George Soros', 'You' and 'Old Friends' – he guides the viewer to a new state of mind, one that creates an emotional distance between them and the fear, anxiety and frustration produced by the dire state of the economy.

The Anarchist Banker (2010) [190] is a 30-minute film by Jan Peter Hammer based on Fernando Pessoa's 1922 short story about a one-man fraud that almost bankrupted the Portuguese state – an event that led indirectly to the military coup of 28 May 1926 and the de facto dictatorship that lasted until the 1970s. In Hammer's film, the story has been adapted for audiences living in the wake of the 2007 financial crisis and the recession-led 'credit crunch' that followed. Rather than offering any ameliorative, as in Superflex's work,

The Anarchist Banker is scripted as a dialogue between a talk-show host and a banker, Arthur Ashenking (who is modelled on Artur Alves dos Reis, the financier who inspired Pessoa's original story), whose spirited defence of neo-liberalism and the economic policies of Milton Friedman seems at odds with the current recessionary climate. Ashenking not only makes a strong case for free-market ideology, privileging personal success over solidarity, but also engages with the question of whether capitalism, and the free-market ideology that underwrites it, works in general, for both individuals and communities.

In Steve Lambert's *Capitalism Works for Me! True/False* (2011–) [192], the question of the work's title is addressed directly to those affected by the financial crash. Confronted with a billboard-sized, neon-lit sign with an attached scoreboard, participants are asked to vote true or false – by means of buttons attached to the sign – in response to the question. Here, Lambert utilizes the visual language of Broadway musicals and theatre to attract participants, while the scoreboard system would be familiar to anyone who has attended a sports event. This visual aesthetic undoubtedly makes the work inviting, but the questions it raises are significant, enquiring as they do into the impact of capitalism on people's lives. In displaying his work in public places where people of all ages and backgrounds can vote on the matter, Lambert produces a space for open discussion. 'This is what art does well', Lambert has noted. 'It creates a space where new ideas and perspectives can be explored. A space unlike any other.'[1]

In *Recession* (2009) [194], Dan Perjovschi covered the walls of the

[189] SUPERFLEX – The Financial
Crisis, 2009. Video, colour,
sound, four parts, 12 min.

[190] JAN PETER HAMMER –
The Anarchist Banker, 2010.
HD video, colour, sound, 30 min.

[191] DREAD SCOTT –
Money to Burn, 2010.
Performance

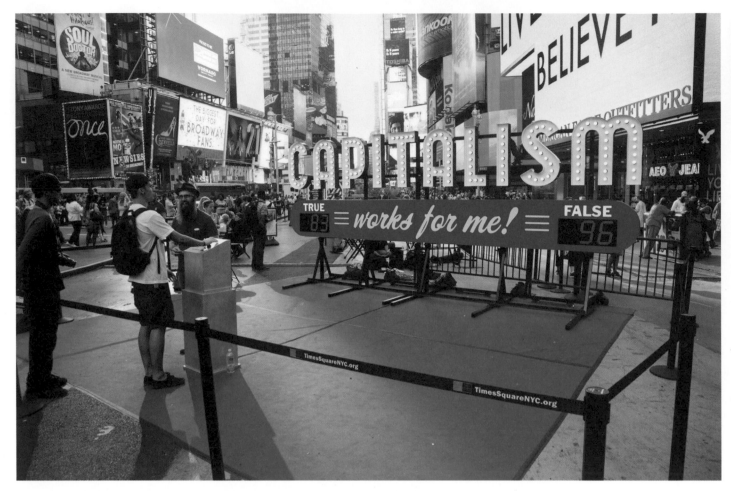

[192] STEVE LAMBERT – Capitalism Works for Me! True/False, 2011–.
Aluminium and electrical installation, 2.7 × 6.1 × 2.1 m (8¾ × 20 × 7 ft)

[193] KARMELO BERMEJO – The Grande Finale. Bank Loan Granted to an Art Gallery Used to Pay a Firework Display at the Closing Ceremony of Art Basel Miami Beach 2009, 2009. Colour photograph, 125 × 180 cm (49¾ × 70¾ in.), and HD video transferred to DVD, colour, sound, 2 min.

[194] DAN PERJOVSCHI – Recession, 2009.
Installation at the Ludwig Forum, Aachen

[195] ALICIA HERRERO – Act II – Bank: Art & Economies, 2010.
From Public Considerations, a Symposium in Three Acts.
Performative talk, video and publication

[196] MONA VATAMANU AND FLORIN TUDOR – Le Capital, 2007-11.
Film, colour, sound, 48 min. 24 sec.

Ludwig Forum in Aachen in Germany with his trademark chalk cartoons. As in the case of Lambert's work, the choice of medium was significant, producing an accessible and yet invariably transient series of questions and comments in the context of a gallery space. On entering the gallery, viewers were confronted with such statements as 'Take a good look, you payied [sic] for this' and 'Made in Germany (with a little help of [sic] China)', as well as a cartoon of someone shouting 'Less is more' at a man holding an empty cup. The sardonic wit of Perjovschi's work does nothing to lessen the fact that the financial crisis has been catastrophic for many, that the burden of it has not been shared by all, and that a minority appear to have profited from it.

While Perjovschi's work uses elements of art theory and a newspaper-cartoon aesthetic to explore, in often humorous terms, the economic crisis, Karmelo Bermejo's *The Grande Finale. Bank Loan Granted to an Art Gallery Used to Pay a Firework Display at the Closing Ceremony of Art Basel Miami Beach 2009* (2009) [193] is a more self-reflexive work. As explained in its title, Bermejo's installation involved an art gallery borrowing money from a bank to finance a firework display that, when lit, produced the word 'Recession'. The video of this work shows the fireworks being lit, the word 'Recession' combusting into life, and then the display burning out until nothing remains but a few sparks. If we were looking for a fitting epitaph for the credit-fuelled boom that preceded the financial crash of 2007, then Bermejo's work would certainly provide it. Crucially, it also represents a pertinent enquiry into the politics of why and to whom banks were lending money in the first place.

Dread Scott's performance *Money to Burn* (2010) [191] takes a more direct and, perhaps, nihilistic approach to the question of economic value and financial crises. Strolling up and down Wall Street in New York, Scott can be seen with US dollars pinned to his chest imploring anyone who has 'money to burn' to bring it to him. In a methodical and apparently unconcerned manner, the artist proceeds to burn money – most of it his own – and gather the ashes in a metal bucket. He is eventually stopped by a police officer, who appears to be on the verge of arresting the artist for an offence of some kind. In its destruction of money in this way, and on the hallowed ground that is Wall Street (also the title of the 1987 film that spawned the phrase 'Greed is good'), Scott's performance not only questions the value of money but also alludes to the fact that billions of dollars had been 'burned' in the very buildings before which it is taking place.

The history of capital and capitalism is explored in Mona Vatamanu and Florin Tudor's *Le Capital* (2007–11) [196], a film in which the artists present a lecture on Karl Marx's seminal volume. Published in 1867, *Das Kapital* – the subtitle of which, *Kritik der politischen Ökonomie* (Critique of political economy), is central to the book's overall message – proposes a far-reaching, if not immodest, thesis: that the exploitation of labour, being the source of profit and so-called surplus value, is the guiding principle and motivating force behind capitalism. In the film, we see the artists slowly turning the pages of a copy of Marx's book, an intense and laboured process that could not be further away from the pace of contemporary economics and modern-day working practices. This strategy

is intended to encourage us, the viewer, to read the book together with Vatamanu and Tudor, who consistently revisit their past and retrospectively explore the ideology they were immersed in as youngsters growing up in Romania.

In *Bank: Art & Economies* (2010) [195], the second 'act' in Alicia Herrero's *Public Considerations, a Symposium in Three Acts*, the legacy of Marx's thesis and how it is understood in today's financial climate were explored across a number of platforms. This complex work consisted of several films, a publication and a series of talks in different auditoriums across Buenos Aires. The work included contributions from artists, activists, a political analyst and economist, and a Marxist economist, who presented essays, theories and experiments. Here, as we have seen throughout this book, art's involvement in the public sphere created a space in which a variety of different audiences could engage in discussion and debate about subjects as diverse as financial regulation, the politics of the black market and the future of capitalism.

The black market, in which goods and services are traded illegally, is a major component of current economic systems. Estimated to involve 1.8 billion people worldwide, and believed to be worth more than $1.7 trillion, the black market often relies on barter and other forms of non-monetary exchange.[2] An overt emphasis on the black market, however, tends to obscure the twilight world of offshore accounts and the non-payment of taxes. These and other financial irregularities are examined in *Headless* (2007–) [197], a large-scale performance-art project led by Goldin+Senneby, a 'framework for collaboration' set up by the artists

Simon Goldin and Jakob Senneby. At the heart of the project, which has involved writers, artists, designers, curators, journalists, bloggers, academics, private detectives and film-makers, is an investigation into Headless Ltd, a real yet mysterious offshore company located in the Bahamas. The project has also given rise to a self-referential detective novel – *Looking for Headless* by the fictional author K. D. – in which the novelist John Barlow, who is writing a book on behalf of two artists working under the name of Goldin+Senneby, is sent by them to investigate Headless. At one stage, Barlow encounters a British academic called Angus Cameron, who, in real life, has acted as 'spokesperson' for the project since 2008. In part mimicking the far-from-transparent system it sets out to explore, *Headless* is itself an apt lesson in the obfuscation and tenacity involved in avoiding current financial regulations.

In our discussion of contemporary art's engagement with the current economic crisis, it is important to move beyond the specifics of banking practices and financial transactions and consider how artists have contributed to the alternative systems of exchange and distribution that exist both beyond and alongside current markets. Jeanne van Heeswijk's project *2up2down/Homebaked* [198] began in 2010 and was showcased as part of the Liverpool Biennial in 2012. Situated in the Anfield area of Liverpool, Mitchell's Bakery was much used by the local community, including the football supporters who frequented it on match days (Liverpool Football Club's ground being located only a short distance away). In 1998 the entire area was earmarked for redevelopment, and many properties were placed under

[197] GOLDIN+SENNEBY – Headless, 2007–.
Above: 'The Decapitation of Money', with Angus
Cameron (economic geographer), K.D. (fictional
author), Anna Heymowska (set designer), Johan Hjerpe
(graphic designer), Kerwin Rolland (sound designer).
Installation view at Kadist Art Foundation, Paris,
2010. Right: 'The Decapitation of Money', a walk in
the Marly forest with Angus Cameron, spokesperson
of Goldin+Senneby

[198] JEANNE VAN HEESWIJK – 2up2down/
Homebaked, 2010–. Clockwise from
top left: 2up2down project base at
former Mitchells Bakery, 2012; Baking
workshop, 2013; Rise-up Anfield, 2011

[199] MARTHA ROSLER – Above: Meta-Monumental Garage Sale, Museum of Modern Art, New York, 2012. Installation. Right: Meta-Monumental Garage Sale (detail, Mercedes), Museum of Modern Art, New York, 2012

[200] RENZO MARTENS – Institute for Human Activities, 2012–. Organization

[201] HANS HAACKE – BONUS-Storm, 2009. Installation, flashing light box and six wall-mounted industrial fans, light box 121.9 × 182.9 × 16.5 cm (48 × 72 × 6½ in.), each fan 83.8 cm (33 in.) diameter × 45.7 cm (18 in.) depth

[Page 209][202] THEASTER GATES – Dorchester Projects, 2009. 2-year design-build project, Chicago

compulsory purchase orders and demolished. However, the multimillion-pound investment expected in the area never materialized, and many of the buildings were left abandoned or, in the case of Mitchell's Bakery, financially unviable. Having spent two years in the area prior to 2012, Van Heeswijk organized a group of more than twenty people to work with architects and other design specialists in order to renovate the bakery, which has since become a shop, a meeting place and a project space for the surrounding community of Anfield.

In 2010 Martha Rosler staged the *Fair Trade Garage Sale* at Basel's Museum of Cultural History as part of Art Basel, a premier art fair attracting collectors and dealers from across the world. The phenomenon of the 'garage sale' involves householders displaying unwanted goods at the front of their house and offering them for sale to passers-by, an activity that is in marked contrast to the high-stakes transactions that were taking place at Art Basel. In a manner similar to Van Heeswijk's self-organized, community-based projects, Rosler's work draws on the ideal of a local community and an alternative economy of commodity exchange. The first *Garage Sale* was staged in 1973 at the art gallery of the University of California, San Diego. It has since been held in Vienna, Barcelona, Stockholm, Dublin, Hanover, London and, in 2012, New York, where, under the title *Meta-Monumental Garage Sale*, it occupied the central atrium of the Museum of Modern Art [199]. When asked if *Garage Sale* was a historical work or a contemporary piece, the artist replied, 'by its nature, *Garage Sale* cannot be a historical work because commerce is always located in the present.'[3]

In both Rosler's and Van Heeswijk's project, we see an artist not only engaging with local economies but also investing, so to speak, in the political ideal of community. These forms of engagement are equally in evidence in Theaster Gates's *Dorchester Projects* (2009) [202], in which the artist acquired a series of abandoned houses and businesses on Chicago's South Side with the intention of turning them into a cultural hub for the local community. With considerable input from members of this community, *Dorchester Projects* has grown into a paradigm of sorts for artist-led projects focused on the economic revitalization of urban areas.

While Gates's interventions serve as a model for the cultural and socioeconomic renewal of specific urban locales, Renzo Martens's *Institute for Human Activities* (2012–) [200] is concerned with the revitalization of a very different kind of community. In a settlement located 800 kilometres (500 miles) from Kinshasa, the capital of and largest city in the Democratic Republic of the Congo, Martens has initiated a gentrification programme based on the use of art and its networks as a means of generating economic wealth. This scheme, operating in one of the world's most disadvantaged regions, is designed to attract arts practitioners and investment into an area that would otherwise remain impoverished. However, it also provides a space in which to reflect on and acknowledge the economic mechanisms through which art as a practice operates the world over.

In focusing on the ways in which art can be used to influence positively the lives of the communities it co-opts into its practices, Martens's project both expands

on and deconstructs the economies within which art operates. One of the key strategies employed by Martens involves an outreach programme that directs its resources towards developing relations with the local community. The aim, ambitiously, is to promote economic development through the forging of productive connections between art as a practice and the use of business and development aid. This ideal of civil renewal through forms of artistic practice and active citizenship seeks to strengthen community bonds by means of nascent community-based groups and activities, of which cultural practices are but one, albeit crucial, element. The project, thereafter, asks a fundamental question: who benefits from the *work* of art?

In Hans Haacke's *BONUS-Storm* (2009) [201], we are presented with a different take on art as an asset. Consisting of six wall-mounted industrial fans beneath a flashing light box that reads 'BONUS', the work adopts the language of game shows to comment on the bonus culture at the heart of the banking system. This culture has been acknowledged as helping to promote the risk-taking that played a significant part in the financial crisis of 2007. Haacke, who has long been central to an artistic tradition concerned with deconstructing the economics of art, including its production, distribution and consumption, is also offering a critique of where many of those bonuses went – bearing in mind that investment in art is practised not only by collectors and dealers, but also by hedge funds and investment managers.

Ron Terada's *Catalogue* (2003) [203] took a different approach to these questions, resulting, as was the intention of the work, in nothing of actual value other than a catalogue. In most cases, a catalogue is a means of promoting work or of allowing it to be enjoyed beyond its exhibition in a gallery; however, Terada's show was about the production of the catalogue itself, which, in turn, formed one of the principal components of the show. The $40,000 cost of producing the catalogue was met by a variety of sponsors. In return for their contribution, each sponsor was named in the catalogue and received a signed limited edition – limited to the number of sponsors – of the finished article. Their names were also used in the publicity for the show, which itself appeared as part of the exhibition. In making explicit the connections between sponsorship, artistic practices and the advertising and publicity for a show, *Catalogue* represents a comment on both an economy based on monetary value and the value that accrues to an artwork by virtue of such extraneous factors as catalogues, advertising and publicity.

In Andrea Fraser's 60-minute video *Untitled* (2003) [204], the economic relationship between an artist and their collectors is exposed by means of a sexual liaison. In preparation for the work, Fraser approached the Friedrich Petzel Gallery in New York to arrange a commission between her and a private collector. The nature of this commission would be a sexual encounter between Fraser and the collector; moreover, the encounter would be recorded, and a copy of the recording would be given to the collector as part of the commission. Here, the economy of collecting and an artist's relationship to her collectors is, so to speak, stripped bare.

The various transactions involved in the production of an artwork are also

key to understanding the work of Tino Sehgal, whose choreographic installations have been staged at Documenta 13 in Kassel in Germany, at Tate Modern in London, at the Guggenheim Museum in New York, and at the 51st and 55th Venice biennales, where, on his second appearance, he was awarded the prestigious Golden Lion award for best artist.

In Sehgal's Tate Modern piece, *These Associations* (2012), the gallery's Turbine Hall was populated by seventy 'interpreters', who mingled with visitors and engaged them in a series of activities and conversations. In many of the artist's installations, as was the case here, the spectator is a key factor in the work's production. However, no documentation or reproduction of the work is allowed, and in order to purchase one of Sehgal's creations – which sell for tens of thousands of pounds – the buyer must engage in a conversation with the artist in the presence of a notary during which he must agree to a number of strict conditions concerning, among other things, the work's display. There is no final contract or certificate of authenticity, and the transaction is sealed with a handshake. Given the intricacies involved here, it may come as no surprise to learn that Sehgal studied political economy at university.

In a world of readily available credit, Janice Kerbel embarked on several years of research that involved the extensive study of a bank located at 15 Lombard Street in London. The resulting documentation, brazenly presented in *Bank Job* (1999) [205], consisted of photographs of the building, maps, blueprints, the location of the bank's security cameras and details of the most effective escape routes a person might follow should they actually choose to rob the bank, right down to directions to a hideout in Spain. In addition to redistributing wealth, a bank heist, it would seem, offers one of the more direct means of critically engaging with an economy based on capital accumulation and a free-market ideology.

[203] RON TERADA – Catalogue, 2003.
Publication paid for by the participation of 10
corporate and 18 private sponsors, 96 pages, hardback,
offset print on uncoated paper, 27 × 20 cm (10½ × 8 in.)

An exhibition catalogue is usually seen as a marketing
tool, something to supplement an artist's work and raise
awareness of it after the show has closed. However,
in an inversion of that relationship, Terada made the
catalogue's production the focus of the show, drawing,
in turn, explicit attention to its marketing function
and its existence as an object of value in its own right.

[204 ANDREA FRASER – Untitled, 2003.
Video, colour, sound, 60 min.

Collectors of art tend to collect physical
objects and thereafter display them as signs
of both culture and value. In this work, the
artist became the object, and the collector
purchased her services. That those services
were sexual could be read as a wry comment
on the nature of both producing art and
collecting it.

[205] JANICE KERBEL – Bank Job, 1999.
Installation with 8 text panels, 24 black-
and-white photographs, aerial photograph,
Ordnance Survey map, blueprint, city map,
string, pins, cork, wood

In the late 1990s Janice Kerbel posed as an
architecture student and staked out a bank in
London. After eighteen months, she published
an in-depth and surprisingly rigorous set
of instructions enabling anyone not only to
rob the bank in question but also to make an
effective getaway after doing so. To date,
the bank has remained secure.

KNOWLEDGE

Producing Information in a Globalized World

SOMETIMES,
IN A DAZE,
THEY COMPLETELY
~~DISMANTLED~~
THE ~~CADAVER~~,
THEN FOUND
THEMSELVES
HARD PUT TO
FIT THE ~~PIECES~~
TOGETHER AGAIN.
-

GUSTAVE FLAUBERT

CONTEMPORARY ART HAS LONG BEEN ASSOCIATED WITH EXPLORING AND RETRIEVING FORMS OF KNOWLEDGE THAT, IN ONE WAY OR ANOTHER, HAVE BEEN OBSCURED FROM VIEW.

As researchers and archivists of information and knowledge, artists often engage in that most political of activities: the exposure and representation of that which was not only hidden away or absorbed into dominant narratives, but also prevented from being considered in broader, more open debates and thereby rendered apolitical. Throughout this chapter, the issue of how knowledge is produced and in what forms, together with the politics of disseminating information in a globalized world, will be central to an examination of how art is creating alternative systems of knowledge production.

Against this backdrop, the 'knowledge economy' has emerged as a key component of any consideration of art as a practice and the production of information. The knowledge economy is focused on the production and management of knowledge in an interconnected, globalized world where information and expertise – the mental capacity of workers – are as critical as other economic resources or, indeed, carry more value than products and services. In the context of our discussion, it

is also important to observe how the Internet and the rise of social media have realigned the relationship between information retrieval and systems of knowledge production.

In Bureau d'Études's *The World Government* (2005) [206], systems of governance are explored in a detailed, information-based map. The complexity of the French collective's work is a direct reflection of the myriad interconnections and crossovers that exist between multinational corporations, world governments and the other, less well-defined political agents that are involved in global governance. Knowledge is politicized here inasmuch as it reveals nodes of influence that exist beyond both political and national boundaries. The key to the success of Bureau d'Études's maps is the way in which they are able to convey substantial amounts of information in a relatively digestible form. Their previous maps have covered such subjects as prison complexes, European surveillance systems and the world's financial systems.

The uncovering of hidden narratives, and the information contained therein, was central to the work of Mark Lombardi, a one-time reference librarian in the Fine Arts Department of the Houston Public Library. In the early 1990s Lombardi began researching a number of scandals, including the Bank of Credit and Commerce International (BCCI) affair and the so-called Savings and Loan crisis (which saw the failure of approximately a quarter of America's savings and loan associations). During the course of his research, Lombardi generated thousands of index cards, which he soon found to be an impractical and unwieldy form of information storage.

[206] BUREAU D'ÉTUDES –
The World Government,
2005. Map

[Page][209] ASHLEY HUNT –
A World Map: In Which We
See, 2004–11. Drawn at
18th Street Gallery, Los
Angeles, in 2009. Chalk
and pastel on blackboard

[207] MARK LOMBARDI – BCCI-ICIC & FAB 1972-91 (4th Version), 1996-2000.
Coloured pencil and graphite on paper, 132.1 × 350.5 cm (52 × 138 in.)

[208] MARK LOMBARDI – George W. Bush, Harken Energy, and Jackson Stevens c. 1979-90 (5th Version),
1999. Graphite on paper, 61.3 × 122.6 cm (24 × 48¾ in.)

It was at this stage that he started presenting his research as written outlines of events and institutions and then as hand-drawn diagrams. This combination of image and text ensured that Lombardi could not only follow the complexities involved in these scandals but also plot them for future researchers and viewers.

The numerous connections that exist between governments and corporations in the global economy are extensively presented in *George W. Bush, Harken Energy, and Jackson Stevens c. 1979–90 (5th Version)* (1999) [208], a capacious work that outlines the ties between the Bush and Bin Laden families. In *BCCI-ICIC & FAB 1972–91 (4th Version)* (1996–2000) [207], we see a network of relationships between intelligence agencies in the United States, Britain, Pakistan, Saudi Arabia and the United Arab Emirates, all facilitated by the BCCI and the International Credit and Investment Corporation. This particular work documents just under two decades of activity, and became infamous after attracting the attention of the FBI in the aftermath of 9/11.

Throughout the work of artist and activist Ashley Hunt there is an intention to schematize 'invisibilities' and give form to indistinct knowledge systems. In his large-scale work *A World Map: In Which We See* (2004–11) [209], colourful nodes orbit one another in a series of increasingly complex relationships, with the links between each node, as in the work of Mark Lombardi, suggesting specific relationships. Areas associated with 'bare life' connect to 'sovereign power', 'privilege/subjection', 'inclusion/ exclusion' and 'human rights'; elsewhere, phrases appear linked in a causal chain, such as 'bodies stripped of social function', 'bodies stripped of utility for state/capital reproduction and accumulation' and 'bodies stripped of rights'.[1]

This graphic-led approach to the interpretation and communication of knowledge has been embraced by Visualizing Palestine, whose projects use graphics as a means of understanding the sociological aspects of Palestine's relationship with Israel. The goal of Visualizing Palestine's work, which combines social sciences, information technology, design and urban studies, is to effect a call for social justice based on visual narratives of inequality and dispossession. For *Gaza Water Confined and Contaminated* (2012) [211], the group developed an 'infographic' that details the water supply to Gaza and the fact that 117 municipal wells in the city are polluted (meaning that 95 per cent of the water is unfit for human consumption). Speaking of their practice, members of Visualizing Palestine have observed that although visuals are often used to highlight social injustices, they remain underused, which is precisely where their infographics come in: 'they bridge the gap between the unedited information – that packs relatively little punch – and the viewer, who wants to get the whole story quickly.'[2]

In Claude Closky's *Untitled (NASDAQ)* (2003) [210], we are presented with information that has been generated by the stock market and relayed via the Internet. For many, the raw data of such stock exchanges as NASDAQ (National Association of Securities Dealers Automated Quotations) is impenetrable and confusing. Transferred to wallpaper and hung on a wall in Closky's work, this information is further abstracted

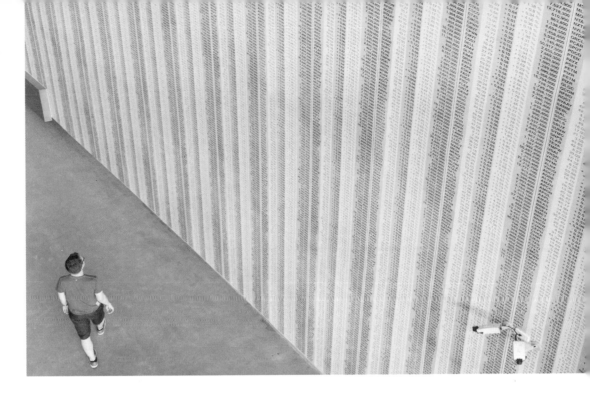

[210] CLAUDE CLOSKY – Untitled
(NASDAQ), 2003. Wallpaper,
silk-screen print, dimensions
variable. Exhibition view at
21st Century, Art in the First
Decade, Gallery of Modern Art,
Brisbane, 2010

[Page 221][213] HASAN ELAHI –
Tracking Transience, 2002–.
Interdisciplinary project

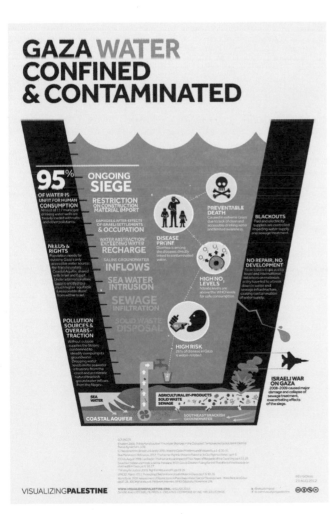

[211] VISUALIZING PALESTINE – Gaza Water Confined
and Contaminated, 2012. Infographic

[212] PRATCHAYA PHINTHONG – An Average Thai Berry
Picker's Income, 2010. Framed Swedish notes and
coins, 76.6 × 47.1 cm (30 × 18¾ in.)

into an arabesque of data. Historically, wallpaper designs have reflected the tastes and mores of a particular era. In replacing the more decorative elements of wallpaper with numbers, Closky refers to one of the more sobering aspects of modern society: the sense that it is figures, in their definition of monetary value, that determine our age, and that we are increasingly governed by choices made in financial markets.

In contrast to the global nature of the preceding works, Pratchaya Phinthong's installation *An Average Thai Berry Picker's Income* (2010) [212] considers the meaning and uses of information at the level of a single worker. Phinthong conceived of the installation during a residency at the Centre d'Art Contemporain de Brétigny, approximately 35 kilometres (22 miles) to the south of Paris, where, instead of working in the centre, Phinthong chose to join a group of Thai berry-pickers in Sweden. At the end of the picking contract, Phinthong and the other workers were paid 8,000 krona each (of a promised 30,000 krona), of which only 2,513 krona, approximately £235, remained after petrol and food costs had been deducted. For the installation, Phintong displayed this paltry sum in a glass vitrine for public consumption. During the course of his berry-picking, the artist had also sent daily text messages to the curator at Brétigny with details of the weight of berries he had picked that day. This number was then represented in the exhibition space in the form of an equal weight of random objects, waste and recycling. In Phinthong's work, the abstract figures of dubious labour practices are given material weight with the help of objects deemed as inconsequential as the labourers involved in berry-picking seem to be in the eyes of their employers.

The personalization of information for political purposes is taken to its extreme in a work by Hasan Elahi. Having been detained and questioned at Detroit Airport in June 2002 for supposed terrorist activities, Elahi was subjected to a further six months of questioning before being cleared of all suspicion. Concerned that he would run into similar problems the next time he tried to re-enter the United States, he began voluntarily to inform the FBI of his whereabouts. What began with a few phone calls and emails eventually developed into *Tracking Transience* (2002–) [213], a comprehensive account of Elahi's daily activities, including photographs of his meals and a website (www.trackingtransience.net) that records his location several times a day. In this radical form of self-surveillance, Elahi raises questions about the politics of not only immigration control but also technology and knowledge production.

This ambition to capture and relay information about individual movements also informed Wafaa Bilal's *3rdi* (2010–11) [214], a project that took a similar, if even more radical, approach to monitoring and self-surveillance. In 2010 Bilal had a small camera surgically attached to the back of his head. The photographs taken by this camera – one per minute – were then transmitted to a website, thereby creating a visual account of Bilal's movements across time and space. In both Elahi's and Bilal's work, we see the politics of self-surveillance emerge in the application of technology and the systems of communication enabled and supported by the Internet.

[214] WAFAA BILAL – 3rdi, 2010–11.
Year-long performance

In 2010 Wafaa Bilal had a camera inserted into
the back of his head. Despite the discomfort
involved, the artist used this camera to
record images of his daily life at a rate of
one per minute; these images were then relayed
to a dedicated website. As a result of his
unwavering commitment to the idea, the project
lasted for a total of 369 days.

[215] TARIQ HASHIM – www.gilgamesh.21, 2007.
Video, colour, sound, 52 min.

In Hashim's film, two men living very different lives in very different
parts of the world attempt to rehearse a play via the Internet. One,
the artist, lives in Copenhagen, where the Internet connection is good;
the other, however, lives in Baghdad, where blackouts regularly bring
a halt to online services. In contrasting the two men's varying levels
of access to the Internet and the 'information superhighway', the film
highlights a wider sense of societal breakdown in Iraq.

Tariq Hashim's film *www.gil-gamesh.21* (2007) [215] documents a long-distance collaboration between the artist, then living in Copenhagen, and Basim al-Hajar, who was living in Baghdad. Detailing the politics of access to communication and means of information exchange, the film follows the two men as they rehearse a dramatization of the Babylonian *Epic of Gilgamesh* using webcams, YouTube and text messages. In Iraq, where the electricity supply is erratic at best, the Internet connection is particularly unreliable. Thus, al-Hajar must suffer the consequences of residing beyond the reach of the so-called information superhighway, which has revolutionized human interaction.

In the aftermath of the revolutions and uprisings that swept across the Middle East and North Africa in 2011, many looked to artists to re-present and reinterpret these events for a global audience. However, as we saw in our earlier discussion of Ahmed Basiony's work (page 96), this can be both problematic and reductive, with art being co-opted to make a political point. One of the collectives working in Egypt throughout the uprisings was Mosireen, which has been instrumental in rethinking how information is relayed and produced during a time of conflict. The organization, which provides training and technical support for citizen-based journalism, organizes public screenings and events across Egypt. For its large-scale initiative *Tahrir Cinema* (2011–; see pages 4–5), the group set up an open-air cinema in Tahrir Square. Serving as a form of media outlet, the cinema shows Mosireen's own work alongside films by various other groups, many of which highlight the abuses carried out by Egypt's Supreme Council of the Armed Forces and the way in which information has been controlled. In avoiding official censorship, this platform presents first-hand accounts and a perspective on events that has become politically empowering for many involved in the production of information in revolutionary Egypt.

In conceptualizing knowledge production, artists continue to offer ways in which to understand the politicization of images in a globalized economy. Roy Samaha's *Transparent Evil* (2011) [216] takes the form of a short documentary made up of both moving and still images captured over the course of a week during the early demonstrations in Tahrir Square. Shot by the artist and his friend Gheith al-Amine, who happened to be travelling with Samaha at the time, the work centres on the emptiness and silence that existed beyond the tension and urgency in the square itself. A computer-generated voiceover narrating diary entries from the period lends the work a degree of anonymity, while the film as a whole seems actively to resist the demands of global media and their insistence on using sensational images of revolt and civil unrest.

In Julia Meltzer and David Thorne's *In Possession of a Picture* (2005–) [217], the artists explore the question of which forms of visual information are deemed acceptable and which not. Highlighting cases where individuals have been arrested or detained for videotaping or photographing apparently innocuous locations in the United States (including bridges, casinos, banks, landmarks, tourist attractions and other, less conspicuous sites of interest), the work consists of a series of framed prints. Each of these prints, one for every location, is

composed of a blank space representing the confiscated image of the location and an image of the same location readily downloaded from the Internet. As we have seen, the Internet has transformed the politics of not only the storage and production of information but also its retrieval, radically altering forms of representation in the process.

The issue of what information can be revealed and what must remain hidden is central to the work of Taryn Simon, who, for *An American Index of the Hidden and Unfamiliar* (2007), managed to negotiate access to sites across the United States that are key not only to its security but also to the day-to-day operations of its main organizations (including the CIA, NASA and US Customs and Border Protection). The majority of these sites have never been seen by the public, and remain hidden from view and subject to exceptional laws. In some instances, such as a test area for bombs at the Eglin Air Force Base in Florida, or an HIV research unit at the Harvard Medical School in Boston, national security is at stake, and Simon's images of these sites come complete with an explanation of what we are looking at and why it is deemed sensitive.

In an image titled *Nuclear Waste Encapsulation and Storage Facility, Cherenkov Radiation, Hanford Site, U.S. Department of Energy, Southeastern Washington State* [218], the accompanying text explains that we are looking at a collection of nuclear-waste capsules containing cesium and strontium; the blue glow surrounding the capsules is caused by Cherenkov radiation. The facility, which houses 1,936 such capsules, was built as part of the Manhattan Project, a research and development programme that produced the world's

first atomic bombs. Located in the state of Washington, it is one of the most contaminated and highly controlled sites in the United States. Radiation can also be 'seen' in the Otolith Group's film *The Radiant* (2012) [220], which features images of the aftermath of the 2011 earthquake and subsequent tsunami that led to the partial meltdown of the Fukushima Daiichi nuclear power station in Japan. The information contained in this film is both factual and allusive, in so far as it deals with the complexity of visualizing radiation. In tackling this challenge, the film travels through time and space, reflecting on the costs and benefits of nuclear energy through images of Japanese cityscapes and landscapes both before and after the devastation.

In his interest in hidden narratives, Omer Fast has explored the relationship between information and its delivery. In *CNN Concatenated* (2002) [219], Fast spliced together hours of CNN news footage taken from different years, thereby subverting the original message. Based on a 10,000-word database compiled by the artist, the phrasing is both startling and insidious, with such sentences as 'Look, I know that you're scared' and 'You listen to your heartbeat, will it slow down' drawing us into a counter-narrative that becomes compelling in its own right. Here, Fast presents a personalized and occasionally paranoiac deconstruction of television news and the information it thrives on.

In November 2008 Steve Lambert and Andy Bichlbaum (aka Jacques Servin of the Yes Men) joined forces with activist groups, writers, advisers and numerous volunteers to publish and distribute more than 1.2 million copies of *The New York Times Special Edition* [221] across

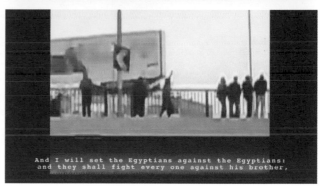
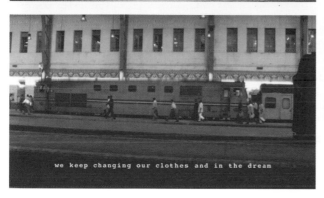

they are together, they work together
then they start working against each other

Intelligence agents and We have
important information to transmit

we keep changing our clothes and in the dream

And I will set the Egyptians against the Egyptians:
and they shall fight every one against his brother,

[216] ROY SAMAHA – Transparent Evil, 2011.
Video, colour, sound, 27 min.

Ambassador Bridge, Detroit, Michigan
unnamed persons, date unspecified

Robert Mavrinac
http://www.mavrinac.com/cgi-bin/photo.
cgi?gallery=detroitriver&photo=ambassador
_sunset.photo

[217] JULIA MELTZER AND DAVID THORNE –
In Possession of a Picture, 2005-.
Project and installation

[218] TARYN SIMON –
Nuclear Waste Encapsulation and Storage Facility, Cherenkov Radiation,
Hanford Site, U.S. Department of Energy,
Southeastern Washington State
Submerged in a pool of water at Hanford Site are 1,936 stainless-steel nuclear-waste
capsules containing cesium and strontium. Combined, they contain over 120 million curies
of radioactivity. It is estimated to be the most curies under one roof in the United States.
The blue glow is created by the Cherenkov Effect which describes the electromagnetic
radiation emitted when a charged particle, giving off energy, moves faster than light
through a transparent medium. The temperatures of the capsules are as high as 330 degrees
Fahrenheit. The pool of water serves as a shield against radiation; a human standing
one foot from an unshielded capsule would receive a lethal dose of radiation in less
than 10 seconds. Hanford is among the most contaminated sites in the United States.
2005/2007. Chromogenic print, 94.0 × 113 cm (37¾ × 44½ in.) framed, edition of 7

[219] OMER FAST – CNN Concatenated,
2002. Video, colour, sound,
18 min. loop. Installation view
at Wexner Art Center, Ohio, 2012

[220] THE OTOLITH GROUP – The Radiant, 2012.
HD video, colour, sound, 64 min. 14 sec.

In The Radiant we are presented with images of the aftermath of the
Tohoku earthquake and tsunami that led to the partial meltdown of the
Fukushima Daiichi nuclear power plant in 2011. This video-essay examines
the complexities involved in informing people about and conceptualizing
radiation, an increasingly dominant aspect of modern life.

[221] STEVE LAMBERT AND ANDY BICHLBAUM –
The New York Times Special Edition, 2008.
Collaborative project

the United States. Dated 4 July 2009, this fourteen-page edition of the newspaper contained a series of stories announcing, among other things, the establishment of national health care and, on its front page, the end of the war in Iraq. Such details as the date, which was set in the future, the fact that the paper was free and the slightly adjusted *New York Times* motto (which read 'All the News We Hope to Print' instead of 'All the News That's Fit to Print') soon identified the project as a hoax. Rather than trying to fool or mislead readers, the paper was intended to encourage the public to imagine a time in the future when the stories it contained might actually come true. The same stories were simultaneously published on a website – also an imitation of the original – which was viewed by more than 300,000 people in the two days following distribution of the paper.

In Trevor Paglen's *The Last Pictures* (2012–) [222], a project based on sending an artwork into space, the politics of information storage and knowledge production are taken to their extreme. Working with scientists, philosophers, anthropologists and artists over a five-year period, and entering into a debate about the issues currently facing the world, Paglen selected 100 images and had them etched on to an 'ultra-archival' silicon disc encased in a gold-plated shell. In 2012 this disc, which is designed to last billions of years, was attached to the exterior of the communications satellite EchoStar XVI and launched into geostationary orbit. It is expected that, in the moments before the sun's eventual death in approximately 5 billion years' time, this artefact will be one of the last human-made objects in existence.

The images contained on the disc – of shipping containers, hydraulic mining, migrants on the US–Mexican border, industrial fishing, an Occupy-movement protest in Hong Kong, a Palestinian refugee, a Japanese internment camp, Illinois State Penitentiary, melting glaciers, an unmanned drone flying over Waziristan, international financial markets – were chosen to represent where we are now as a globalized society. For Paglen, this is a defining goal of artistic practices: art, in the form of visual information, provides us with a way of looking at ourselves and our potential futures. As a collection of images that include representations of the political, social, economic and, for many, increasingly precarious nature of life on earth, *The Last Pictures* not only engages with many of the issues explored in this book, but also, in Paglen's words, embraces the sobering fact that, in the distant future, these images 'might explain ... why the people who made them are not there anymore'.[3]

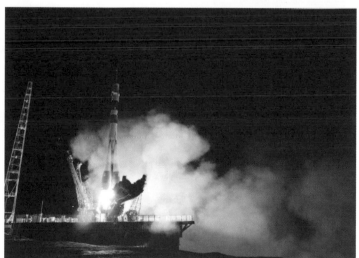

[222] TREVOR PAGLEN – <u>The Last Pictures</u>, 2012–.
Ultra-archival disc, micro-etched with 100 photographs
and encased in a gold-plated shell, mounted to
communications satellite EchoStar XVI

In the moments before the sun finally expires, in roughly
5 billion years' time, a number of items will no doubt
still be in existence, including, perhaps, Trevor Paglen's
'ultra-archival' silicon disc. This disc was attached to
the exterior of the communications satellite EchoStar XVI
in 2012. Etched on to it are 100 images that, in Paglen's
sobering words, may one day help to explain 'why the people
who made them are not there anymore'.

Introduction

1 Critics of neoliberalism argue that it seeks, through economic doctrine, to limit the scope of governments and the safety nets they provide for their societies. Another telling element of a neoliberal order concerns what David Harvey has referred to as a process of 'accumulation through dispossession', whereby the accumulation of wealth in the main global financial centres is achieved through the effective dispossession of the majority of people who live beyond these centres and, likewise, live beyond recourse to legal and political representation. See David Harvey, *A Brief History of Neoliberalism*, Oxford and New York, 2005.

2 Sekula writes: 'In photographing the Seattle demonstrations my working idea was to move with the flow of protest, from dawn to 3 a.m. if need be, taking in the lulls, the waiting and the margin of events. The rule of thumb for this sort of anti-journalism: no flash, no telephoto lens, no gas mask, no auto-focus, no press pass and no pressure to grab at all costs the one defining image of dramatic violence.' Allan Sekula, in Alexander Cockburn *et al.*, *Five Days that Shook the World: Seattle and Beyond*, London and New York, 2000, p. 122.

3 For a fuller discussion of these and other issues, see Grant H. Kester (ed.), *Art, Activism, and Oppositionality: Essays from Afterimage*, Durham, NC, 1998.

4 For full details of Rakowitz's project, see 'From Invisible Enemy to Enemy Kitchen: Michael Rakowitz in Conversation with Anthony Downey', *Ibraaz*, 29 March 2013, www.ibraaz.org/interviews/62 (accessed 12 April 2013).

5 For a related project, *Straight* (2008–12), Ai Weiwei and his team recovered more than 100 tonnes of metal rebar that had failed to stop a number of schools from collapsing during the earthquake, killing thousands of children. These metal supports, severely twisted by the force of the disaster, were straightened out and stacked on the floor to form a large carpet-like work, the undulations of which recalled the seismic waves generated by earthquakes. First shown at the Hirshhorn Museum in Washington, DC, *Straight* was subsequently exhibited in 2013 as part of the 55th Venice Biennale.

6 Rabih Mroué, in 'Lost in Narration: Rabih Mroué in Conversation with Anthony Downey', *Ibraaz*, 5 January 2012, www.ibraaz.org/interviews/11 (accessed 6 January 2013).

7 For a fuller discussion of this development, see Giorgio Agamben, *Homo Sacer: Sovereign Power and Bare Life*, tr. Daniel Heller-Roazen, Stanford, CA, 1998, *passim*.

8 Ursula Biemann, 'X-Mission', *ArteEast*, www.arteeast.org/2012/02/09/x-mission/ (accessed 8 March 2013).

9 These ideas are key to the work of Jacques Rancière, especially his argument that 'Politics exists wherever the count of parts and parties of society is disturbed by *the inscription of a part of those who have no part*'. Jacques Rancière, *Disagreement: Politics and Philosophy*, tr. Julie Rose, Minneapolis, 1999, p. 123, emphasis added.

10 For a fuller discussion of these ideas, see Jacques Rancière, *Aesthetics and Its Discontents*, tr. Steven Corcoran, Cambridge, 2009.

Globalization

1 See Amy Chua, *World on Fire: How Exporting Free Market Democracy Breeds Ethnic Hatred and Global Instability*, London and New York, 2003.

2 Manfred B. Steger, *Globalization: A Very Short Introduction*, 2nd edn, Oxford, 2009, p. 36.

3 For a fuller discussion of this work, see Anthony Downey, 'Yto Barrada, "A Life Full of Holes: The Strait Project"', in *Third Text*, Vol. 20, No. 5, 2006, pp. 617–26.

4 CAMP, 'Wharfage', www.camputer.org/event.php?this=wharfage (accessed 9 June 2013).

5 For a more detailed discussion of these issues, see Pamela M. Lee, *Forgetting the Art World*, Cambridge, MA, and London, 2012.

6 Joseph Stiglitz, a one-time chief economist at the World Bank, has noted how the IMF reflects the 'interests and ideology of the Western financial community', which, in its promotion of neoliberal programmes of development, needs to support globalization as a process regardless of its effects on communities. This can often lead to both full-scale structural adjustments to a country's debt repayment that affect millions living on or below the poverty line and a dependency on Western goods at the expense of more local, less expensive products. Joseph Stiglitz, *Globalization and Its Discontents*, London, 2002, p. 130. For a fuller account of how such debt-repayment adjustments can have a direct impact on communities, see Noreena Hertz, *The Debt Threat: How Debt Is Destroying the Developing World*, New York, 2004.

7 See Chua, *World on Fire*.

8 The consolidation and reconfiguration of former colonial relations under the rubric of globalization is one of the keys to understanding what Michael Hardt and Antonio Negri have named 'Empire'. 'Even the most dominant nation-states', Hardt and Negri write, 'should no longer be thought of as supreme and sovereign authorities, either outside or even within their own borders. *The decline in sovereignty of nation-states, however, does not mean that sovereignty as such has declined*. Throughout the contemporary transformations, political controls, state functions, and regulatory mechanisms have continued to rule the realm of economic and social production and exchange. Our basic hypothesis is that sovereignty has taken a new form, composed of a series of national and supranational organisms united under a single logic of rule. This new global form of sovereignty is what we call Empire.' Michael Hardt and Antonio Negri, *Empire*, Cambridge, MA, and London, 2000, p. xii, emphasis in original.

9 For Neil Smith, the exploitation of Third World labour has been a necessary process for the developed world, not only to keep costs down but also to keep the Third World and LDCs in their place: 'Capital, rather than using the underdeveloped world as a source of markets, has instead used the Third World as a source of cheap labour, thus preventing its full integration into the world market.' Neil Smith, *Uneven Development: Nature, Capital and the Production of Space*, 3rd edn, London and New York, 2010, p. 209.

Labour

1 Doris Salcedo, quoted in Dalya Alberge, 'Welcome to Tate Modern's Floor Show – It's 548 Foot Long and Is Called Shibboleth', *The Times*, 9 October 2007.

2 For Jessica Livingstone, the connection is incontrovertible: 'Within the context of globalization, it is necessary to investigate not just the possible male perpetrators but also the export-processing zone and the city of Juárez itself.' Jessica Livingstone, 'Murder in Juárez: Gender, Sexual Violence, and the Global Assembly Line', in *Frontiers: A Journal of Women's Studies*, Vol. 25, No. 1, 2004, pp. 59–76, p. 59.

3 For a fuller discussion of these issues in relation to Margolles's work, see Anthony Downey, '"127 Cuerpos": Teresa Margolles and the Aesthetics of Commemoration', in Tony Godfrey (ed.), *Understanding Art Objects: Thinking through the Eye*, Farnham, 2009, pp. 105–13.

4 David Harvey, *A Brief History of Neoliberalism*, Oxford and New York, 2005, p. 169.

5 Among the artists involved in Gulf Labor are Haig Aivazian, Shaina Anand, Ayreen Anastas, Doug Ashford, Doris Bittar, Tania Bruguera, Sam Durant, Rene Gabri, Mariam Ghani, Hans Haacke, Brian Holmes, Rana Jaleel, Guy Mannes-Abbott, Naeem Mohaiemen, Walid Raad, Michael Rakowitz, Andrew Ross, Gregory Sholette, Beth Stryker, Ashok Sukumaran and Murtaza Vali.

6 Guy Standing, *The Precariat: The New Dangerous Class*, London and New York, 2011.

7 Theaster Gates, http://theastergates.com/home.html (accessed 13 August 2013).

8 These points and others are explored in Gregory Sholette, *Dark Matter: Art and Politics in the Age of Enterprise Culture*, London, 2011.

9 Maurizio Lazzarato, 'Immaterial Labour', in Paolo Virno and Michael Hardt (eds), *Radical Thought in Italy: A Potential Politics*, Minneapolis, MN, 1996, pp. 133–47, p. 33.

10 The political dimension of the art world as a place of work for many is explored in Hito Steyerl, 'Politics of Art: Contemporary Art and the Transition to Post-Democracy', in *e-flux journal*, No. 21, December 2010, available online at www.e-flux.com/journal/politics-of-art-contemporary-art-and-the-transition-to-post-democracy/#ftnref1 (accessed 15 June 2011).

CITIZENS

1 For Giorgio Agamben, the 'refugee should be considered for what it is, nothing less than a limit-concept that at once brings a radical crisis to the principles of the nation-state and clears the way for a renewal of categories that can no longer be delayed.' Giorgio Agamben, 'Beyond Human Rights', in *Means Without End: Notes on Politics*, tr. Vincenzo Binetti and Cesare Casarino, Minneapolis, 2000, pp. 22–3.

2 *Nostalgia* is a three-part video installation. In Part I, a single-channel HD video, a man explains how a trap is set. In Part II, a two-channel HD video, two actors (one playing the role of the artist) re-enact a conversation between the artist and a West African national seeking asylum in London. In Part III, the one under discussion here, a refugee Briton is interrogated to find out how he crossed from Britain to Africa.

3 For a fuller discussion of Abu Hamdan's work, see 'Word Stress: Lawrence Abu Hamdan in Conversation with Anthony Downey', *Ibraaz*, 2 May 2012, www.ibraaz.org/interviews/21 (accessed 26 April 2013).

4 I have discussed this film and its relationship to the subject of camps at length in 'Camps (or the Precarious Logic of Late Modernity)', in *Fillip*, No. 13, spring 2011, pp. 38–47, available online at http://fillip.ca/content/camps-or-the-precarious-logic-of-late-modernity (accessed May 2011).

5 Raqs Media Collective, 'Dreams and Disguises, As Usual', in Monica Narula et al (eds), *Sarai Reader 2005: Bare Acts*, Delhi, 2005, pp. 162–75, p. 164.

6 According to Maria Hlavajova, the work 'reflects on the nation-state in the present day circumstances of the so-called West and asks how we can negotiate its prospects vis-à-vis the challenges posited by that which defines our contemporary condition: (illegal) immigration.' Maria Hlavajova, 'Introduction: Citizens and Subjects,' in Rosa Braidotti et al (eds), *Citizens and Subjects: The Netherlands, for Example* (exh. cat.), Dutch Pavilion, 52nd Venice Biennale, 2007, pp. 10–12, p. 10.

7 Pim Fortuyn was described by his detractors as a 'far-right populist', although the word he used to describe himself was 'pragmatist'. His policies were directed towards placing limits on immigration, multiculturalism and what he considered to be the spread of Islam in the Netherlands. He was assassinated by Volkert van der Graaf on 6 May 2002.

8 Jens Jessen, quoted in 'Please Love Austria – First Austrian Coalition Week', www.schlingensief.com/projekt_eng.php?id=t033 (accessed 12 April 2013).

9 The Kosovo War was a direct result of the so-called Yugoslav Wars, which included war in Slovenia (1991), the Croatian War of Independence (1991–5) and the Bosnian War (1992–5).

10 Quoted in Okwui Enwezor, 'Matter and Consciousness: An Insistent Gaze from a Not Disinterested Photographer', in David Goldblatt et al, *David Goldblatt: Fifty-One Years* (exh. cat.), AXA Gallery, New York, then touring, 2002–3, p. 17.

ACTIVISM

1 For further information on these performances, see http://liberatetate.wordpress.com/performances/ (accessed November 2013).

2 Thomas Hirschhorn, quoted in Randy Kennedy, 'Bringing Art and Change to Bronx: Thomas Hirschhorn Picks Bronx Development as Art Site', *New York Times*, 30 June 2013.

3 For a fuller discussion of this issue, alongside a debate on participative practices, see Claire Bishop, *Artificial Hells: Participatory Art and the Politics of Spectatorship*, London and New York, 2012.

4 Claire Bishop, 'The Social Turn: Collaboration and Its Discontents', *Artforum*, February 2006, pp. 179–85, p. 183.

5 Intrigued by the question of what King Baudouin might have thought or done on that day, Höller wrote to Baudouin's widow, Queen Fabiola, but his letter was ignored. Crucially, however, it resulted in the project being withdrawn from an exhibition celebrating Brussels' status as European Capital of Culture in 2000, so it took place the following year. No visual documentation of the work exists, and any interpretation put forward is based on the accounts of the participants.

6 Founded by Jacque Servin and Igor Vamos, The Yes Men pride themselves on correcting the activities of 'big-time criminals'. To date, their activities have targeted such corporations as Dow Chemical, the World Trade Organization, Exxon Mobil and the *New York Times*, among many others. The Yes Men have also produced two films, *The Yes Men* (2003) and *The Yes Men Fix the World* (2009), both of which explore their activist projects in greater detail.

7 In reference to the venue for *State Britain*, Wallinger has noted that 'There are different ways of enacting protest and there are various platforms and media to do that. But really this museum was the only way of making this work. I think it neatly sidetracked any issues to do with authenticity, and also the "is it art" thing, because there was an urgency for people to have a close look at this, and the only place they could do it was there.' Quoted in Martin Herbert, *Mark Wallinger*, London, 2011, p. 182.

8 The other two videos in the trilogy are *RE: The_Operation* (2002) and *Now Promise Now Threat* (2005).

9 *Tiqqun* is also the publisher of, among other titles, *The Coming Insurrection* (2007), a book that theorizes the 'imminent collapse of capitalist culture', and *Introduction to Civil War* (2009), which proposes that society is not so much in crisis as at an end.

CONFLICT

1 In *Media Spectacle and the Crisis of Democracy*, Douglas Kellner argues that 'media spectacles' not only dominate global news coverage but also effectively distract the viewer from issues of genuine public concern. Kellner examines the role of media spectacle in the events of 9/11 and the subsequent wars in Afghanistan and Iraq, and the role that media politics and representations play in advancing foreign-policy agendas and militarism. See Douglas Kellner, *Media Spectacle and the Crisis of Democracy: Terrorism, War, and Election Battles*, Boulder, CO, and London, 2005.

2 Yael Bartana, in Galit Eilat, 'A Conversation with Yael Bartana', in Charles Esche and Esra Sarigedik Oktem (eds), *Yael Bartana: Videos and Photographs*, Eindhoven and Rotterdam, 2006, pp. 35–43, p. 39.

3 The tapestry, made with the permission of Picasso himself, had been commissioned in 1955 by Nelson Rockefeller, who later donated it to the United Nations.

TERROR

1 The idea that 'everything changed' after 11 September 2001 has been contested by a number of commentators. In *Civic War and the Corruption of the Citizen*, Peter Alexander Meyers suggests that the changes brought about by 9/11 were already underway, and that the constitution of already existing political powers became the pretext for unprecedented political opportunism and civil irresponsibility. See Peter Alexander Meyers, *Civic War and the Corruption of the Citizen*, Chicago and London, 2008.

2 W. J. T. Mitchell has explored aspects of this anxiety in relation to the precise role of verbal and visual images in the so-called war on terror. See W. J. T. Mitchell, *Cloning Terror: The War of Images, 9/11 to the Present*, Chicago and London, 2011.

3 See Slavoj Žižek, *Welcome to the Desert of the Real!: Five Essays on 11 September and Related Dates*, London and New York, 2002, p. 16.

4 For a fuller discussion of this image and its function in popular culture, see Anthony Downey, 'At the Limits of the Image: Representations of Torture in Popular Culture', in *Brumaria*, No. 14, 2009, pp. 123–32.

HISTORY

1 Despite his unsuccessful presidential campaign, Rios Montt was elected to the Guatemalan congress in 2007, thus becoming immune from prosecution until 2012. He was eventually convicted of genocide and crimes against humanity on 10 May 2013; however, the conviction was overturned, and he remains at large while he waits for the original trial to resume.

2 In 1789 Clarkson produced *Description of a Slave Ship*, a woodcut portraying the inhuman and abject conditions in which slaves were transported from Africa to the Americas during the so-called Middle Passage. In its direct-ness and graphic simplicity, it had a profound effect on political opinion.

3 The Sinti are a Romani people of central Europe, and had lived in Germany and Austria since the Middle Ages. In concen-tration camps, Sinti were forced to wear either a black triangle, which designated them 'asocial', or a brown triangle, which was reserved for the Romani people.

CAMPS

1 Biopolitics has been largely associated with the work of Michel Foucault, and much of the debate and controversy surrounding the subject emerged in the wake of Foucault's untimely death in 1984. For Michael Hardt and Antonio Negri, it is essential that the productive element of Foucault's theory, the notion that it produces new subjectivities or social types, be addressed and progressed, rather than the merely restrictive elements of biopolitical determin-ism. See Michael Hardt and Antonio Negri, *Commonwealth*, Cambridge, MA, and London, 2009, pp. 58–9.

2 For an extended discussion of these issues, see Anthony Downey, 'Exemplary Subjects: Camps and the Politics of Representation', in Tom Frost (ed.), *Giorgio Agamben: Legal, Political and Philosophical Perspectives*, Oxford and New York, 2013, pp. 119–42.

3 The overall project was initiated in 2001, when Eid-Sabbagh and the pho-tographer Simon Lourié ran a series of summer workshops in six Palestinian refugee camps in Lebanon: Shatila, Nahr al-Bared, Ain al-Hilweh, Rachediyeh, Burj al-Barajneh and Burj al-Shamali. Eid-Sabbagh spent the next five years in the camps before settling in Burj al-Shamali, where she lived until recently.

4 The Arab Resource Collective seeks to create a 'virtual Palestine' linking, in this particular instance, the communities living in five refugee camps around Lebanon: Shatila, Rachediyeh, Nahr al-Bared, Shabriha and Ain al-Hilweh.

5 Jawad Al Malhi, in *Provisions, Sharjah Biennial 9: Book 1* (exh. cat.), 9th Sharjah Biennial, 2009, quoted in www.sharjahart. org/projects/projects-by-date/2009/ here-malhi (accessed 28 July 2013).

6 A list of legal, semi-legal and official camps in and around Europe is published by the Flüchtlingsrat Niedersachsen (Niedersachsen Council on Refugees and Exiles). See www.nds-fluerat. org (accessed November 2013).

7 At the time of writing, Guantánamo Bay still housed 270 detainees, of which only 19 had been formally charged.

8 Occupy London's camp was in existence from 15 October 2011 until 14 June 2012. OWS protesters had set up their camp, in Zuccotti Park in New York's financial district, on 17 September 2011, and were forcibly removed on 15 November 2011.

9 Trevor Paglen, 'A Most Peculiar Airline', http://vectors.usc.edu/issues/4/ trevorpaglen/ (accessed 8 March 2013).

ENVIRONMENTS

1 R. K. Pachauri and A. Reisinger (eds), *Climate Change 2007: Synthesis Report*, Geneva, 2007, available online at www. ipcc.ch/publications_and_data/ar4/syr/en/ contents.html (accessed 18 March 2013).

2 For the full 'apology', see www. youtube.com/watch?v=zciWUOrIUqo (accessed November 2013).

3 For more information, see www. geobodies.org/art-and-videos/egyptian-chemistry (accessed 12 March 2013).

4 Pamela M. Lee, *Forgetting the Art World*, Cambridge, MA, and London, 2012, p. 133.

5 Ravi Agarwal, in 'Interview with Ravi Agarwal', 4 June 2013, http:// maldivespavilion.com/blog/interview-with-ravi-agarwal/ (accessed 14 August 2013).

6 Mark Dion, in 'Mark Dion: "Neukom Vivarium"', www.art21.org/texts/mark-dion/interview-mark-dion-neukom-vivarium (accessed November 2013).

ECONOMIES

1 Steve Lambert, quoted in http://visitsteve. com/made/capitalism-works-for-me-truefalse/ (accessed 14 June 2013).

2 This figure is calculated by adding up a number of black-market activities – from drug trafficking and film piracy to prostitution – currently being monitored. See www.havocscope. com (accessed 10 December 2013).

3 Martha Rosler, 'The Garage Sale is a Metaphor for the Mind', in Luis Jacob (ed.), *Commerce by Artists*, Toronto, 2011, p. 109.

KNOWLEDGE

1 For Hunt, these maps theorize how 'prisoners in a domestic context, and refugees in an "extra-national" context, compose a growing body of stateless persons, upon whose erasure and subjugation global affluence and neoliberal capitalism are built'. See Natascha Sadr Haghighian and Ashley Hunt, 'Representations of the Erased', in Maria Hlavajova et al (eds), *On Knowledge Production: A Critical Reader in Contemporary Art*, BAK Critical Reader Series, Utrecht and Frankfurt am Main, 2008, p. 169.

2 Visualizing Palestine, in Haig Aivazian, 'Succinctly Verbose: Visualizing Palestine in Conversation with Haig Aivazian', 8 May 2013, www.ibraaz.org/ interviews/72 (accessed 2 May 2013).

3 Trevor Paglen, in 'Trevor Paglen: The Last Pictures', video, 11:50, available online at http://creativetime.org/projects/the-last-pictures/ (accessed November 2013).

Adrian Paci: Vies en transit/Lives in Transit (exh. cat.), Jeu de Paume, Paris, 2013/PAC Padiglione d'Arte Contemporanea, Milan, 2013–14/Musée d'Art Contemporain de Montréal, 2014

Agamben, Giorgio, *Homo Sacer: Sovereign Power and Bare Life*, tr. Daniel Heller-Roazen, Stanford, CA, 1998

——, *Remnants of Auschwitz: The Witness and the Archive*, tr. Daniel Heller-Roazen, New York, 1999

——, *Means Without End: Notes on Politics*, tr. Vincenzo Binetti and Cesare Casarino, Minneapolis, 2000

——, *State of Exception*, tr. Kevin Attell, Chicago and London, 2005

Agier, Michel, *Managing the Undesirables: Refugee Camps and Humanitarian Government*, tr. David Fernbach, Cambridge and Malden, MA, 2011

Allan Sekula, Titanic's Wake (exh. cat.), Centre de Création Contemporaine, Tours, 2000–1/Centro Cultural de Belém, Lisbon, 2001/Samuel P. Harn Museum of Art, University of Florida, Gainesville, 2004–5/Camera Austria, Kunsthaus Graz, 2005

Alberro, Alexander, *Conceptual Art and the Politics of Publicity*, Cambridge, MA, and London, 2003

Aliaga, Juan Vicente, *Akram Zaatari. El molesto asunto/The Uneasy Subject* (exh. cat.), Museo de Arte Contemporáneo de Castilla y León, 2011/Museo Universitario Arte Contemporáneo, Mexico, 2012

Apel, Dora, *War Culture and the Contest of Images*, New Brunswick, NJ, and London, 2012

Araeen, Rasheed, *Art Beyond Art: Ecoaesthetics – A Manifesto for the 21st Century*, London, 2010

—— et al (eds), *The Third Text Reader: On Art, Culture, and Theory*, London and New York, 2002

Babias, Marius (ed.), *Hito Steyerl* (exh. cat.), Neuer Berliner Kunstverein, 2010

Bales, Kevin, *Disposable People: New Slavery in the Global Economy*, rev. edn, Berkeley, CA, and London, 2012

Banerjee, Subhankar (ed.), *Arctic Voices: Resistance at the Tipping Point*, New York, 2012

Bassil, Karl, and Akram Zaatari (eds), *Akram Zaatari: Earth of Endless Secrets* (exh. cat.), Kunstverein München/Sfeir-Semler Gallery, Hamburg/Beirut Art Center, 2009

Baudrillard, Jean, *The Spirit of Terrorism and Other Essays*, tr. Chris Turner, rev. edn, London and New York, 2003

Bilal, Wafaa, and Kari Lydersen, *Shoot an Iraqi: Art, Life and Resistance under the Gun*, San Francisco, 2008

Bishop, Claire, *Artificial Hells: Participatory Art and the Politics of Spectatorship*, London and New York, 2012

—— (ed.), *Participation*, London and Cambridge, MA, 2006

Boltanski, Luc, and Eve Chiapello, *The New Spirit of Capitalism*, tr. Gregory Elliot, London, 2005

Bonacossa, Ilaria, and Latitudes (eds), *Greenwashing. Environment: Perils, Promises and Perplexities* (exh. cat.), Fondazione Sandretto Re Rebaudengo, Turin, 2008

Borchardt-Hume, Achim (ed.), *Miraculous Beginnings: Walid Raad* (exh. cat.), Whitechapel Gallery, London, 2010

—— et al (eds), *Zarina Bhimji* (exh. cat.), Whitechapel Gallery, London/The New Art Gallery Walsall/Kunstmuseum Bern, 2012

Bourriaud, Nicolas, *Relational Aesthetics*, tr. Simon Pleasance et al, Paris, 2002

Bradley, Will, and Charles Esche *Art and Social Change: A Critical Reader*, London, 2007

Braidotti, Rosi, et al (eds), *Citizens and Subjects: The Netherlands, for Example* (exh. cat.), Dutch Pavilion, 52nd Venice Biennale, 2007

Buchloh, Benjamin (ed.), *Gerhard Richter*, Cambridge, MA, and London, 2009

Butler, Judith, *Precarious Life: The Powers of Mourning and Violence*, London and New York, 2004

—— and Athena Athanasiou, *Dispossession: The Performative in the Political*, Cambridge and Malden, MA, 2013

Calirman, Claudia, *Brazilian Art under Dictatorship: Antonio Manuel, Artur Barrio, and Cildo Meireles*, Durham, NC, and London, 2012

Camnitzer, Luis, et al, *Global Conceptualism: Points of Origin, 1950s–1980s* (exh. cat.), Queens Museum of Art, New York, 1999/Walker Art Center, Minneapolis, 1999–2000/Miami Art Museum, 2000

Cauter, Lieven De, et al (eds), *Art and Activism in the Age of Globalization*, Rotterdam, 2011

Chomsky, Noam, *9/11*, New York, 2001

Chua, Amy, *World on Fire: How Exporting Free Market Democracy Breeds Ethnic Hatred and Global Instability*, London and New York, 2003

Ciliberto, Michele, et al, *Declining Democracy: Ripensare la democrazia tra utopia e partecipazione/Rethinking Democracy between Utopia and Participation* (exh. cat.), Centro di Cultura Contemporanea Strozzina, Florence, 2011–12

Coles, Alex (ed.), *Site-Specificity: The Ethnographic Turn*, London, 2000

Costello, Diarmuid, and Dominic Willsdon (eds), *The Life and Death of Images: Ethics and Aesthetics*, London and Ithaca, NY, 2008

Cramerotti, Alfredo, *Aesthetic Journalism: How to Inform Without Informing*, Bristol and Chicago, 2009

Danchev, Alex, *On Art and War and Terror*, Edinburgh, 2011

David, Marian, et al, *Santiago Sierra: 7 Trabajos/7 Works* (exh. cat.), Lisson Gallery, London, 2007–8

Demos, T.J., *The Migrant Image: The Art and Politics of Documentary during Global Crisis*, Durham, NC, and London, 2013

Documenta11_Platform5: Exhibition Catalogue (exh. cat.), Museum Fridericianum, Kassel, 2002

Documenting Disposable People: Contemporary Global Slavery (exh. cat.), Hayward Gallery, London, then touring, 2008–10

Downey, Anthony (ed.), *Uncommon Grounds: New Media and Critical Practices in North Africa and the Middle East*, London, 2014

—— and Lina Lazaar (eds), *The Future of a Promise: Contemporary Art from the Arab World* (exh. cat.), Magazzini del Sale, Venice, 2011

Dziewior, Yilmaz (ed.), *Yael Bartana* (exh. cat.), Kunstverein Hamburg, 2008

Ehmann, Antje, and Kodwo Eshun, *Harun Farocki: Against What? Against Whom?* (exh. cat.), Raven Row, London, 2009–10

Enwezor, Okwui (ed.), *Archive Fever: Uses of the Document in Contemporary Art* (exh. cat.), International Center of Photography, New York, 2008

Gaensheimer, Susanne (ed.), *Christoph Schlingensief* (exh. cat.), German Pavilion, 54th Venice Bienalle, 2011

——, *Ai Weiwei, Romuald Karmakar, Santu Mofokeng, Dayanita Singh* (exh. cat.), German Pavilion, 55th Venice Biennale, 2013

Genzmer, Synne, et al, *Mike Parr: Edelweiss* (exh. cat.), Kunsthalle Wien, Vienna, 2012

Goldblatt, David, et al, *David Goldblatt: Fifty-One Years* (exh. cat.), AXA Gallery, New York, then touring, 2002–3

Grimonprez, Johan, *Dial H-I-S-T-O-R-Y: A Film by Johan Grimonprez*, Brussels, Osterfildern-Ruit, Ghent and New York, 2003

Groys, Boris, *Art Power*, Cambridge, MA, and London, 2008

—— and Peter Weibel (eds), *Medium Religion: Faith. Geopolitics. Art.* (exh. cat.), ZKM Center for Art and Media, Karlsruhe, 2008–9

Hailey, Charlie, *Camps: A Guide to 21st-Century Space*, Cambridge, MA, and London, 2009

Hardt, Michael, and Antonio Negri, *Empire*, Cambridge, MA, and London, 2000

——, *Commonwealth*, Cambridge, MA, and London, 2009

Harvey, David, *A Brief History of Neoliberalism*, Oxford and New York, 2005

——, *Spaces of Global Capitalism: Towards a Theory of Uneven Geographical Development*, London and New York, 2006

Held, David, and Anthony McGrew, *Globalization/Anti-Globalization: Beyond the Great Divide*, 2nd edn, Cambridge and Malden, MA, 2007

Hind, Dan, *The Return of the Public*, London and New York, 2010

Hlavajova, Maria, *Concerning War* (exh. cat.), BAK, basis voor actuele kunst, Utrecht, 2005

———, *Sanja Iveković: Urgent Matters* (exh. cat.), BAK, basis voor actuele kunst, Utrecht/Van Abbemuseum, Eindhoven, 2009

——— et al (eds), *On Knowledge Production: A Critical Reader in Contemporary Art*, BAK Critical Reader Series, Utrecht and Frankfurt am Main, 2008

Hoffmann, Felix (ed.), *Unheimlich Vertraut: Bilder vom Terror/The Uncanny Familiar: Images of Terror* (exh. cat.), C/O Berlin, 2011

Indij, Guido (ed.), *Buena memoria: Un ensayo fotográfico de Marcelo Brodsky/ Good Memory: A Photographic Essay by Marcelo Brodsky*, Buenos Aires, 1997

Jacob, Luis (ed.), *Commerce by Artists*, Toronto, 2011

Kester, Grant H., *Conversation Pieces: Community and Communication in Modern Art*, Berkely, CA, and London, 2004

———, *The One and the Many: Contemporary Collaborative Art in a Global Context*, Durham, NC, and London, 2011

Khatib, Lina, *Image Politics in the Middle East: The Role of the Visual in Political Struggle*, London and New York, 2012

Kittelmann, Udo, and Klaus Görner (eds), *Teresea Margolles: Muerte sin fin* (exh. cat.), MMK Museum für Moderne Kunst, Frankfurt am Main, 2004

Latour, Bruno, *Politics of Nature: How to Bring the Sciences into Democracy*, Cambridge, MA, and London, 2004

Lazzarato, Maurizio, *The Making of the Indebted Man: An Essay on the Neoliberal Condition*, tr. Joshua David Jordan, Semiotext(e) Intervention Series 13, Los Angeles, 2012

Lemert, Charles, et al (eds), *Globalization: A Reader*, Abingdon and New York, 2010

Lind, Maria, and Hito Steyerl (eds), *The Greenroom: Reconsidering the Documentary and Contemporary Art #1* (exh. cat.), Center for Curatorial Studies and Hessel Museum of Art, Bard College, Annandale-on-Hudson, NY, 2008–09

Manacorda, Francesco, and Ariella Yedgar, *Radical Nature: Art and Architecture for a Changing Planet, 1969–2009* (exh. cat.), Barbican Art Gallery, London, 2009

Marazzi, Christian, *The Violence of Financial Capitalism*, tr. Kristina Lebedeva and Jason Francis Mc Gimsey, rev. edn, Semiotext(e) Intervention Series 2, Los Angeles, 2011

Medina, Cuauhtémoc (ed.), *Teresa Margolles: What Else Could We Talk About?* (exh. cat.), Mexican Pavilion, 53rd Venice Biennale, 2009

Michalka, Matthias (ed.), *Harun Farocki: Nebeneinander* (exh. cat.), Museum Moderner Kunst Stiftung Ludwig Wien, Vienna, 2007

Mignolo, Walter D., *The Darker Side of Western Modernity: Global Futures, Decolonial Options*, Durham, NC, and London, 2011

Mitchell, W. J. T., *Cloning Terror: The War of Images, 9/11 to the Present*, Chicago and London, 2011

Mytkowska, Joanna (ed.), *Artur Zmijewski: If It Only Happened Once, It's as if It Never Happened/Einmal ist keinmal* (exh. cat.), Kunsthalle Basel, 2005

O'Neill, Paul (ed.), *Curating Subjects: Occasional Table*, London, 2007

Paglen, Trevor, *Blank Spots on the Map: The Dark Geography of the Pentagon's Secret World*, New York and London, 2009

———, *Invisible: Covert Operations and Classified Landscapes*, New York and London, 2010

Portraits and Power: People, Politics and Structures (exh. cat.), Centro di Cultura Contemporanea Strozzina, 2010–11

Primoratz, Igor, *Terrorism: A Philosophical Investigation*, Cambridge and Malden, MA, 2012

Raad, Walid, *Scratching on Things I Could Disavow: A History of Modern and Contemporary Art in the Arab World: Part I_ Volume 1_ Chapter 1 (Beirut: 1992–2005)*, REDCAT, Los Angeles, 2009

Rancière, Jacques, *The Politics of Aesthetics: The Distribution of the Sensible*, London and New York, 2006

———, *Aesthetics and Its Discontents*, tr. Steven Corcoran, Cambridge and Malden, MA, 2009

Raqs Media Collective: The Imposter in the Waiting Room (exh. cat.), Bose Pacia, New York, 2004

Robbins, Paul, *Political Ecology: A Critical Introduction*, Malden, MA, and Oxford, 2004

Sainsbury, Helen (ed.), *Miroslaw Balka: How It Is* (exh. cat.), Tate Modern, London, 2009–10

Sassen, Saskia, *Territory, Authority, Rights: From Medieval to Global Assemblages*, Princeton, NJ, and Oxford, 2006

Schaschl, Sabine (ed.), *In Memory, Omer Fast* (exh. cat.), Kunsthaus Baselland, Basel/Kunstverein Hannover, 2009

Schavemaker, Margriet, and Mischa Rakier, *Right About Now: Art and Theory Since the 1990s*, Amsterdam, 2007

Schmitz, Britta, and Bettina Schaschke (eds), *Ayşe Erkmen: Weggefährten* (exh. cat.), Hamburger Bahnhof, Museum für Gegenwart, Berlin, 2008–9

Scholte, Jan Aart, *Globalization: A Critical Introduction*, 2nd edn, Basingstoke and New York, 2005

Schweizer, Nicole (ed.), *Alfredo Jaar: La Politique des images* (exh. cat.), Musée Cantonal des Beaux-Arts, Lausanne, 2007

Sealy, Mark, and Tom O Mara (eds), *Yto Barrada: A Life Full of Holes –*

The Strait Project (exh. cat.), Open Eye Gallery, Liverpool, 2005

Sholette, Gregory, and Oliver Ressler, *It's the Political Economy, Stupid: The Global Financial Crisis in Art and Theory*, London, 2013

Siemons, Mark, and Ai Weiwei, *Ai Weiwei: So Sorry* (exh. cat.), Haus der Kunst, Munich, 2009–10

Smith, Neil, *Uneven Development: Nature, Capital and the Production of Space*, 3rd edn, London and New York, 2010

Stahel, Urs, and Daniela Janser, *Ai Weiwei: Interlacing* (exh. cat.), Fotomuseum Winterthur, 2011/Jeu de Paume, Paris, 2012

Standing, Guy, *The Precariat: The New Dangerous Class*, London and New York, 2011

Stipancić, Branka (ed.), *Mladen Stilinović: Artist's Books 1972–2006*, Istanbul and Eindhoven, 2007

Steyerl, Hito, *The Wretched of the Screen*, e-flux Journal Series, Berlin, 2012

Stiglitz, Joseph, *Globalization and Its Discontents*, London, 2002

———, *The Price of Inequality*, London, 2013

The Invisible Committee, *The Coming Insurrection*, Semiotext(e) Intervention Series 1, Los Angeles, 2009

Tiqqun, *Introduction to Civil War*, tr. Alexander R. Galloway and Jason E. Smith, Semiotext(e) Intervention Series 4, Los Angeles, 2010

Waspe, Roland, et al, *Emily Jacir* (exh. cat.), Kunstmuseum St Gallen, 2007/Villa Merkel, Galerien der Stadt Esslingen am Neckar, 2007–08

Weibel, Peter, and Timothy Druckrey (eds), *Net_Condition_: Art and Global Media*, Graz, Karlsruhe, Cambridge, MA, and London, 2001

Weiss, Rachel, et al, *Making Art Global (Part 1): The Third Havana Biennial 1989*, London, 2011

Widenheim, Cecilia, et al (eds), *Work, Work, Work: A Reader on Art and Labour*, Stockholm and Berlin, 2012

Zizek, Slavoj, *Welcome to the Desert of the Real!: Five Essays on 11 September and Related Dates*, London and New York, 2002

———, *Iraq: The Borrowed Kettle*, London and New York, 2005

Zmijewski, Artur, and Joanna Warsza (eds), *Forget Fear* (exh. cat.), 7th Berlin Biennale for Contemporary Art, 2012

[196] Courtesy the artists
[197] Left: Photo Aurélien Mole.
 Produced for Kadist Art Foundation,
 Paris, 2010. Photo Emilie Villez
[198] Top left: Photo Liverpool Biennial.
 Top right: Photo Jessica Doyle. Bottom
 left: Photo Jeanne van Heeswijk.
 Courtesy Jeanne van Heeswijk
[199] Courtesy the artist and the
 Museum of Modern Art, New York.
 Right: Photo Werner Kaligofsky
[200] Courtesy the Institute for
 Human Activities, Galerie Fons
 Welters, Amsterdam, and Wilkinson
 Gallery, London
[201] Courtesy Hans Haacke and Paula Cooper
 Gallery, New York. © DACS, London
[202] © Theaster Gates. Courtesy
 White Cube. Photo Sara Pooley
[203] Courtesy Catriona Jeffries, Vancouver
[204] Courtesy the artist
[205] Courtesy greengrassi. © Janice Kerbel
[206] Courtesy Bureau d'Études
[207] Whitney Museum of American
 Art, New York. Purchase, with funds
 from the Drawing Committee and
 the Contemporary Committee
[208] Private Collection. Courtesy
 Donald Lombardi and Pierogi Gallery,
 New York. Photo John Berens
[209] Courtesy the artist and 18th
 Street Gallery, Los Angeles
[210] Exhibition curated by N. Chambers,
 A. Clark, T. Ellwood, S. Raffel,
 K. Weir. Courtesy the artist and
 Galerie Laurent Godin, Paris
[211] Courtesy Visualizing Palestine
[212] Courtesy the artist and gb agency, Paris
[213] Courtesy the artist
[214] Courtesy the artist
[215] Courtesy Tariq Hashim
[216] Courtesy Roy Samaha
[217] Courtesy Julia Meltzer and David Thorne
[218] Courtesy Gagosian Gallery.
 © Taryn Simon
[219] Courtesy the artist and gb agency, Paris
[220] Courtesy The Otolith Group
[221] Courtesy the artists and Charlie
 James Gallery, Los Angeles
[222] Top left: *Greek and Armenian Orphan
 Refugees Experience the Sea for the First
 Time, Marathon, Greece*. Top right:
 *Migrants Seen by Predator Drone, U.S.–
 Mexico Border*. Centre left: *Cheyenne
 Mountain, Colorado Springs, Colorado*.
 Centre right: *Image wafer in production*.
 Bottom left: *The Artifact open with image
 wafer exposed*. Bottom right: *Soyuz Fg
 Rocket Launch, Baikonur Cosmodrome,
 Kazakhstan*. Courtesy Trevor Paglen

Acknowledgments
In a book of this size, bringing together as
it does ten or so years of exhibitions visited
and countless discussions had, it would be
very difficult to acknowledge everyone who
has been involved in its creation. I would
nevertheless like to thank Rosemary Willink
for her assiduous research into images
and artists' biographies, and Lauren Mele
for setting up the initial framework for
image research. A special thank you goes to
Jacky Klein, whose unwavering support and
confidence in the book were central to its
realization from the outset. I would also like
to thank my colleagues Marcus Verhagen,
Edgar Schmitz, Anna Moszynska, Gilda
Williams, Pierre Saurisse, Maxa Zoller,
Richard Noble and Jennifer Thatcher for their
many insights into the shows we have all
seen together over the years. A further debt
of gratitude is owed to Mark Ralph, for his
diligence in reading through the text, and
to Jo Walton and Celia White, for their
perseverance in locating images and other
materials. Finally, this book is dedicated
to Sally Anne and Beatrice Aida, whose
encouragement and unselfish dispositions
have been instrumental in its completion.